YOLANDA M. LÓPEZ

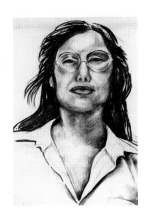

A VER: REVISIONING ART HISTORY

Gronk, by Max Benavidez (2007)
Yolanda M. López, by Karen Mary Davalos (2008)

A Ver: Revisioning Art History stems from the conviction that individual artists and their coherent bodies of work are the foundation for a truly meaningful and diverse art history. This series explores the cultural, aesthetic, and historical contributions of Chicano, Puerto Rican, Cuban, Dominican, and other U.S. Latino artists. Related educational, archival, and media resources can be found at the series home page, www.chicano.ucla.edu/research/ArtHistory.html, including downloadable teacher's guides for each book. A Ver . . . Let's see!

Series Editor
Chon A. Noriega, University of California, Los Angeles

National Advisory Board
Alejandro Anreus, William Patterson University
Gilberto Cárdenas, University of Notre Dame
Karen Mary Davalos, Loyola Marymount University
Henry C. Estrada, La Plaza de Cultura y Artes, Los Angeles
Jennifer A. González, University of California, Santa Cruz
Rita Gonzalez, Los Angeles County Museum of Art
Kellie Jones, Columbia University
Mari Carmen Ramírez, Museum of Fine Arts, Houston
Yasmin Ramírez, Hunter College, The City University of New York
Terezita Romo, independent writer and curator, Sacramento

A VER: REVISIONING ART HISTORY

VOLUME 2

YOLANDA M. LÓPEZ

KAREN MARY DAVALOS

FOREWORD BY CHON A. NORIEGA

UCLA CHICANO STUDIES RESEARCH CENTER PRESS

LOS ANGELES

2008

Copyright 2008 by the Regents of the University of California.
All rights reserved. Printed in China.

CSRC Director: Chon A. Noriega
Senior Editor: Rebecca Frazier
Business Manager: Luz Orozco
Manuscript Editor: Catherine A. Sunshine
Design and Production: William Morosi

Developmental Editor: Colin Gunckel
Research Assistants: Janyce Cardenas, Lauro Cons, Beth Rosenblum, Mirasol Riojas, Ariana Rosas
Getty Intern: Nathalie Sánchez

 UCLA Chicano Studies Research Center
193 Haines Hall
Los Angeles, California 90095-1544
www.chicano.ucla.edu

 Distributed by the University of Minnesota Press
111 Third Avenue South, Suite 290
Minneapolis, Minnesota 55401-2520
www.upress.umn.edu

Front cover: Yolanda M. López, *Portrait of the Artist as the Virgin of Guadalupe*, from the Guadalupe series, 1978.
 Oil pastel on rag paper, 22 x 30 inches.
Front flap: Photograph of Yolanda M. López by Joe Ramos.
Back cover: Yolanda M. López, *Mexican Chair*, 1986. Acrylic paint, toothpicks, and wood on kitchen chair,
 37 x 15 x 17½ inches.
Back flap: Photograph of Karen Mary Davalos by Glenn Cratty; courtesy Loyola Marymount University.
Frontispiece: Yolanda M. López, detail of *Self-Portrait*, from Tres Mujeres/Three Generations series, 1975–76.
 Charcoal on paper, 4 x 8 feet.

Library of Congress Cataloging-in-Publication Data

Davalos, Karen Mary, 1964-
 Yolanda M. López / Karen Mary Davalos.
 p. cm. – (A ver—revisioning art history ; v. 2)
 Includes bibliographical references and index.
 ISBN 978-0-89551-103-4 (cloth : alk. paper) – ISBN 978-0-89551-110-2 (pbk. : alk. paper)
 1. López, Yolanda M., 1942—Criticism and interpretation. 2. Mexican American women artists. I. University of
California, Los Angeles. Chicano Studies Research Center. II. Title.
 N6537.L66D38 2008
 709.2–dc22

 2008031025

♾ This book is printed on acid-free paper.

CONTENTS

PROJECT SUPPORT

The UCLA Chicano Studies Research Center
acknowledges the generous support of
Tamar Diana Wilson

A Ver: Revisioning Art History
is made possible through the generous support
of the following institutions:

The Getty Foundation
The Ford Foundation
The Andy Warhol Foundation for the Visual Arts
The JPMorgan Chase Foundation
The Rockefeller Foundation
The Joan Mitchell Foundation
UC MEXUS

AFFILIATED INSTITUTIONS

Archives of American Art, Smithsonian Institution • California Ethnic and Multicultural Archives (CEMA), University of California, Santa Barbara • Centro de Estudios Puertorriqueños, Hunter College, New York • Cuban Research Institute, Florida International University • Hispanic Research Center, Arizona State University, Phoenix • Inter-University Program for Latino Research (IUPLR) • Institute for Latino Studies, University of Notre Dame • Jersey City Museum • La Plaza de Cultura y Artes, Los Angeles • Latino Art Museum, Pomona • Latino Museum, Los Angeles • Los Angeles County Museum of Art • Mexican Cultural Institute, Los Angeles • Mexican Museum, San Francisco • El Museo del Barrio, New York • Museum of Fine Arts, Houston • National Association of Latino Arts and Culture (NALAC)

ACKNOWLEDGMENTS

This work would not have been possible without the generosity, creativity, and wisdom of Yolanda M. López. Patient and witty, she allowed me to sit with her, day and night, and talk about art, life, and everything, and she never laughed at my ill-formed questions or simple interpretations. I am deeply indebted to her. David Gaylord inspired me to explore and trust my response to art. I dedicate this book to these two artists. A team at the UCLA Chicano Studies Research Center assisted me with this project: Yolanda Retter helped me locate obscure references and my soul when lost; Michael Stone provided me with video recordings and generously lent me space, a few good jokes, and his friendship; Janyce Cardenas worked tirelessly hunting down facts and books; Beth Rosenblum got the project off to a quick start; and Colin Gunckel saw it through to completion. Chon A. Noriega, whose true talent lies in bringing together collaborators who motivate and inspire, invited me to join A Ver. He is the Wizard of Oz, pulling the levers and making the magic, but always providing a way home. To my children, Maria Olivia and Glennon, whose ability to engage in a critique of Chicana/o art makes me swell with joy. They also functioned from time to time as research assistants—sorting files, rewinding audio tapes, and picking up books from the library—and I am delighted to have had their help. David Stanton, my partner, took over all kitchen duties during the writing of this book and never complained. I am grateful to my sisters, brothers, and parents for believing that I could produce another book. My father, Ruben M. Davalos, PhD, read a chapter of an earlier version of the manuscript and asked for two more. His genuine interest in my work means a lot to this loud-mouthed third child. My mother, Mary Catherine Davalos, has read everything I have ever written or edited, including my illegible notes in the margins; she is the keenest proofreader on the planet. The conclusions in the book are my own, including any errors, but the work I do is consistently fed and pushed by *una colectiva de las mujeres* in higher education. I could never let my vanity pretend that I arrived here on my own, or alone.

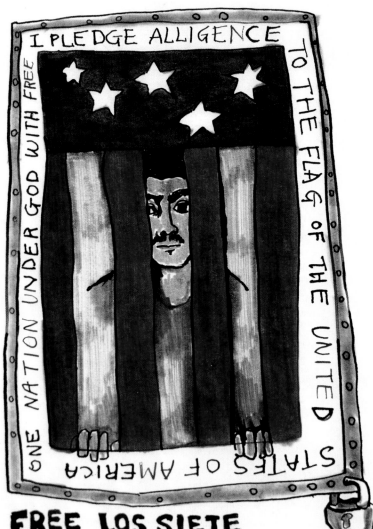

FREE LOS SIETE

FOREWORD

CHON A. NORIEGA

In the 1970s, Yolanda M. López produced some of the most iconic and widely circulated images of the Chicano civil rights movement, addressing pressing issues related to social justice and human rights while also producing conceptually grounded alternatives to the social and cultural invisibility of women within these struggles. These works include *Who's the Illegal Alien, Pilgrim?* and the Guadalupe series (both 1978), which engaged pre-Columbian and Catholic iconographies that were already familiar in Chicano art and social protest. But López made several notable interventions. She introduced satirical humor as well as a sense of the female quotidian into political discourse, and she subverted the formal structures and techniques of both Mexican devotional art and American mass media. As Karen Mary Davalos notes about *Who's the Illegal Alien, Pilgrim?*, the poster's Aztec warrior figure appropriates both John Wayne in the revisionist Western *The Man Who Shot Liberty Valance* (1962) and the "Uncle Sam" of Army recruitment posters, thereby insinuating the warrior's statement *within* U.S. political discourse itself. The Guadalupe series appropriates a religious icon used to sustain a Madonna-whore dichotomy in Mexican culture as well as to limit the scope of Chicana political participation to mere symbolism. Here, López uses la Virgen de Guadalupe as a template for Chicana portraiture, not as types (whether abject or active) but as individual women at work and play across generations and the life cycle. Because these and other works were based on photographic studies, López introduces an indexical underpinning in the creative process that tempers the works' iconic function by subtly cutting against the movement's own myth-building and cultural nationalism. Icons can be useful, but they also can be mistaken for the "real thing" rather than understood as a constructed image used for particular purposes. Davalos explains, "López's primary impulse as an artist is the investigation of images. She analyzes the production, function, and context of images that enter public culture."

In considering this primary impulse, it is important to note the diverse sources and influences that contributed to López's

Yolanda M. López, study for *Free Los Siete*, 1969.

ix

artistic practice. Growing up as a Chicana in San Diego on the U.S.-Mexico border had a profound impact on López, although not necessarily in the ways that one might expect. For López, these experiences manifested a paradox: living next to Mexico, she nonetheless grew up understanding Mexican culture in negative terms, an impression based less on lived experience than on media stereotypes, tourism, and commodity culture. In addition, while her family provides a significant source for her art (expressed in terms of matrilineal genealogy), López's upbringing was in many ways a nontraditional one. She was raised in a nonreligious household by a single mother, then by her grandparents, and later by a gay uncle, and her familial identity focused more on working-class concerns and labor rights than on Mexican or Chicano culture. In the late 1960s, when she lived in San Francisco, López met Emory Douglas, minister of culture for the Black Panther Party. Douglas, whose radical graphic art appeared in the *Black Panther* newspaper, showed López quick and low-cost layout techniques. His visual style, a collage of mass media text and photographs, thick outlines, and declarative text, inspired her own efforts to develop an art of social protest within San Francisco's pan-Latino community. When López returned to San Diego in the 1970s to complete her graduate education, her teachers (notably Allan Sekula and Martha Rosler) helped her further develop the conceptual aspects of her work through a formal art training that engaged semiotics, deconstruction, and feminism. These experiences proved transformative: López emerged as a political artist concerned with the politics of representation rather than with cultural essence, nationalist identity, or the recovery of an "authentic" and lost culture.

López's *Free Los Siete* (1969) provides an excellent and early example of her commitment to a multivalent political art. She excerpts passages from the U.S. Pledge of Allegiance that foreground the flag as the emblem that unites citizen and nation, both "under God": "I pledge allegiance / to the flag of the United States of America / one nation under God with free." In the black-and-white poster, this text appears inside the representation of a frame with a padlock in the lower right corner, forming a "matted" border around an image of six Latino males imprisoned behind the stars and stripes of the U.S. flag. Below this frame is the title, written in boldface using the same style as the pledge: "Free Los Siete." Derived from an earlier color drawing, López's

poster circulated widely in *¡Basta Ya!* newspaper as part of an effort to defend seven Central American youths accused of killing a police officer in San Francisco's Mission District on May 1, 1969. Some eighteen months later, the youths known as Los Siete de la Raza were acquitted following accounts that police in the heavily pan-Latino neighborhood had used excessive force. The mass arrest and trial spurred mobilization of a defense committee, with support from the Black Panther Party, and also led to community-based programs and services through the newly formed La Raza Information Center. López's poster, created while she was a member of Los Siete Defense Committee, appeared early during the year between the arrest and the trial that started in June 1970. It expresses the fear that Los Siete would not have the very rights promised by the pledge: democracy, liberty, justice, and equality. Indeed, in the poster, these rights are absent, not so much implied as replaced outright by the word "free" (which is not in the pledge itself). This last word, which appears at the top of the poster, must be read two ways at once: as a promise that has been cut off mid-syllable (syntactically, one expects "freedom" to appear; symbolically, the word contradicts the image it helps "frame"), and as the first word in the bilingual imperative at the bottom of the poster that names the defense committee and the artwork: Free Los Siete. In order to secure liberty for Los Siete—that is, to bring together both articulations of "free," as pledge and as demand—the community will need to mobilize to defend its rights.

In *Free Los Siete*, as with López's subsequent artistic production, the work's political message is clear and purposeful. At the same time, the work cannot be mistaken for art that merely illustrates a position, both because of the work's formal complexity and because it is engaged in a more complicated project of repositioning the viewer with respect to language and representation. López's *Free Los Siete*, and other artwork from this period, was arguably even more radical than the political art of her mentors, teachers, and peers in that it was unsigned. The artist actively withholds her authorship in order to have the poster circulate as an expression of the community itself, as a critique of the failure of the nation-state to secure "liberty and justice for all," and as a free-floating icon within a social movement. Consequently, these images often reflect upon the movement itself but not upon the artist who created them. López's political commitment,

A young protester holds López's *Free Los Siete* poster. Printed in *¡Basta Ya!*, no. 10 (June 1970).

combined with the masculine framework for recognition within the social movement, served to obscure critical attention to her distinctive visual style, conceptual framework, and provocative investigations into what has been called a "politics of the signifier." Indeed, as Davalos argues, "López is simultaneously a feminist artist, a conceptual artist, a political artist, and a portraitist working in and against the modernist tradition." As the first major publication on López, this book explores the artist's ongoing commitment to an art of social protest, elaborates the social and cultural history and intellectual currents within which she has worked, and brings much-needed attention to the artist in all her complexity.

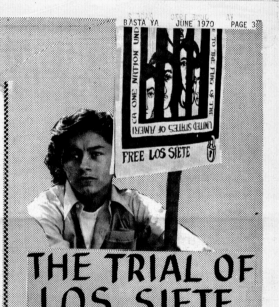

INTRODUCTION

Chicana feminist artist Yolanda M. López is best known for her triptych that transforms the Virgin of Guadalupe into a new vision of Chicana womanhood and subjectivity. Produced in 1978, it is one of the first visual expressions to reclaim Guadalupe as a feminist icon of empowerment.[1] The triptych combines elements of this religious imagery with portraits of the artist, her mother, and her grandmother in order to challenge and redefine Chicana representation. Within each portrait, the repeated and manipulated iconography of Guadalupe signals women's dignity and value. This homage to working-class Chicanas, young and old—what López calls "ordinary women"—references modernism, Christian devotional art, revolutionary politics, and a feminist subjectivity. What makes the triptych and the series from which it comes so powerful is a multilayered "proposal" for liberation embedded within the alternative representations of Chicanas.[2] As noted by art historian Charlene Villaseñor Black, the triptych both "questions and re-creates traditional gender constructions" and "records and validates [Mexican and Chicana] family histories."[3]

López's search for dignified and contemporary images of Chicanas emerged from her dissatisfaction with media and popular representations of Mexican and Mexican-origin women, which she could not reconcile with what she saw growing up on the border, as a young adult in the San Francisco Bay Area, or within her own family. By 1978 she was already acutely aware of racial stereotyping and the concurrent erasure of Mexicans from the national narrative. López was born and raised in San Diego, California, and learned firsthand the disconnect between the nation's myths and its realities. In this segregated military town, she was taught that *Mayflower* pilgrims were her forefathers. It wasn't until she left home for college that she understood the systemic erasure of her indigenous and Mexican heritage. Her reformulation of Chicana subjectivity was thus an effort to acknowledge the complex social and historical conditions that inform the experiences of Mexican and Mexican American women.

Her identity as a Chicana and her artistic training occurred on the picket lines of the Third World Liberation Front at San

Francisco State College (now San Francisco State University) and in the streets of San Francisco's Mission District. It was through activism that she learned an art of politics and a politics of art. Her aesthetic expression merged the struggle for equity among women, people of color, the poor, and workers. In the 1970s, when she returned home to San Diego, she developed a language for her artistic vision while training with Allan Sekula and Martha Rosler at the University of California, San Diego. Although at the time of her application to the program she had little idea of the deconstructivist and semiotic emphasis of the art department, it matched and fueled her anticapitalist, anti-racist, and antisexist visual analysis. Over the years, her political concerns and her conceptual approach to art allowed her to resist romantic representations of indigenous cultures and women, and her sense of humor further supports an avoidance of the dogmatic. Her sharp wit and playfulness found its way into her installations and video, as well as her photo collages that informed the triptych and her posters.

López's primary impulse as an artist is the investigation of images. She analyzes the production, function, and context of images that enter public culture. She was consequently a forerunner in the battles against the mass media and the enter-tainment industry for their demeaning portrayals of Mexicans and Chicanos. Furthermore, her attention to subtle messages rather than "positive vs. negative" representations makes her artwork a precursor to feminist analysis of media and film.[4] Her semiotic investigation develops from complex readings of codes and signs; she engages or imagines a multiplicity of subjects and positions that accounts for a feminist perspective, a critique of global capitalism, racism, and heterosexist privilege.

Yet her work is not a cacophony of meaning that cannot be understood. Although scholars tend to isolate aspects of her aesthetic project, dicing up the feminist or antiracist discourse, her work operates on multiple levels. Additionally, the signifi-cance of the work has been overlooked when it is marginalized as "folkloric" or "ethnic" in nature, a charge typically leveled by Eurocentric art critics or by those who misunderstand her conceptual project or dismiss it because of its feminist content. Alicia Gaspar de Alba, in her important analysis of the exhibi-tion design of *Chicano Art: Resistance and Affirmation, 1965–1985*, writes that the groundbreaking show symbolically rendered

Chicana artists such as López "between yesterday and tomorrow, between tradition and change" since their work, displayed in the gallery called "Feminist Visions," was positioned between the galleries "Reclaiming the Past" and "Redefining American Art." In addition, the Guadalupe triptych was excluded from the gallery of "Urban Images," as if López were not "drawing upon images and events from [her] own cultural reality as part of [her] creative process."[5] The first scholarly examinations of López's art began in the mid- to late 1980s, nearly a decade after she created the poster *Who's the Illegal Alien, Pilgrim?* and the Guadalupe triptych. Popular reviews and visual arts scholarship on the Guadalupe series contextualize her work in feminist aesthetic reclamations of the goddess, although López declares no spiritual connection to Guadalupe and was not interested in feminine mystical power.[6] This book documents the sources for her deconstruction of images, and it engages her work as countermemory or alternative narratives erased, ignored, or not yet present in the public discourse of the nation or in Chicano communities throughout the United States.

As López asserts in artist statements and exhibition brochures, the interrogation of images is more than a rejection of stereotypes. She aims to offer new possibilities for Chicanas and women of color living under conditions of patriarchy, racism, and material inequality. Indeed, López has been her own best art historian, offering conceptual and historical analysis of her work in interviews, pamphlets, and brochures that have accompanied exhibitions. Although her publication record is not extensive, her coauthored essay "Social Protest: Racism and Sexism" is notable, comparable in significance to the definitive 1980 essay in which Malaquías Montoya and Leslie Salkowitz Montoya argue that Chicano art should be an art of liberation, a political art.[7] López's essay was written with Moira Roth, an art historian and champion of women's and outsider art who directed the Mandeville Art Gallery at the University of California, San Diego, from 1974 to 1976.[8] It contends that feminists and art critics must pay attention to the dynamics of race, privilege, and racism in the production, circulation, and valuation of art. The essay also provides a feminist historical context for López's work. That is, it documents an oppositional consciousness in her work and places it alongside the art of Faith Ringgold, Betye Saar, Nancy Spero, and May Stevens.[9]

Read along with the intellectual engagements of Chicana feminists, it suggests that López theorized visually that which writers such as Gloria Anzaldúa, Cherríe Moraga, Sandra Cisneros, and Carla Trujillo, and scholars Norma Alarcón and Chela Sandoval, developed in written form.

Similar to the work of these feminist authors, López's oeuvre is political, yet it shifts into various modes of resistance, "read[ing], renovat[ing] and mak[ing] signs on behalf of the dispossessed."[10] She incorporates revolutionary and insurgent aesthetics as well as a hybrid cultural nationalism that allows for pan-Latino solidarity and historical materialism. The earliest drawings, paintings, and collages propose new identities and expressions; her figurative images arise from absence and vacancy and thus become countermemories to the contemporary mass media and popular culture. She recognizes that Chicanas' identities are constrained and empowered by their own communities, and so she imagines another present and future made of graceful, dignified, honest "ordinary women." For López, the site of recuperation is the female figure, and thus portraiture has been her most common aesthetic strategy.

To best understand her complex conceptual framework, it is perhaps easier to compartmentalize the art historical analysis. But these false divisions should not become reified or be mistaken for a complete account of her work. López is simultaneously a feminist artist, a conceptual artist, a political activist, and a portraitist working in and against the modernist tradition. Although her inspiration to create images of "ordinary women" emerged from her activism, she draws from a particular strain of modernism and its impulse to portray the quotidian. While the modernist artists of the late nineteenth century, such as Manet, Cézanne, and Courbet, produced images that commented on everyday life and industrializing urban space, this modernist strain is not known for producing a critical analysis of the gendered and raced relations of society. Such a critique of sexism and racism would surface more forcefully in the mid- and late twentieth century, and López contributed to the examination of raced and gendered marginalization. But as a student of social movements and semiotic analysis, López also recognized her artistic expression as a rejection of abstract expressionism and other high modernist styles that emphasized formalism and valued "pure" aesthetic experience.[11]

Her work emerges from concepts, signs, and meaning rather than from explorations of figuration and pigmentation, internal self-expression, or abstraction. Certainly, López's "ordinary women" are strikingly similar to the subjects of early modernist paintings of mundane experience and humble settings. The difference, and this is a critical distinction, is that her subject matter is specific women with whom she has intimate relationships and whose raced, classed, and gendered identities have been marginalized or silenced altogether. As art historian Carol Duncan points out about modern art in American galleries, the "women of modern art, regardless of who their real-life models were, have little identity other than their sexual availability, and often, their low social status." Modern art tends to represent anonymous women, not specific individuals, a representation that Duncan describes as a "preoccupation with sexually available female bodies."[12] Moreover, the modernist tradition, especially that which developed in New York after World War II, could not account for art that addressed the experiences of working-class Chicanas and Mexicanas, relegating it to the category of "ethnic art" because of its narrative qualities, political purpose, or subject matter. Art historians have just recently begun to deconstruct the so-called universal subject of modern art and the way its normative or standard measures conceal a specifically raced and gendered position.

The best example of López's overarching oppositional framework is the fact that she produced the Guadalupe triptych at the same time as the poster *Who's the Illegal Alien, Pilgrim?* The articulation of new images for Chicana womanhood and the interrogation of nation, belonging, and history illustrate her emphasis on the deconstruction of images. Both from 1978, these works question how we as Chicanas and Chicanos see ourselves, the sources of our imagery, and the context of the images. More broadly, she explores in these two works the view of the citizen within the nation or community and notions of membership within the transnational spaces of the Americas.

When López's son, Rio, was a small child and still learning to read, she had an experience that profoundly refueled her interest in visual language. While she was reading a children's book to Rio, he made a comment about a Mexican man in the story. Surprised at his comment, she explored the source, and

when she came across an image of a mustached man wearing a large sombrero, she asked her son:

> "Who's the Mexican?" Because I didn't know. How did he know someone [in the book we were reading] was a Mexican? . . . He says, "The man with the big hat." And I looked at him, and I said, "Well, does your *papa* wear a big hat?" And he looked up at me with sort of a confused [look]. Why would I ask that kind of question? And it suddenly dawned on me that he had already absorbed the imagery. [It] becomes easily read very, very, very young.[13]

It was a poignant moment for López as a mother and as an artist because she realized that children appropriate the master narrative of the nation at an early age. She also realized that her son was growing up as she had, with an absence of multiple and complex representations of Mexicans, knowing best the false or quaint ones found in tourist art or commercial media. Had anything changed since her involvement with Los Siete Defense Committee? These consumable images had already become for him the authentic Mexican. Her challenge to myths of authenticity would thus lead to work with alternative images that might be less recognizable but still fully Chicano or Mexican. Her intention was never to present these representations as singularities; they are contingent and depend upon a range of other images and social contexts. Her son's perplexed face reminded her that she was working in a vacant space, a place of absence, and while taking apart and reformulating stereotypical or useless images she had to be mindful of the vacuum. The urgency she knew from the social upheaval of the late 1960s and early 1970s was redoubled that year. This sense of a social imperative permeates all her work, driven perhaps by life lessons of her childhood, the story to which we now turn.

FROM *LA FRONTERA*
FAMILY AND COURAGE IN SAN DIEGO

In the modest pamphlet that accompanied Yolanda M. López's master's thesis exhibition in 1978, the following dedication appears: "To Senobio and Victoria F. Franco, who courageously crossed el Rio Grande on a moonless and dangerous night in 1918." Their crossing, while unremarkable as a migration story, was part of a unique journey that took Senobio and Victoria from Mexico City to Louisiana and later to New York City. The artist's acknowledgment of her grandparents on the occasion of her MFA exhibition reveals much about the relationship between her family's history and her artistic approach.

Several factors influenced her grandparents' decision to migrate to the United States, including the deaths of five of their children. The Mexican Revolution (1910–20) produced social disorder and dislocation for over a decade. Senobio and Victoria were trying to create a family at a time of a collapsing economy and pervasive violence. During the revolution and the civil war, Mexico lacked a central banking system. Commercial banks were allowed to issue their own currencies, and the opposing sides created their own monetary systems.[1] This made it difficult for Senobio to support a family, since the money he earned sometimes became worthless. Economic insecurity was not their only worry: the revolution created a constant threat of violence. Victoria later told her granddaughter stories about people challenging and menacing anyone on the street, demanding "Which side are you on?" Women faced the threat of sexual violence, and Victoria's family hid young women from raiding bandits and revolutionary armies.

In 1915 bandits destroyed crops before the harvest, creating an artificial famine in central Mexico. That year, epidemics swept through Mexico City; hunger and disease together caused 25,000 reported deaths, more than 5 percent of the city's population.[2] According to historical demographer Robert McCaa, the Mexican Revolution constituted the "greatest disaster in Mexican history since the conquest"; increasing mortality rates, decreasing fertility, and mass emigration resulted in the loss of

millions of people.[3] Victoria and Senobio's five young children died of influenza and dysentery. Senobio "was just distraught, because he wanted a family . . . and they just kept dying." Losing the fifth child, who died at the age of five, was particularly painful. The couple consequently decided to leave Mexico to make a better life, to start over. Her grandparents "just left," recalls López. They hoped that the United States would offer better living conditions and health care.[4]

Her grandfather Margarito Senobio Franco had been born in Guadalajara, Jalisco, on February 22, 1881. He came from a family of merchants and professionals, including doctors, and entered the United States with tailor's skills. Her grandmother Victoria Fuentes was born in Mexico City and grew up in a small town, Santa Anita, known for its floating gardens. Her family sold flowers. Both grandparents had entrepreneurial experiences that distinguished them from other migrants in the early twentieth century, but their skills and business experience in Mexico were not enough to produce a life of economic security or middle-class leisure in the United States.[5] The Franco children, Margaret, Henry, William, Robert, and Michael, grew up in a working-class environment: as Victoria explained to the family, "We're poor but we're clean," indicating their dignity and self-reliance.[6] They also had a taste for well-made and fashionable clothes, and López remembers growing up in a family of handsomely dressed men and women. Her mother, Margaret, and her uncles, particularly Michael, were all influenced by Senobio's profession as a tailor, and his taste and sense of style influenced three generations. López remembers her four uncles as "movie-star handsome in their crew cuts and mustaches."[7] The working-class orientation of the family and their appreciation of the importance of personal appearance would permeate López's artistic production, and the conviction that respect is reserved not only for the sacred or powerful drove her decade-long examination of "ordinary women."

The dedication to her grandparents also sets the tone for López's emphasis on *homage* and her critique of sentimentality, a tendency characterized by an overly romantic view of a people. Her grandparents' crossing was made on a night that was "moonless and dangerous." The image of the couple—Senobio, age thirty-five, and Victoria, age twenty-six—walking to the edge of el Río Bravo, as it is known in Mexico, and pressing forward

blindly into a dark and unknown river, plays on our senses and fears. But what makes the nighttime "dangerous"? Why did López describe their journey with these two words, since the adjective "moonless" might be sufficient to evoke the risks of crossing the border? From what, other than the lack of light, does this danger emerge? Her dedication does not explain the horror; it remains undescribed. It was not until a 1986 interview that López revealed that her account of a "dangerous night" was not an attempt to pull at our heartstrings but was grounded in fact. Her grandparents had been chased by the Texas Rangers, who shot at them several times "as they crouched helplessly in the small skiff they used to cross the river."[8] López's narrative of her grandparents' border crossing is not sentimental, exaggerated, or pretentious, and the term *danger* was not hyperbolically employed.

This simple yet compelling narration echoes the visual style that López creates in her art, particularly the works on exhibition in 1978: the Guadalupe triptych, the Tres Mujeres/Three Generations series, and the series ¿A Donde Vas, Chicana? Getting through College. The large scale of the works as well as the narrative connection between them forcefully suggests that the images are not simply renderings of López's family members or self-portraits. As López notes in the brochure that accompanied her MFA exhibition in 1978, the works have a collective quality: "everyone should see their own grandmother too." The strategy against romanticism is central to her visual project, as is her use of family history to reference collective experience. In Tres Mujeres and the later series Women's Work Is Never Done, she draws our attention to the hard lessons of survival. Calling us to be mindful of the social inequities faced by women, Mexican immigrants, and Chicanos, her artwork does not portray people prevailing against oppression; after all, in Victoria's mind, the trauma of crossing the border resulted in the miscarriage of her child, and the revolutionary leaders were responsible for the rape of young women and the hunger of her family. Instead López emphasizes their human dignity, constructed with or without middle-class measures of success. This is her family story.

JOURNEY TO SAN DIEGO

Victoria and Senobio crossed the border during a period in which approximately a million other Mexican migrants came to the United States. Like many of them, Senobio dreamt that he would eventually return to Mexico, even potting his fruit trees in barrels so he could later plant them "on his little ranch" in his homeland.[9] But beyond this, their lives were unique among Mexican immigrants of that time.

Victoria crossed el Rio Grande while pregnant, but soon thereafter she had a miscarriage in a "dusty small town" near or in Brownsville, Texas.[10] This was the sixth child the couple buried. After Victoria healed from her miscarriage, they took a train to Louisiana because they figured that Senobio, who knew French, could communicate there until they both learned English (Victoria never did become fluent in the dominant language). The family memory of the train ride also indicates their exceptional circumstances. Because they were dressed in suits, the conductor or porter assumed they were seated in the wrong car and moved them to another part of the train reserved for whites. Senobio's light complexion, contemporary attire, and high-button shoes represented whiteness to the porter, and the family was apparently identified as distinct enough to ride separately from other Mexicans. They settled in Shreveport, Louisiana, and in 1919 Victoria gave birth to Margarita Franco de Fuentes, Yolanda's mother.

López relates that her grandmother had a measure of authority in the household. Victoria did not like the heat in Shreveport, and so they moved to New York City, where Senobio continued his business as a tailor. They later moved to Buffalo, New York, but Victoria did not like the cold and snow either. After spending nearly a decade on the eastern seaboard, including Atlantic City, New Jersey (fig. 1), they bought a new Packard and drove west, briefly living in Texas and Sacramento before settling in San Diego. Margaret was nine years old when the family arrived in California. Their first home in San Diego included a plot of land large enough to support a garden and animals. Victoria, who had only a third-grade education but had taught herself to read, managed the household by growing their food and raising goats and chickens (and, later, pigeons). Her ingenuity allowed them to survive the Great Depression. In 1942

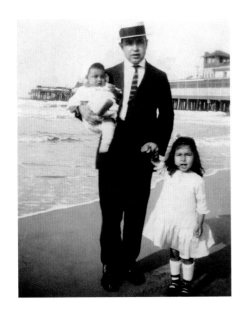

Figure 1. Senobio Franco and children Enrique (Henry) and Margarita (Margaret) at the Atlantic City Boardwalk, ca. 1924.

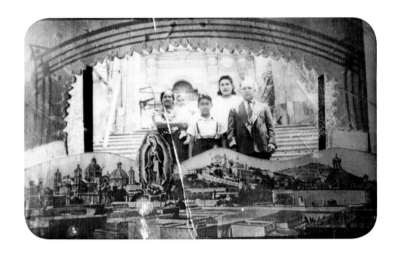

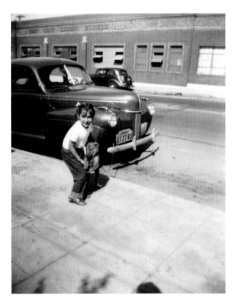

they sold the farm and bought a house on National Avenue in the Logan Heights barrio, the residence recorded on Yolanda's birth certificate (figs. 2, 3).[11]

The household on National Avenue eventually consisted of Senobio and Victoria Franco; Mike, Margaret's youngest brother (fig. 4); Margaret, her husband Mortimer, and Yolanda, who was born in 1942. The latter three lived in a trailer in the backyard. The marriage lasted only two years, and López knew little of her father. Tense interactions with him when she was in her mid-twenties further discouraged any reconciliation.[12] López was raised by her mother, grandmother, and, until the age of eleven, her grandfather. Uncle Mike became her father figure as she grew into her teenage years, and he took her with him to the San Francisco Bay Area in 1961, after her high-school graduation. López's later decision to enter motherhood as a single woman in her thirties was not surprising, since two women had raised her. This upbringing also influenced the content of her artwork, generating a range of feminine representation that rejects racist and patriarchal expectations.

At the time López was born, San Diego was growing rapidly as a military-industrial center.[13] Although the expanding local job market held the promise of better wages and job security, Mexicans were not given access to these benefits. According to historians Carlos M. Larralde and Richard Griswold del Castillo, Mexicans and Mexican Americans were "forbidden to work in the petroleum industry, shipyards, and other vital war industries"

Figure 2. Family photograph at La Villa de Guadalupe (shrine of the Virgin of Guadalupe), with Yolanda at the age of six months, Mexico City, 1943.

Figure 3. Yolanda with the family dog on National Avenue, Logan Heights, San Diego, 1949.

and were relegated to low-skilled and low-paying jobs instead.[14] San Diego's economic development also favored tourism, and there was a small professional and retirement community. It was this segment of the economy that valued Senobio's skills as a tailor, but Margaret found it difficult to shelter, feed, and clothe Yolanda and her two younger sisters, Mary and Sylvia, on her wages as a presser and seamstress (fig. 5).

The city of San Diego could not keep pace with the housing, transportation, and service needs of its workers as the local economy boomed. Housing in particular was scarce for the

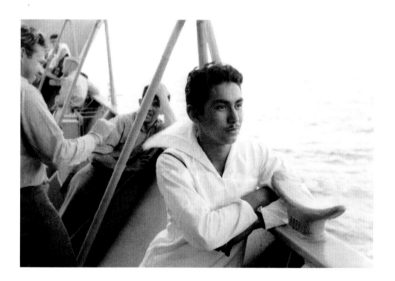

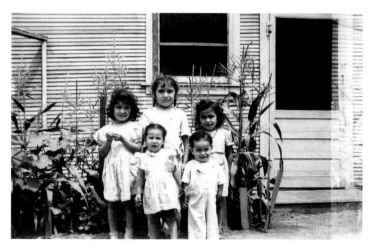

Figure 4. Michael Franco (Uncle Mike) in the Navy, 1949.

Figure 5. Yolanda (center) with her younger sisters, Mary and Sylvia, and her cousins Ruthie and Henry Franco Jr. on National Avenue, Logan Heights, San Diego, ca. 1949.

thousands of workers who swelled San Diego's population by 50 percent from 1940 to 1942, and many lived in their cars or in garages, tents, abandoned streetcars, or all-night theaters.[15] In addition, high-interest loans and pro-developer policies did not benefit workers.[16] Victoria and Senobio's ability to purchase a house was extraordinary, although the difficult housing situation explains in part Margaret's residence in the backyard trailer. The family's options were limited. The housing in southeastern San Diego, which included Logan Heights, was deteriorating or dilapidated in comparison to the rest of the city.[17] Although Logan Heights, known as Barrio Logan, was once "the second-largest [Chicano] barrio on the West Coast," during López's childhood urban development devastated the neighborhood.[18] In the 1950s "zoning laws were changed, turning Logan into an industrial area rather than a residential one."[19] Cultural studies scholar Raúl Villa documents how the change in land-use policy allowed for the location of junkyards, light industry, and wrecking operations near homes and schools.

López's grandparents eventually decided to move the family farther from the industrializing area, conceivably in reaction to the devastation of Barrio Logan, or perhaps as a result of new and restrictive zoning laws. Around 1950 they bought a home on 33rd Street in Shelltown, a San Diego neighborhood that had "no sidewalks, no paved roads."[20] This Mexican community lacked municipal services, but it offered an array of Mexican businesses, including a cantina and a *tortillería* next door to the family's new residence, as well as a *carnicería* and *panadería*. Throughout López's childhood, the military boom reinforced racial and economic divisions, making segregation a factor in her youth.[21] López left San Diego in 1961, just as highway construction bisected the community and displaced even more residents. She would return ten years later to witness and participate in a historic reclamation of this space by the Chicano community.

LESSONS FROM MARGARET

López's upbringing in a multigenerational family resulted from choice, cultural sensibility, and economic necessity, and it provided her with rich experiences and memories. Victoria and Senobio took her on frequent trips to Tijuana, and before she

started school her grandparents took her to Acapulco for several months. The smell of gasoline still makes her nostalgic for the times she spent watching her uncles, Henry and William, clean auto engines. Uncle Mikey would bring home exotic animals, further supporting her joy in exploration. López's grandmother and grandfather showered her with unconditional love, protection, and comfort; she was their favorite. Her mother, on the other hand, was apparently seldom home, especially on Saturdays. But López has no memories of family members chastising or censuring Margaret for her behavior. As a single woman, Margaret benefited from the multigenerational household, as Victoria took daily responsibility for the girls.[22]

Margaret redefined womanhood, and therefore she influenced López's ability to challenge traditional gender expectations. Margaret was not a woman who expressed a great deal of tenderness. Without disappointment or frustration, López reports, "She loved us, but it was not the kind of all-encompassing, uncritical love that one expects."[23] Margaret worked long hours, especially in the mid-1950s, when she cared for the children on her own, and López recalls her mother rising before sunup and returning home after dark. These material factors shaped Margaret's expressions of maternity. She did not spend much time cooking. She did, however, encourage creativity and beauty, teaching López the value and skill of working with one's hands and a love of craftsmanship and visual expression.

When López was in high school, Margaret made "elaborate costumes" for the annual Grecian/Roman banquet of the Latin Club.[24] She also copied the patterns of designers such as Yves Saint Laurent, making fashionable clothes out of inexpensive materials. López vividly recalls wearing a fully lined burlap coat that her high school friends admired. Margaret continued to sew for her daughter, designing and creating in 1978 "a Guadalupe gown based on a Calvin Klein disco dress pattern" and made from low-cost materials, which López wore for her MFA opening (fig. 6).[25] The use of inexpensive fabric for high fashion taught López to recognize that one's creative expression did not depend on expectations of quality. She learned to play with materials in order to challenge notions of high art; this critical strategy would later manifest itself in Tres Mujeres/Three Generations (drawn on butcher paper "in defiance of precious materials"), in the use

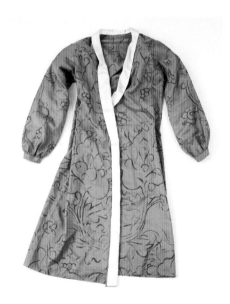

Figure 6. Virgin of Guadalupe dress worn by Yolanda M. López at her MFA opening, 1978. Designed and created by Margaret Franco Stewart.

of color Xerox in the late 1970s and early 1980s, and in installations consisting of everyday objects.[26] Her use of unrefined materials emerges from her family's rasquache sensibility, but it also signifies her resistance to Eurocentric notions of fine art. Cultural critics Tomás Ybarra-Frausto and Shifra M. Goldman have each described the rasquache aesthetic of "making do with what's at hand," and López engages this style in her art by using everyday objects and materials.[27] However, as I discuss later, the mundane items that she uses are frequently household objects that she wishes to discard rather than sanctify, and she employs them for their pedagogical lesson rather than for their beauty.

Nevertheless, as Villa notes, "practical inventiveness [is] motivated by limited material conditions," and much of López's visual subject matter comes from her working-class experiences.[28] It was again her mother who taught her the value of labor, the laborer, and worker solidarity. Margaret was employed at the Grant Hotel as a presser, and she became a union member, at one point serving as secretary. Like many service workers in San Diego, she suffered from the lack of public transportation. The bus system was insufficient, forcing many riders to travel one or two hours to reach their destinations.[29] López recalls walking four blocks to the bus stop and taking long bus rides with her mother to and from Bayside Settlement House, the child care center that she and her sisters attended each morning and evening during their elementary school years.[30] These bus rides became lengthier for Margaret in 1957, when she took a job adjusting uniforms for officers at the Naval Training Center, located on the northwestern side of town.

Tedious as they were, the bus rides afforded time for conversation. López learned about her mother's union activity, and she credits her mother for teaching her "never to cross a union picket line."[31] Moreover, López recognized that her mother's pro-union stance was rare in a conservative town, and it shaped her own nonconformity and "boldness" as an artist. It was a freedom "just to do whatever you darn well choose to do" and an appreciation for women's labor, both inside and outside the home, that would focus López's aesthetic imagination.[32] Her mother's independence and unorthodox life likely shaped López's self-identification as a "provocateur," an identity that supporters would value in the 1990s when López was incapacitated by an aneurysm.[33]

For a short time around 1953, at the request of her second husband, James Stewart, Margaret did not work outside the home. Her stint as housewife was short-lived because James lost his job and then the car, and the family needed her income to survive. That marriage also did not last long, ending in the mid-1950s. The divorce may have been hastened by James's abusive behavior. Margaret had to find a new home, as James had moved the family to an apartment in North Park, a community with a negligible Mexican population. For the children, it was the beginning of a period marked by self-sufficiency and independence. Margaret and her daughters found a small place near Lincoln High School. They deliberately selected a location that would allow López to travel easily to and from school and also look after her younger sisters, including Annale, who was born after they moved to the new home.

This home was the first place where Margaret would care for the girls without daily support from another adult. As the oldest daughter, Yolanda inherited much of the responsibility for her sisters. She made meals, kept the children clean, mended their socks, and tended their bruises. It was a "good childhood," filled with adventure and ingenuity. She and a sister slept on the enclosed porch. When the electricity was turned off the family lived by candlelight, which she and her friends associated with a beatnik lifestyle, not poverty. López remembers: "Not having money for Kotex, and my mother ripping up the sheets to use [as sanitary napkins] . . . using Oxydol, which was like Tide, to wash our hair, because we didn't have shampoo . . . and my grandmother teaching me how to wear shoes that had worn out" by cutting around the sole of the toe or by putting cardboard in the shoe to cover a hole. Margaret could not afford to pay the fee to have trash hauled away each week, "so on trash day, we went out with little bags, and put them in other people's [cans]."[34] After high school, López left home in order to ease her mother's financial burden.

"MY FAMILY WAS VERY VISUAL"

Throughout her childhood, López was surrounded by creative expression. Her grandparents, mother, and uncles, particularly Uncle Mikey (fig. 7), encouraged her to develop her own artistic voice. Referring to her family, López recalls, "Everybody

made everything."[35] She watched the men refurbish car engines, construct furniture out of salvaged wood, and make playthings for the sisters to share. The garden on 33rd Street was a source of the grandmother's creative energy, and although Victoria would not allow anyone to pick the roses, Yolanda was permitted to gather other flowers for homemade hats crafted from pie plates and old stockings. Victoria's artistic sensibility was also displayed in a special arrangement of family pictures and a bronze crucifix. Although López recalls this display in each house the family occupied, she has no memory of her grandmother's religious devotion, and therefore the arrangement might have expressed Victoria's sense of aesthetics, how she registered a relationship between the profane and the sacred, and how she documented the family heritage rather than her spirituality. Regardless of Victoria's intention, the display signaled to López that her grandmother valued and arranged images. Her grandfather was a "Sunday painter," and López recalls gazing at a picture of a moonlit ocean, possibly a copy of Albert Pinkham Ryder's *Silver Moon*, that hung above her bed on the porch. "But he also taught me how to use a hammer, how to use a shovel, not to be afraid of tools."[36] She was frequently his companion in the back-yard as he rebuilt the Streamline Trailer, upholstered furniture, or burned leaves from the garden.

Senobio also shared his love of music and theater. He often listened to opera at home. "Every summer we attended the road tours of Broadway shows like *The Pajama Game* and Mexican variety musicals."[37] These seasonal experiences at the Ford Bowl with her two grandparents nurtured an appreciation for music. As a child, López was also exposed to the creative arts outside the home. At the Bayside Settlement House artistic expression was central to the curriculum, reflecting the ethos of a late-nineteenth-century reform movement that aimed to enrich and uplift the lives of working-class and immigrant residents. During the summers, teachers from Bayside would walk the children to Balboa Park and take them on visits to the Fine Arts Museum, the zoo, and the Natural History Museum. They were taught puppetry and papier-mâché. These adventures and the exposure to the arts thrilled López, and her description of her family's "visual" sensibilities and her joyful times at the settlement house suggest that the creation of objects and the embellishment of space were early aesthetic lessons.

Figure 8. Yolanda M. López, *Female Sitter*, 1955. Watercolor, 11 x 9 inches.

As the "creative genius" in the family, Uncle Mike shared his love of all the arts, deliberately encouraging López's artistic expression. With Mike, López attended orchestral and theatrical performances in Los Angeles and San Francisco. Even before their move to Northern California, he helped cultivate her taste in art by making her clothes and jewelry, fixing her hair in the latest color or style, or playing recordings of Broadway musicals. Mike would paint murals on the walls and floors of his home, and the beautiful trompe l'oeil designs reflected a tropical garden. He was the first to supply her with a watercolor set and drawing tablets (fig. 8), although her mother would buy the children a new coloring book and the soundtrack for each Disney movie that was released.[38] López quickly learned to distinguish the limitations of different media, and as a teenager she "discovered pen and ink, [and] fell in love with it."

While her grandfather and uncle cultivated an appreciation for the performing arts, her mother found pleasure in images. Margaret read *Modern Screen, Silver Screen Magazine*, and *Confidential*, a gossip magazine with flashy photographs.[39] According to López, she and her mother would cut out pictures and make collages of their favorite Hollywood actresses, compiling their own scrapbooks. In the 1970s, López repeated this montage technique in her artwork, joining items into a new conversation created from the pasted form. It also assisted her graphic style when she designed artwork for *¡Basta Ya!*, the Mission District newspaper in the late 1960s. Her use of this dialectic technique may echo the Dada artists who embraced photomontage and collage during World War I, but her artistic inspiration was a post–World War II domestic craft taught to her by her mother. In 1974, working independently of her undergraduate studio arts classes at California State University, San Diego, she joined unlike objects or forms into a new reality to create several portraits of Victoria Franco, mixing pencil drawing, newsprint, photography, and colored paper (figs. 9, 10, 11).[40]

Visual information, then, was an early fascination for López. In elementary school she and her friend Johnny Wong pored over *Life* magazine at the Bayside Settlement House library. She collected and organized images for her scrapbooks. López relished rainy days at Bayside because the teachers

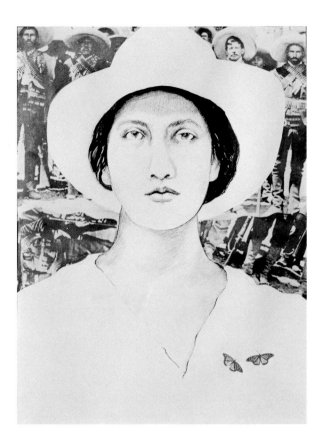

would bring out a "stash of comic books."[41] When Yolanda was fifteen, Margaret surprised her daughter with a subscription to *Mad Magazine*.[42] She became a fan of Wallace Allan Wood and William Elder and eventually picked up the *New Yorker*, reading it for the cartoons. Mikey helped her get summer jobs at the Old Globe Theatre when she was fourteen or fifteen years old, and it inspired her to become a costume or set designer, while the Disney movies aroused her curiosity about a career in animation.

Her grandmother reinforced Yoland's appreciation of satire and wit. In an artist's statement published in 2001, López credits Victoria with inspiring a critical eye: "Victoria Fuentes Castillo, grandma, tried to teach me civility. I really did try to pay attention when she cooked and to mind my manners. However it was her critical and wry conversation that interested me most."[43] The sense of humor in López's

artwork is often overlooked, overwhelmed by the engagements of antisexist and antiracist discourse as well as by debates that emphasize identity politics as a criterion of so-called ethnic art. Typical of her use of visual puns are the color Xerox collages of the Guadalupe series, particularly the image with a photograph of Margaret's slightly larger head on Guadalupe's smaller body: the disproportion and misalignment is intended to produce a laugh (fig. 12). Similarly, *Walking Guadalupe* is meant to inspire a chuckle (fig. 13). López does not envision a disrespectful, full-bellied laugh, but a wrinkled-mouth chortle at the sight of the Virgin released from her captivity, tottering forward in high-heeled, open-toed shoes and a gown that has been cut away so that she can walk. López's use of word play is evident in *Your Vote Has Power*, from the series Women's Work Is Never Done. In this print López creates an image meant to frighten the nativist whose biggest fear is a reproductive

Figure 10. Yolanda M. López, Victoria F. Franco series (3 of 4), 1974. Mixed-media collage, 18 x 15 inches.

Figure 11. Yolanda M. López, Victoria F. Franco series (4 of 4), 1974. Mixed-media collage, 18 x 15 inches.

Figure 12. Yolanda M. López, *Untitled* (Guadalupe with Margaret F. Stewart's face), 1978. Mixed-media collage, 6 x 10 inches. Study for the Guadalupe series.

Latina who expresses her political voice. The act of voting is turned into women's labor, but instead of implying drudgery, it connotes political empowerment.

Moreover, play is central to her artistic process, in which "deliberate play" allows for experimentation and stimulates ideas, composition, and design.[44] Each *tableau vivant* created in 1978 with Susan R. Mogul is a moment of deliberate play, to see what might happen if an energetic young woman poses for the camera, surrounded by symbols of her Mexican, feminist, and artistic identities, as if in a performance of the contemporary

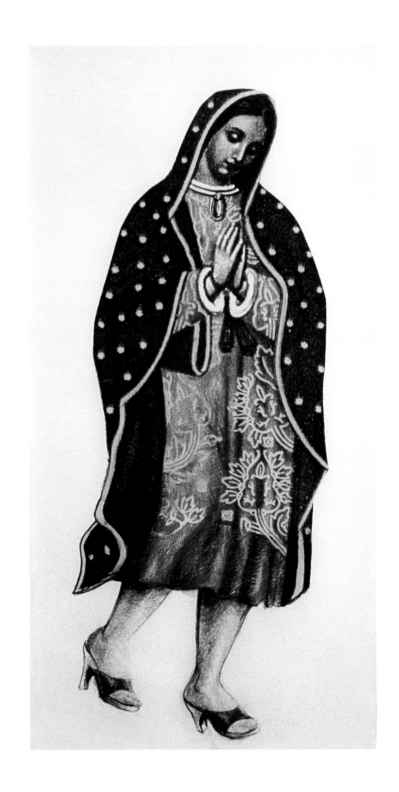

Figure 13. Yolanda M. López, *Walking Guadalupe*,
1978. Mixed-media collage, 6 x 10 inches. Study for
the Guadalupe series.

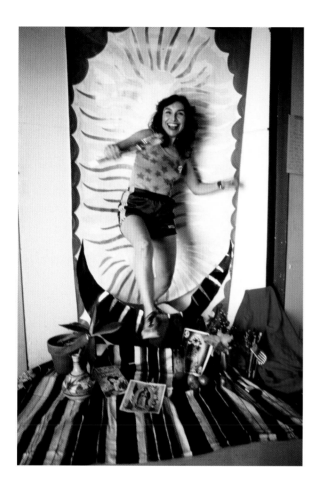

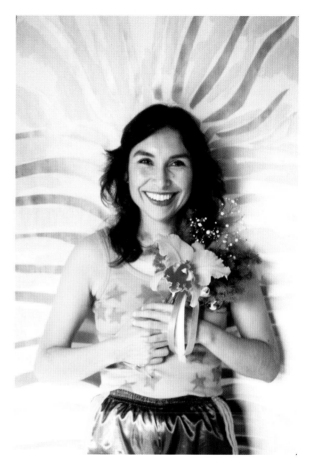

Guadalupe (figs. 14, 15). The color Xerox technique, which she learned from artist René Yáñez, allowed her to play with Guadalupe's image, rapidly and easily creating effective collages. Yáñez, co-founder of Galería de la Raza in San Francisco, had introduced Xerox as an artistic technique to Mission District Latino artists, and López found it useful because she could quickly rework the image without much expense or time. In this sense, deliberate play produced her "sketches" or the foundation for finished works such as the Guadalupe triptych or *Who's the Illegal Alien, Pilgrim?*

Perhaps it was the free spirit cultivated at home that allowed López to move with Uncle Mikey and his partner, Treger, to Sausalito in Northern California within four days of her

Figure 14. Susan R. Mogul, Tableaux Vivant series, 1978. Color photograph.
Reproduced courtesy of the artist.

Figure 15. Susan R. Mogul, Tableaux Vivant series, 1978. Color photograph.
Reproduced courtesy of the artist.

graduation from Lincoln High School. While she does not recall the trip up the coast in a baby-blue Cadillac, López has vivid memories of packing her belongings into two paper shopping bags—evidence of her material poverty.[45] She enrolled in summer school at San Francisco State College. There, a professor of art history, Dr. Story, and an artist, Ralph Putzker, assisted her with an application to the College of Marin, the two-year institution where she completed an associate degree in art in 1964.

She found herself learning on the picket lines at San Francisco State and in the Mission District as she fought for the defense of Los Siete de la Raza, seven Latino youths accused of killing a police officer. Activism became the training ground for her artistic vision and identity; it would supplant her formal education in this respect. She played a significant role in the Chicano movement in Northern California and did extensive work within the Latino communities of the Bay Area. Her belief in community-based political activity guided her choices even after she left San Francisco. Returning to her hometown to complete a bachelor's degree, López enrolled in painting and drawing at California State University, San Diego, in 1971. Once settled, she turned again to community service and advocacy.

In general, her family supported her nonconformist path. Like her mother, who divorced two men before the onset of the feminist movement, López did not expect or receive familial rejection or reprimand for her unconventional life. She found multiple ways to express new ideas for Chicana womanhood, including an appreciation for well-made men's clothes and the rejection of makeup and feminine hairstyle. She wore baggy pants from army surplus outlets, simple T-shirts, and a pony tail. This look encouraged a sense of liberation. Later, she would make the decision to have a child outside of marriage.[46] These personal choices that enacted a new Chicana womanhood were echoed in the new visual imagery of women that she created. During López's youth, the only clear indication that women were expected to obey and serve was conveyed in the treatment Victoria received from some of her sons. For the most part, they ignored their father's dignified treatment of his wife and expected their mother to clean up after them. Her uncles' misguided contempt for her grandmother angered López, and it was these types of observations at home and in the community that led her to revere ordinary women.[47]

WHAT'S A MEXICAN? ARE YOU SPANISH?

While López was raised in an environment rich in independent and creative expression, she was largely deprived of a Mexican identity. The American notion of difference, U.S. cultural and historical amnesia reproduced in school curricula, and the anti-Mexican environment in San Diego contributed to this poverty.[48] In an interview, filmmaker Jesús Treviño asked her about growing up Mexican. Her answer surprised the seasoned producer. Recapping the conversation, López notes, "I told him that I had no sense of what Mexican culture was, even though I went home and we had beans and rice, and . . . my grandmother and grandparents all spoke Spanish, and so did my uncles." In fact, her first language was Spanish, and although the children in her family eventually addressed their grandmother in English, as in many Mexican American and Chicano households, she was forced to repeat the first grade because she had not mastered English and her Spanish language abilities were not valued.[49] Trying to assist Treviño, she explained: "The only experience that I had with Mexican culture was the tourist arts . . . plaster pigs to velvet-covered plaster bulls . . . velvet paintings, and the leather tourist bags, and all that, which . . . people have a lot of contempt [for]. . . . I couldn't point to anything that said, 'This is Mexican culture.'" López would have seen this material culture of the tourist trade during her trips to Tijuana. She did not have the language or terms to describe her experiences as culturally Mexican because her family did not perform those markers that others identified as "Mexican": specific religious rituals, holidays, certain styles of dress and comportment, or an appreciation for Mexican popular culture. The only markers available to her, language and food, were stigmatized in San Diego.

Her early schooling emphasized sameness through a European heritage. "I grew up in San Diego being taught that my forefathers and foremothers came across on the *Mayflower.* I recited the pledge of allegiance every morning and enjoyed singing 'America the Beautiful.' I didn't think about it too much, but participated as part of understanding my identity as an American."[50] The illogic of this fantasy heritage did not become apparent to her until she was in college, although in her teenage years she had some awareness of the disjuncture

between her family's heritage and the one she assumed was hers. "What seemed obvious to every one of my schoolmates perhaps . . . played itself [out] every time I interacted with a department store [clerk] or a school adviser."[51] The polarization, racism, and anti-immigrant atmosphere was palpable whenever she entered public space. The myth of the fantasy heritage could not account for her dark skin, eyes, and hair, or the language she spoke.

During her childhood, López developed a fascination with Japanese culture. It signified difference and pride. "I took Japanese folk dance in high school, and learned to write my name in Japanese. . . . There was a little store that sold Japanese folk art and all that stuff, little knickknacks, wonderful little well-made, beautifully made pottery and hairpins and boxes. All sorts of wonderful things."[52] The allure of Japanese culture may have been inspired by her experience in the San Diego City Schools, which in the post–World War II period created a curriculum focused on tolerance and diversity in an effort to stem growing tensions between local whites, blacks, Mexicans, migrants from Oklahoma, and resettled Japanese Americans. San Diego was one of twenty-nine cities in the country to implement an intercultural curriculum, and the first in California.[53] Based on democratic notions of equality, respect, and cooperation, the systemwide curriculum attempted to foster intercultural understanding through such activities as celebrating the holidays of various groups.[54] To its credit, the curriculum attempted to look beyond the black/white paradigm. Teachers attended in-service workshops about Chinese historical development in San Diego, Japanese contributions to the United States, and Jewish customs. There was a component dealing with Mexican culture and California history, although that portion was not offered in the schools López attended. But for López, the multicultural instruction did not expand the notion of American cultural citizenship; it simply emphasized the foreignness of Asian Americans. It was an intercultural orientation that viewed "racial minorities, especially Mexican and Asian Americans, as undeniably foreign."[55] She was taught to appreciate Japanese culture as an exotic *difference* in comparison to the normative American society.

The conservative environment of San Diego also led López to doubt her heritage and question its value. Staunchly anticommunist groups fueled racial prejudice against "foreigners" and "undesirables" in the city. "Are you Spanish?" was the common

question posed to López during her childhood, and as a teenager she realized that the questioners used the euphemism "Spanish" to avoid the insult of suggesting she was Mexican.[56] Although she lived only twenty minutes from the Mexican border, the question did not seem absurd or incongruous because racial denial functioned to soothe nativist fears, for her and others. The American myth of sameness created "a contradiction that lived within [her] brain . . . a split between the physical and historical self as an indigenous person and the public school education [she] received in a town that depended on defense industry contracts and sailors."[57]

Within this nationalist model, sameness became the stuff of social cohesion. It is this facet of nationalism that disturbs López's aesthetic sensibility and drives her to value multiplicity over singularity within the Chicano movement. By the time she stood with Asian American, African American, and Latino students at rallies of the Third World Liberation Front (TWLF) in San Francisco, she had a clear understanding of the difference she and her family represented in San Diego. Her artistic repertoire is a critique of nationalist rhetoric that imagines a common heritage. Her counternarrative for belonging and community would become the source of her political activism and aesthetic style as she sought to construct a new visual vocabulary to liberate Chicanas.

IN THE TRENCHES
DEVELOPMENT OF A POLITICAL ARTIST

Free Los Siete (1969), a black-and-white poster created for the defense of seven Latino youths accused of killing police officer Joseph Brodnick, is a startling commentary by Yolanda M. López. It also illustrates the formation of her artistic voice (fig. 16). The poster depicts an American flag hanging vertically, the stripes converted into prison bars that partially obscure six faces. The seventh person is omitted from the poster because he was never apprehended. The faces cluster near the bottom portion of the image, except for one figure whose face is located in the top register. His unflinching gaze, unobstructed by the prison bars, looks directly at the viewer as if to convey the artist's impression of the community's struggle and solidarity. Only one figure looks down and does not confront the viewer, but his gaze draws the viewer's eyes to the second layer of López's criticism. The heavy black lines of the flag stripes/jail bars are framed by text from the Pledge of Allegiance.

The blending of text and image is a technique that López would use again in one of her most celebrated posters, *Who's the Illegal Alien, Pilgrim?* In the case of *Free Los Siete*, omitted text creates a powerful dialogue between word and image. Bordering the poster, reading from the top right, are the words "I pledge allegiance to the flag of the United States of America." But the next line, "And to the Republic for which it stands," is absent, as if the flag does not signify the nation, a formal comment on the hollowness of the symbol. The final line of the pledge is truncated. Reading from bottom left are the words "One nation under God with free." The phrase "With liberty and justice for all" is missing and is replaced by the cryptic words "with free." It is as if the last syllable of the word "freedom" has been lopped off, suggesting an incomplete or unequal freedom. Echoing the lack of liberty, a padlock, its key nowhere in sight, hangs from the right side of the outermost black frame and secures the cage, signaling the figures' captivity within the U.S. justice system.[1]

The new meaning given to the stars and stripes in this artwork resonates with other civil rights and antiwar imagery of

Figure 16. Yolanda M. López, *Free Los Siete*, 1969. Printed in *¡Basta Ya!*, no. 3.

FREE LOS SIETE

I PLEDGE ALLEGIANCE TO THE FLAG OF THE UNITED STATES OF AMERICA ONE NATION UNDER GOD WITH FREE

the time. López grew up in a generation that was critical of the liberal state and its inability to guarantee social justice. In fact, the liberal state was reconceptualized and viewed as a source of injustice, as the poster suggests. Since reformist politics was also suspect, the youth of this generation were willing to consider radical tactics to fulfill the promise of the liberal state: empowerment, freedom, and justice. Their political activism generated social movements on multiple fronts, challenging several sectors of society: "from the battle for educational space in universities to protest against the U.S. war in Vietnam, from community controls over housing to the transformation of the conditions of racialized labor."[2] The civil rights movements of the 1960s and 1970s also addressed equality for women and gays and lesbians, drawing together public and private concerns in the pursuit of universal equality. For López, this activism took place through her participation in the TWLF at San Francisco State College and her work with the organization called Los Siete de la Raza in San Francisco's Mission District (fig. 17).

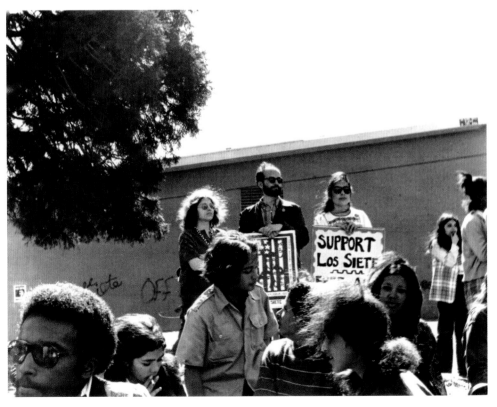

The widely circulated poster also demonstrates how many Chicana artists, including López, were "integrated into the various political fronts of El Movimiento in unprecedented numbers and in significant ways."[3] For example, Barbara Carrasco worked as an artist for the United Farm Workers from 1976 to 1991, Celia Herrera Rodríguez worked for Bert Corona in the early 1970s, Linda Lucero did political advocacy in the Bay Area, and Isabel Castro, Elizabeth Perez (formerly known as Nancy Perez), and Elsa Flores were active in Los Angeles. Inspired in part by Maoist principles, López believed that art should serve the people. This socially motivated artistic commitment rejected the codes of the capitalist market and Western individuality. Like Betty Kano, who contributed to the Third World Liberation Front in Berkeley in 1968, and Jean LaMarr, whose poster of Wounded Knee was widely distributed, López did not sign the broadsides, buttons, and flyers she created for Los Siete de la Raza. The impassioned sensibility of revolution infused her style and the tone of her artistic endeavors.[4] When *Free Los Siete* was exhibited at Galería de la Raza in 1970 at the First Annual Women's Show, the poster surprised the audience because they had assumed it was the work of a male artist.[5] Even at this early juncture of the Chicano art movement, art attributed to men was considered more political than art by women, who were frequently criticized for focusing on personal expressions and private matters. Although scholars have since argued that the boundaries of Chicano art were initially too narrow to include the new political subjects and identities rendered by Chicana artists, López's work with Los Siete and beyond "encompassed both a political position and an aesthetic one."[6]

During the late 1960s and early 1970s, López's work circulated extensively, to the artist's satisfaction. Marchers at rallies and demonstrations waved banners made from *Free Los Siete*. The poster appeared repeatedly in photographs of public events by local newspapers, including Los Siete's newspaper, *¡Basta Ya!*, which was produced to inform the Mission District about the trial and other crusades for justice (fig. 18). López's work for Los Siete found a venue as large as the Latino community. "The streets were my gallery . . . posters, leaflets, lapel buttons, and graphic art for neighborhood newspapers. I saw my work everywhere, and unsigned."[7] The public circulation of her art contrasted somewhat with its display in the

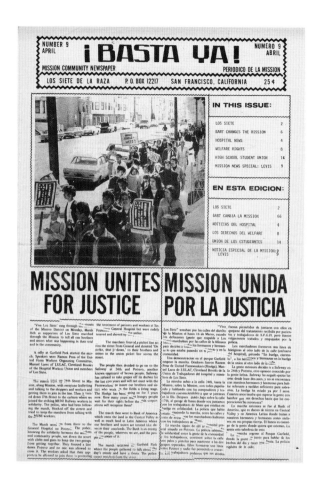

Figure 18. Cover of *¡Basta Ya!*, no. 9 (April 1970). Photograph shows demonstrators at Mission High School on March 16, 1970, carrying poster designed by Yolanda M. López.

neighborhood exhibition venues that emerged in the Mission District: Casa Hispana de Bellas Artes (1966), Artes 6 (1969?), Galería de la Raza (1970), and eventually the Mexican Museum (1975). Although Chicano art history often considers community-based exhibition practices as akin to public art, such as murals and posters, the circulation and impact of unsigned works that enter everyday spaces inside and outside homes, businesses, and public locations distinguish them from works of art shown in a gallery. Even though community arts organizations attempted to challenge the exclusionary nature of the so-called public museum and gallery art market, the works they exhibited were not as freely available as López's leaflets, newspaper illustrations, buttons, and placards.[8] Moreover, the context and function of her art made the work distinct from gallery exhibition; it crystallized her identity as an artist. "It was only within Los Siete that I understood what I was about. And that was because it combined my interest in politics and art, and it was a very comfortable fit for me."[9]

This "comfortable fit" reflects her ideological affiliation with the Chicano movement, the Left, the Black Panther Party, the Third World movement, and women of color feminism. Drawing on the iconography of the Black Panthers and the ideology of the global Left, López defined her art as a political tool for revolution. The revolutionary perspective supported coalition work of many types, particularly activism to end global capitalism and imperialism through alliances between Asians, Latinos, and African Americans. Ideology, not race or culture, was the basis for solidarity. Although her feminist identity would not crystallize until 1971, López's involvement in Bay Area social movements generated intersecting subject positions. Her work would identify injustice on multiple fronts: racism in American society, capitalist exploitation around the world, and patriarchy within the Chicano community. In subtle ways, she would question heteronormativity by creating images of Chicanas that did not depend upon men.

This chapter and the one that follows explore the artist's complex political awareness.[10] Exemplifying Chela Sandoval's "oppositional consciousness," López is a participant in the larger project known as U.S. Third World feminism, which joins several ideologies—anticapitalism, anti-imperialism, antiracism, antisexism, and antiheterosexism—that independently examine power and oppression. With the capacity to "align such divided theoretical domains into intellectual and political coalition," U.S. Third World feminism and its oppositional consciousness allow for shifting tactics and multiple social locations.[11] Expressed across her oeuvre and through her activism, this multifaceted identity allowed López to visually express solidarity with Central Americans resisting U.S. invasion, challenge police repression of black and Latino youths, and acknowledge anti-apartheid activists in South Africa—to name a few of the causes with which she identified (fig. 19).

Living in the Bay Area but also finding her political voice on the picket lines of the TWLF, López developed the ability to organize on behalf of workers, women, and people of color while at the same time referring to herself as a Chicana. As scholars Jason Ferreira, Cary Cordova, and Tomás Sandoval demonstrate, Bay Area activism generated a distinctive pan-Latino orientation, and while this operating strategy shaped the cultural solidarity of the Chicano movement it also broadened the rubric of nationalism into "la raza"—the race, a vernacular term for people of Latin American heritage.[12] This ideological framework, however, did not assume homogeneity among people of color. Differences were embraced and coalitions among Latinos, blacks, and other working-class residents of the Mission were continuously reforged. When López moved back to San Diego in 1971, she could not take for granted the basically inclusive politics that had characterized the Bay Area, and her oppositional consciousness clashed with the Chicano nationalism of San Diego. Decades later, her understanding of pan-Latino coalitions would surface in her multipart installation *Cactus Hearts/Barbed Wire Dreams*, in which she critiques the tendency of the media and the police to view all Latinos as illegal residents. In the Bay Area, this common experience of racial profiling and stereotyping was the foundation for cross-ethnic coalition building and transnational solidarity to combat the militarization of the border and the undeclared war on Central America.[13]

Figure 19. Yolanda M. López, *In Solidarity with the Women of Central America*, 1985. Pen and ink on paper, 12 x 16 inches. Cover illustration for *Tecolote* 15, no. 3 (March 1985).

THIRD WORLD STRIKE

In 1966, two years after completing her associate's degree at the College of Marin, the twenty-four-year-old López transferred to San Francisco State College.[14] Renting a room at the Tarrington Hotel, she worked part time at the Golden Gate Theatre in San Francisco and enrolled part time at the university.[15] Already aware of the cultural revolution in the Bay Area and venturing into the counterculture scene through fashion, style, books, and music, López was drawn to the activism on campus.[16] She joined the Student Nonviolent Coordinating Committee (SNCC). In tandem with protests throughout the country against the Vietnam War, antiwar activism had been escalating at State College. Among other confrontations, students challenged the college administration's policy of notifying the Selective Service System when a student became eligible for the draft.[17] Repression intensified as the campus administration sought to contain student protests, as was happening on other campuses nationally and internationally.

In March 1968 the TWLF, a multiracial and multiethnic student coalition at San Francisco State College, began mobilizing to demand ethnic studies, an admissions policy that matched the population of the city, and financial aid. The term *Third World* emerged during the Cold War to designate nations not aligned with either the Western or Eastern bloc; it subsequently was used to refer to Asian, Latin American, Caribbean, and African nations, placing them at the bottom of a global hierarchy that had European and North American nations at the apex. Students at State College "sought to overturn the pejorative meaning" of the term and create solidarity across lines of race, ethnicity, national heritage, color, and immigration status in their struggle to create an alternative curriculum and a student body that reflected the city's demographic profile.[18] After the administration failed to deliver on its promises, the group of African American, Latina/o, Native American, and Asian American students led a five-month strike using radical tactics that included building occupations, chanting, trash can fires, amplified speeches, picket lines, and sit-ins. From November 6, 1968, through May 1969, all university business was disrupted. At an early point in the strike, President Robert Smith attempted to appease those

faculty members who began to sympathize with the students by agreeing to a campuswide convocation.[19] However, his open disdain for students of color as well as the suspension of leaders within the TWLF backfired.

Smith's successor, S. I. Hayakawa, operating with the support of Governor Ronald Reagan, intensified the military presence on campus by declaring a state of emergency. This allowed for the use of riot gear, billy clubs, helicopter surveillance, and other military tactics developed for the Vietnam War. The students, including López, were aware that Hayakawa had authorized the use of military tactics developed for the very war they opposed, and it had a chilling effect. A decade later, when the same military tactics and equipment, as well as heat sensors and infrared motion detectors, were deployed at the U.S.-Mexico border to apprehend migrants, López would condemn these practices in studies or "sketches" for *Who's the Illegal Alien, Pilgrim?* (fig. 20).

The most brutal repression of the TWLF came on December 3, 1968, a day remembered as Bloody Tuesday. Tactical Squad and California Highway Patrol officers "indiscriminately beat students, faculty, campus staff, community members, medics, photographers, and even church officials," resulting in concussions and other serious injuries.[20] The violence led the American Federation of Teachers and other local unions to throw their support behind the students, joining the TWLF on the picket lines. Public opinion and faculty mobilization against Hayakawa forced the university administration to consent to the demand for a College of Ethnic Studies. It opened in fall 1969 and became, as Lisa Lowe notes in her analysis of ethnic studies, one of the sites "from which to reevaluate disciplinary methods that assume Western cultural autonomy and the universality of the Western subject."[21]

Even before ethnic studies courses became part of the curriculum, the Third World strike taught López to question the production and function of knowledge. This was more than an epistemological exercise, as López began to question not only how some types of knowledge are valued over others but also the relationship between power and representation. Much of this education came through direct action. She was on the picket line every day, and she joined the picket blockade at the main entrance to campus.[22] Her activism meant that she failed her courses, but it taught her invaluable lessons about herself,

Figure 20. Yolanda M. López, *Stop the Vietnamization of San Diego—Say No! to Carter's Plan*, 1978. Mixed-media collage on paper. Study for *Who's the Illegal Alien, Pilgrim?*

society, and the artist's role. According to López, the demonstrations and rallies offered her more insight than her classes. "When I was taking art history classes at San Francisco State College, there was no sense of my role as an artist in society."[23] The immediacy and relevance of the picket lines provided her with a political education. "I ended up spending more time on the picket line than I did as a student in class."[24]

Several factors influenced López's decision to join the strike rather than attend classes. First of all, her mother had raised her to respect worker solidarity. She would not have crossed a picket line under any circumstances. Second, her household was filled with people who were self-taught. For López, learning was never confined to the classroom. But she was not an anti-intellectual, and her love of books, an appreciation that emerged in early childhood, would spur her return to undergraduate studies at California State University, San Diego, in the 1970s. Prior to her arrival at San Francisco State College, bookstores also served as sites for creative, political, and intellectual awakenings.[25] Another major factor in her decision to join the TWLF was the participatory democracy she learned at home, which was reinforced in multiple ways. López remembers excitement in the family as they watched the Democratic conventions over the years, and she recalls that her mother took all three sisters to "stuff envelopes for Jack Kennedy's [presidential] campaign" in 1960.[26] In addition, her mother's union membership signaled the importance of solidarity in the struggle for justice, and the collective action of the students proved invaluable for TWLF when Hayakawa attempted to split the coalition by making promises to the Black Student Union. This sense of shared interests and goals was the high point of López's education at State College.

The TWLF taught López that inclusive political action and self-determination could coexist. A shifting consciousness allowed her to understand the structural inequalities common to people of color while affirming the need for Chicanas and Chicanos to become the producers of their own history, creative imagination, and futures. Although López characterizes her childhood as a period in which she "had no sense of Mexican culture," her involvement with the TWLF brought an immediate awareness of her heritage and the social position of Mexicans and working-class people in the United States.[27] During the convocations at State College, she recognized her cultural identity and the

reason for her lack of knowledge about Mexicans and Mexico. At one convocation López heard Roger Alvarado, Tony Miranda, Nesbit Crutchfield (a leader of the Black Student Union), and Al Wong "talk about their stories growing up and . . . justifying why it was important to have an Ethnic Studies Department."[28] She was impressed with the "articulate, compassionate, intelligent nonwhite people" speaking with "a kind of grace, a respect, and intelligence that [she] had never seen in that way, in a *cumulative* form."[29]

When Crutchfield took the stage she began to understand her experience, her childhood, and her inability to name or identify a Mexican cultural heritage as part of a larger collective experience. Her personal history and her family's experiences were reviewed as part of a "larger historical continuum" of erasure and oppression, and this realization was foundational to the formation of her artistic goals.[30]

> I remember the story that Nesbit Crutchfield told. . . . He talked about being in a school as a youngster and how they were doing a genealogy . . . "Where do your parents and ancestors come from?" . . . and he didn't know where his parents came from. He had *no traceable lineage*. . . . He said he wanted to hide underneath his desk. . . . And I thought too about not having that connection with the American historical tradition.[31]

After Crutchfield finished his story, university president Robert Smith belittled Crutchfield's personal testimony, using language intended to emasculate him. The president's words, manner, and disrespect for the student's sincere expression disturbed López.

> When Bob Smith said, "Be that as it may, you know, you'll just have to wipe your nose and pull up your socks and go on"—and those were his exact words, because I remember that I'd never heard that expression before—well, I was shocked because he was so trivializing all these profound and heartfelt . . . stories. . . . [I knew] why it was important to have a serious history told by ourselves. And to develop our own scholars.[32]

López realized that her own isolation and sense of exclusion was not an individual predicament but was true for other people of color, and this informed her decision to join the Third World

strike. It also shaped her artistic subject matter. The memory of shame suggests that cultural awareness may have been more present in her childhood than she recalls. That is, she may not have had a language to describe her childhood as overtly Mexican, but she clearly had a grasp of the difference she and her family represented in San Diego. This difference, she realized during the convocation, was a social construction, and it guided her investigation of media representations of Mexicans and Chicanos during her work with Los Siete and beyond. Smith's dismissal of these experiences crystallized her critique of power and representation, and this critique became a bedrock for her artistic role and her choice about the audience she intended to address.

During the strike, a recurrent encounter reinforced López's growing understanding of the power held by the producer of an image. While on the picket lines, she recalls,

> we were being photographed, all the way up and down the line. . . . So we were told to bring our own cameras . . . whether they had film or not, just bring it out there and start shooting back because . . . if you're going to take a photograph of me, I'm going to take a photograph of you. . . . There was a real recognition that the power of the image was really important.[33]

These encounters made explicit the struggle over self-definition and self-representation. While the producer of the image—in this case, the police conducting surveillance—controlled and defined its subject by aiming a camera at the students, López saw that the camera could also empower. By directing the camera with or without film back at the police, she played with the deconstructive and semiotic approach to photography by exploding the assumptions about "reality" captured on film and acknowledging the context of the image's production. All of this became the center of her training in graduate school. Through direct action with the TWLF, therefore, López became interested in the function of images and learned to question the production of images. This critical focus sharpened during her work in the Mission District, where she learned that not all self-determined images are useful, liberatory, or positive.

LOS SIETE DE LA RAZA

In March 1969 Latino activists formed America Latina Unida, a community-based organization for youth in the Mission District. Early members included Roger Alvarado, Donna James (Amador), Roberto Vargas, Al Martinet, Yolanda López, Ralph Ruiz, Jimmy Queens, Jose Delgado, and Tony Martinez and Mario Martinez.[34] The group's goal was to address education, recreation, and police brutality, and "within two months of its inception" the members turned their organizing efforts to support the youths, including Tony and Mario, who were accused of killing a police officer on May 1, 1969.[35] The formation of Los Siete de la Raza grew out of a matrix of crises: police brutality, racist media portrayals of youth of color, military response to community activism, police repression of radical leadership, and the criminalization of youth culture and leisure activities such as cruising.[36] It was the combination of these widespread and interconnected forms of suppression and the original intention of America Latina Unida that turned Los Siete into something more than a defense committee. It was a predecessor of the comprehensive community development corporations that matured in the 1980s.

Los Siete founding members cut their organizing teeth in the TWLF and other groups, including the Brown Berets; the Mission Rebels in Action, a primarily black youth organization; and community-based housing and youth employment organizations.[37] This broad base of experience produced a mix of ideologies, principles, and strategies. Although a fund-raising campaign throughout the Southwest in early 1969 was largely unsuccessful, it indicates that the organizers saw themselves as part of the Chicano social and civil rights movement, as did the groups in Colorado, New Mexico, and Texas that were able to donate a few dollars to Los Siete to show their symbolic support for the accused youths. This cultural identity was also evident in the early editions of the Los Siete newspaper, whose masthead announced the organization's address in "San Francisco, Califas, Aztlán"—the last term referring to the mythic homeland of the Mexica peoples that serves as a symbol of Chicano autonomy and indigeneity. In addition to Chicanismo, Los Siete incorporated a rudimentary Marxist analysis, blended Third World solidarity with the term *la Raza*, and drew on the Black Panther

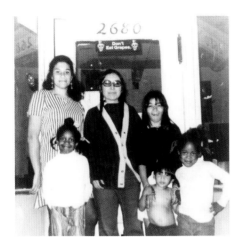

Figure 21. Los Siete committee members Yolanda and Donna James, with neighborhood children, 1969.

Party for financial support, organizing methods, and Maoist principles. The relationship with the Panthers caused an initial split among Los Siete's founding members, but it also provided the most successful strategies for building community support and awareness.

The Black Panther Party offered Los Siete one side of its weekly newspaper, which had a circulation of over 100,000 in 1969, and featured the group at rallies, which brought media coverage. Most important, the Panthers provided the services of Charles Gary, the lead attorney for Huey P. Newton and Bobby Seale, and $25,000 for the legal defense of the six Latino youths facing prosecution.[38] Following the Panthers' principles of self-determination and service to the people, Los Siete members taught political education classes, created a popular breakfast program for children at St. Peter's Church, and provided basic health care through El Centro de Salud, a small storefront clinic (fig. 21).[39] In addition, they created a community law clinic that used a pool of approximately thirty lawyers to assist with police brutality, immigration, and similar cases.[40] The only unsuccessful venture was a small restaurant, El Basta Ya, across the street from the Levi-Strauss factory. It was designed as a space in which the predominantly Latina garment workers could gather to foster solidarity and organize, but the women did not frequent the restaurant.[41] It became another place for activists to congregate, and since the community service programs were a more vital part of the Panthers' revolutionary concept to liberate people from the worries of hunger and health care, Los Siete closed the restaurant.

It was the newspaper, however, that most effectively carried the message to the community. Running in the back section of the *Black Panther*, the first issue, on June 17, 1969, told the story of police harassment that resulted in the death of the officer, the arrests, and the murder charges. It also challenged the mayor's portrayal of the accused youths as hoodlums, punks, and vandals by describing the community-based advocacy of Tony and Mario Martinez, who recruited and prepared Latinos for college. Published four times per month, the newspaper included coverage of revolutionary struggles throughout the world, including those in El Salvador, Nicaragua, Chile, Brazil, Puerto Rico, Mexico, Cuba, Vietnam, China, and Palestine.[42] It was explicit in defining "Third World" and anti-imperialism. While the international coverage was significant, the bulk of

the articles emphasized the defense of the Martinez brothers and linked their case to the imprisonment of Huey P. Newton and Bobby Seale, Luis Talamantez, and other activists of color. Aiming to construct a human profile of the brothers, the newspaper also published poems and letters written by or for the youths on trial and ran stories about their families. López complemented this coverage with photographic collages of men, women, and children at rallies and photographs and drawings of the brothers; her figures and photography depicted ordinary people, not militant or dangerous youths. The raised fist, the symbol of black liberation, consistently appeared in the pages of the newspaper, to signal solidarity with the Panthers and political coalition building against racism, material inequality, and U.S. imperialism. It was the most consistent iconic reference that López made to Emory Douglas, minister of culture and image maker for the Panthers.

¡BASTA YA!—ART FOR THE PEOPLE

López first met Douglas when she accompanied Donna James on a visit to the Panthers' main office to learn some layout techniques from him.

> We went over to the Panthers [headquarters] to see how they put the Panther paper out. . . . I went with Donna James, and Donna was the editor of our paper, and I was the artist. . . . And he showed us how . . . the layouts went, but also that we could sort of like get the *San Francisco Chronicle*, or any paper, and cut out the long lines [to reuse them for] borders.[43]

Douglas favored a visual style that was direct and aggressive because he believed that images function to raise revolutionary consciousness. In the pages of the *Black Panther*, he vilified police as pigs, politicians as rats, and businessmen as vultures.[44] These images initially shocked López, but she admired his gentle spirit and he influenced her artistic conviction and direction. She repeatedly borrowed the Black Power fist, but her modification of the image indicates that López gravitated to aspects of Douglas's work that others overlook.[45]

According to Douglas, "Revolutionary art gives physical confrontation with the tyrants, and also strengthens people

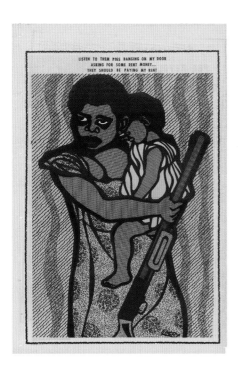

Figure 22. Emory Douglas, poster from the *Black Panther*, February 27, 1971.

Reproduced courtesy of the artist.

to continue their vigorous attack. Revolutionary art is a tool for liberation."[46] Given the passive, powerless, or buffoonish media images of African Americans, Douglas's task was twofold. First, he critiqued stereotypical images of blacks, and second, he offered a new visual vocabulary that could inspire African Americans. As Colette Gaiter notes, Douglas's message "was dramatically different from earlier Civil Rights Movement graphics, which included text-based protest signs with demands like 'JOBS FOR ALL NOW!' Douglas's work was persuasive and directed to a different audience—not to the oppressors, but to the oppressed."[47] By rejecting the images of the complacent black slave, the illiterate good-for-nothing, the savage brute, and the minstrel, Douglas visualized the qualities of Huey P. Newton and Eldridge Cleaver, intellectual and strong black men of power, and offered them for African Americans as a source of self-determination. The major features of his new constructions of blackness were a "hard-core, militant, virile, and invincible black manhood" as well as the less frequent images of black mothers carrying children and guns (fig. 22).[48] His figurative style made use of the previously unimagined or unreal to provoke and empower. López did the same for Chicanos and Latinos but added a feminist sensibility not found as frequently in Douglas's early work.

Whereas Douglas focused his creative energies on new masculine representations, López created images of women in unconventional settings or activities. Certainly, Douglas made images of women with rifles, just as he depicted men carrying guns. Yet these female figures frequently held children or grocery bags, wore aprons, or had their hands in a sink full of dishes, defining them by their domestic and maternal roles. Like other feminist artists, López did not imagine motherhood as an essential female experience or identity. She presented women as leaders and activists in settings without men. When she engages private or domestic issues in her work, she deliberately presents them as public battles, as Douglas did when he depicted poor black women struggling to feed their children. And as I discuss below, López also tried to expand notions of masculinity in the pages of *¡Basta Ya!*

Within the newspaper, López used a variety of styles and techniques. The most popular were drawings with photographs and photomontage as well as contrasting scale for dramatic

effect, a technique favored by Douglas.[49] A collage of photos served several purposes. López could include a range of faces and figures to demonstrate the diversity within the movement or connect social injustice across racial groups, national borders, and political causes. Photomontage was thus a powerful way to suggest shared oppression. It also allowed for multiple photos to appear when the paper faced a shortage of space. But the collage and retouched photographs also reminded readers of the construction of the image—each photo had been cut (literally) from its original context before being placed in the newspaper (fig. 23).

This approach to images, which encourages the viewer to acknowledge the fabrication of the work while also demystifying the artist as the "autonomous auteur with a capacity for genius," would later converge with the deconstructive and semiotic argument in the art curriculum of the University of California, San Diego (UCSD).[50] López learned from her professors Allan Sekula and Martha Rosler at San Diego to "abandon the notion of an original, cohesive work."[51] This rejection of the traditional notion of artist as genius supported her preference for a democratized reception of the product, another aspect of the conceptual art explored at UCSD.[52] Her work in *¡Basta Ya!* circulated within the Mission District and at rallies and demonstrations throughout the Bay Area. It both addressed an audience and engaged them in the "struggles against the established order," and it was this "dialogical pedagogy" shared by Sekula and Rosler that allowed López to further explore her role as artist in a capitalist, racist, and sexist world.[53] The rough collages, often separated by the black lines Douglas taught her to use, were precursors to López's color Xerox studies for the Guadalupe series and her portraits of Victoria Franco (1974), especially the combination of ink drawings of her grandmother's face and arms with a collage of photographs and colored paper to render her clothes. While both used "inexpensive, ephemeral,

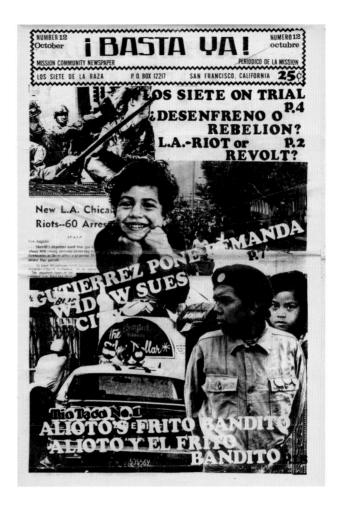

Figure 23. Cover of *¡Basta Ya!*, no. 12 (October 1970).

[and] unintimidating" materials to express López's proposal for imagining brown-skinned women, the initial studies for the Guadalupe series were fabricated from copies of existing images—Botticelli's *Birth of Venus*, Leonardo da Vinci's *Madonna Litta*, and the classic sixteenth-century image of Guadalupe—and thus decentered the artist and "dissolved the work of art into a tool of communication" (figs. 24, 25).[54] Her development in the layout room of *¡Basta Ya!* also depended upon abandonment of the antinarrative emphasis of high modernism, particularly abstract expressionism. The collages and drawings for the newspaper required a blurring of the boundaries between artwork and text. Still, López was dedicated to a visual and accessible medium that communicated with a Latino audience, rejecting the conceptualist art that emerged in the 1970s and "dematerialized" the work into action or invisible forms.[55]

Following Douglas's use of realism, López merged the real with imaginary images. For example, *Libertad para Los Siete* transforms a vacant lot and the old, decaying housing of the Mission District into a sanctuary (fig. 26). The new vision of dilapidated housing as a site of belonging, safety, and refuge is embodied in the slogan "Bring the brothers back home to the Mission!" which appears in the middle register of the poster. At bottom left is a drawing of a small child, a reproduction of Diego Rivera's work. Sitting barefoot on the ground, the boy is engrossed in a book, which is open to a page that reads "Free Los Siete." Slogan-like headlines were frequently used in *¡Basta Ya!*, but in this case the call for liberty and the imaginary home is a double message that also invokes local residential control of the Mission. López reflects on the image and the text:

> I said that in defiance, because people saw the Mission as a crime-ridden area, a very undesirable place. And I kept thinking about the Brer Rabbit story, you know . . . "Whatever you do, don't throw me into that briar patch." And then when he gets thrown into the briar patch, he laughs [and] says, "Ha-ha-ha, this is where I grew up; this is my home." And I think a lot of us felt that way. You know, white people were afraid to go into the Mission, but yet we all felt very comfortable, and it was home for us in the Mission.[56]

The leaflet was meant to illustrate a future community and encourage Mission residents to see their neighborhood through

Figure 24. Yolanda M. López, *Untitled* (Guadalupe as Venus from Botticelli's *Birth of Venus*), 1978. Color Xerox with color transparency, 6 x 8 inches. Study for the Guadalupe series.

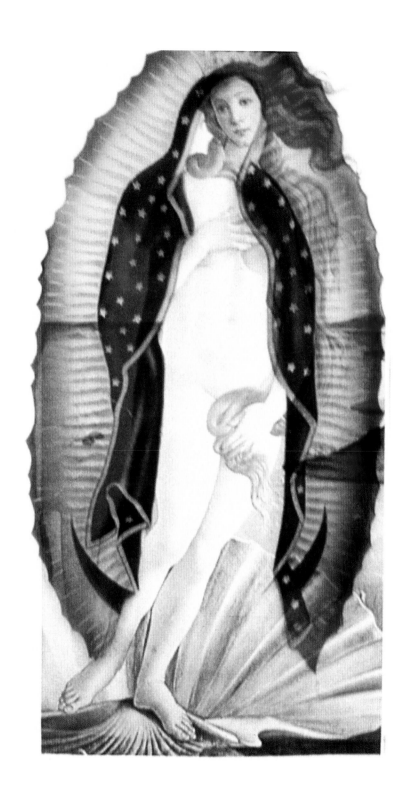

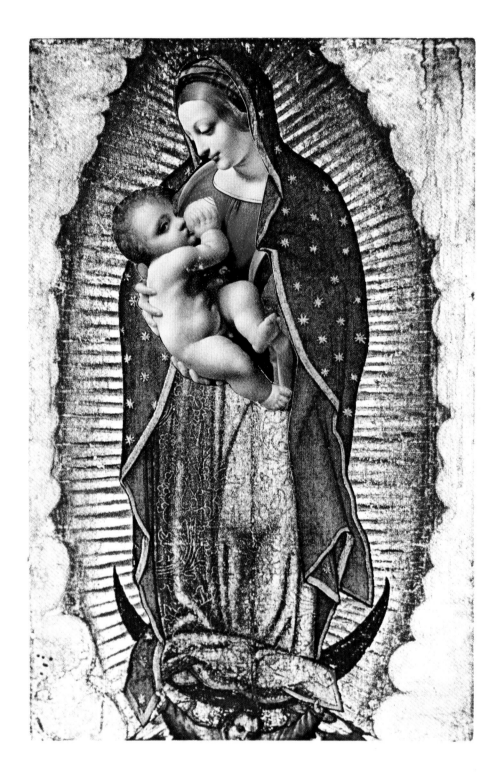

their own eyes, rejecting the media portrayal of the area as dangerous and dirty. Freedom for the brothers meant freedom for the residents of the Mission to create the community they desired, particularly in their struggle for control within the Model Cities Program and for a voice in the design of BART, the Bay Area transportation system intended to serve the middle-class and predominantly white residents of the San Francisco suburbs.

While López acknowledges Douglas's influence on her work, it is important to recognize that she was drawn to his more compassionate imagery. Erika Doss and others argue that Douglas privileged masculine power and violence, but López was influenced by what she identifies as his "humanity" and the portrayal of African American "humanness" (fig. 27).[57] For instance, she recalls:

> He did a very poignant piece. . . . The profile of a black man with a helmet—it was an Army man . . . and in his helmet were pictures of Vietnamese dead, and murdered Black people in the United States. And there was just a single tear going down the side [of his face]. And it was so beautiful. And one of the most, I felt, eloquent [antiwar and anti-imperialist] statements.[58]

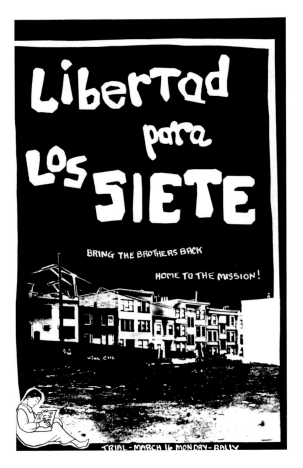

López did not present militant images of Latinos waging war or even carrying guns, and her most angry or defiant icon was the raised fist. Yet this too was balanced with another image on the cover of the newspaper: an open hand extended to the sky, holding a broken chain (fig. 28). Referring to a future possibility, the already broken chain is meant to inspire a sense of victory, celebration, and offering rather than the defiance and anger registered by the clenched fist. This desire to create humanist portraits would surface in her Guadalupe triptych and other works in which López emphasized "ordinary women." Moreover, the open hand is conceptually similar to the Guadalupe triptych because both are a "proposal" for the future.

Elements of her feminist visual project are also present in her work with Los Siete. In the pages of ¡Basta Ya! she aimed for gender balance as well as new gender subjectivities. Only

Figure 25. Yolanda M. López, *Untitled* (Guadalupe as Leonardo's *Madonna Litta*), 1978. Collage, 6 x 10 inches. Study for the Guadalupe series.

Figure 26. Yolanda M. López, *Libertad para Los Siete: Bring the Brothers Back Home to the Mission!* Printed in ¡Basta Ya!, no. 8 (March 1970).

Figure 27. Emory Douglas, poster from the *Black Panther,* September 20, 1969.
Reproduced courtesy of the artist.

one drawing by López reproduces the patriarchal conventions of manhood and womanhood, and it is a romantic portrait of which she is now critical (fig. 29). López finds problematic the "dreamy-eyed" female figure, especially in contrast to the assertive gaze of the revolutionary male who stands above and in front of the woman as if to protect her.[59] As part of a larger composition, however, the romantic illustration functions in dialogue with López's attempt to visualize alternative masculinities. In the foreground, a photograph of a father carrying his son on his shoulders is optimistic, as implied by the child's smile, the father's protective grasp on the boy's arm, and the brown beret on the child's head, signifying the future of the movement. The familial portrait balances the stereotypic representation of masculinity. López turned to a compassionate and humanistic visual literacy because of the media portrayals of Latino youth as "hoodlums" and organizers as "militants." Media stereotypes were a significant hurdle that Los Siete had to overcome in order to mobilize community support for the youths on trial but also to create trust, so that residents would send their children to the breakfast program or the health clinic.

Creating a feminist voice was a gradual process, and as I have suggested, some of her training occurred at home. A turning point came when López, as a young adult, attended the Second International Women's Conference in Vancouver, British Columbia, organized by the Voice of Women/Women Strike for Peace. Attending the April 1971 conference as a member of a delegation from Los Siete, López was inspired by the resistance of Vietnamese women and by their ability to organize Third World women along multiple fronts. Although some participants questioned the reality of Third World coalitions, she found that the blend of feminism and anti-imperialism required an attention to racism and racial privilege. Moreover, the conference helped López articulate her disconnect with the women's movement in the United States.

> There was no way as women of color that we could connect with [the women's movement in the United States]. . . . Because feminism had been in the media, but it was seen primarily as a white middle-class woman's thing. But it wasn't until that conference, listening to Cambodian and other Indochinese women—the spectrum of Indochinese

women—who were actually talking about fighting, about being teachers, about being mothers, about suffering torture, about taking this road trip to tell about Vietnam, to tell about Indochina, and what was going on there, that I suddenly realized that feminism had a larger scope than how the media was interpreting it back to us, as far as what it means for all women. That is when I became a feminist. Then I said, "Yes, I am a feminist."[60]

After the conference, the women in Los Siete brought the issues to the organization's leadership retreat and reformulated the principles of unity.[61] López and the other women of Los Siete drafted feminist principles to guide their activism within the organization, and they started a women's caucus. Both initiatives illustrate the women's emergent ideas about creating gender equity, challenging patriarchal authority, and making the personal concerns and experiences of women into a community-wide agenda. But when Al Martinet, a Chicano activist, took the helm of Los Siete, the measures to empower women never materialized. Reinforcing gender codes, he ordered López to work in the Levi-Strauss garment factory in order to organize the seamstresses there, while the men were sent to organize in higher-paying sectors of the labor market. She left the group because it could not deliver on its feminist promise and because she could not see herself taking up the occupation that had injured her mother's body through repetitive movement and unhealthy environmental conditions. The critique of patriarchy, capitalism, and racialized labor would surface in her later series Women's Work Is Never Done. She used the phrase to mock gender expectations by illustrating women as activists working to end apartheid in South Africa and as voters, scientists, and labor leaders challenging California agribusiness (fig. 30).

Although she left Los Siete, López did not waver in her dedication to Chicana and Chicano empowerment, justice, and autonomy. When she returned to San Diego in 1971, she again sought employment within community-based service and advocacy organizations. López's homecoming coincided with the flowering of political and artistic Chicano activism in San Diego.

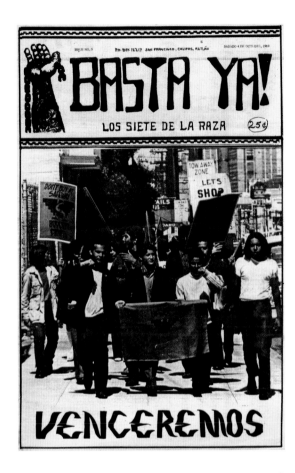

Figure 28. Cover of *¡Basta Ya!*, no. 5 (October 1969).

Figure 29. Yolanda M. López, *Cinco de Mayo: Que Viva La Raza*. Back cover of *¡Basta Ya!*, no. 16 (May 1971).

Figure 30. Yolanda M. López, *Homenaje a Dolores Huerta*, from Women's Work Is Never Done series, 1995. Silkscreen, 20 x 20 inches.

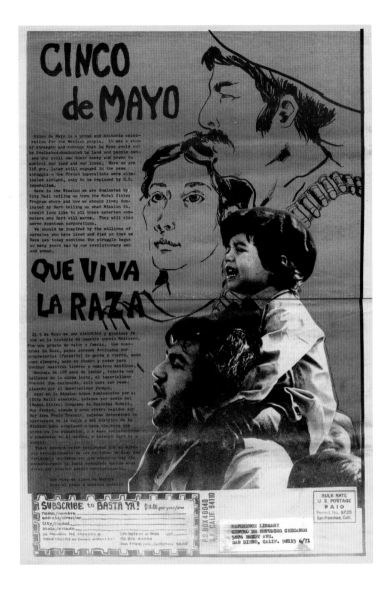

In Logan Heights two decades of residential displacement and environmental pollution from the construction of the freeway and bridge, as well as the noise from the junkyards, generated an intense popular uprising. Urban development projects had literally dissected the community and restructured residential areas as industrial zones, and in 1967 the residents of Logan Heights began to fight back. As Raúl H. Villa notes, one of their first victories was the promise of a park in the "derelict space

HOMENAJE A DOLORES HUERTA: 19__

CALIFORNIA BROCCOLI HARVEST: 1995

HUELGA

WOMEN'S WORK IS NEVER DONE

created under the interchange of the freeway and the bridge access ramp" leading to the Coronado Bridge, which occurred after residents occupied the site on April 22, 1970.[62]

As historians note, the city broke its promise and attempted to construct a California Highway Patrol substation instead. This unannounced plan infuriated residents, who quickly mobilized a response that included a human chain to stop the bulldozers from beginning construction. To keep the bulldozers at bay,

residents turned their demonstration of power into a festive celebration and consecration by planting maguey and other indigenous plants and preparing the soil using their own tools and labor. The massive outpouring of residents caused the city to pause and reconsider its tactics and eventually acquiesce to a democratic process whereby residents could control the use of space in their community. The takeover of the space was a major political victory for Barrio Logan, and it energized other community projects for health care, education, and social services.

However, due to the stonewalling strategies of San Diego mayor Pete Wilson, work did not begin for two years after the city authorized the recreational area. López returned to San Diego just as negotiations with city hall were taking place and she became part of the group that oversaw the physical environment of the park. Through her employment at the Chicano Federation, López was involved in activities to create the murals and the kiosk, and although she was never invited to paint a mural, she became a member of the steering committee.

POLITICAL ART AND THE ART OF POLITICS

As Lucy Lippard argues, the politicization of art and the creation of political art are two different strategies, with the former making no argument about content or form and the latter more interested in ethics.[63] That is, the politicization of art is a strategy that calls attention to the role of power in the art world, an approach frequently associated with the institutional critique proposed by conceptual art. Political art emphasizes the role of power in society, not just the art world. It frequently employs forms and styles that support a message or enhance legibility. For Chicano political art, content was initially limited to community or national issues such as the antiwar campaigns, labor justice, and political representation. Political artists thus work through both avenues, advocating for democratizing spaces and challenging institutional practices as well as creating art that speaks to social inequities. As a political artist, López was part of a larger artistic movement among Chicanos, Latinos, Asian Americans, and African Americans in which art functioned to "nurture and sustain an insurgent consciousness."[64] But she was also a participant in the conceptual art movement that emerged

in the 1960s to reject the established art-market system, destabilize the myth of the privileged artist, and encourage the political agency of the audience by openly opposing capitalism and other forms of oppression.[65] One of her most successful expressions as a political artist is *Who's the Illegal Alien, Pilgrim?*, an india ink drawing that she created in 1978, the same year as the Guadalupe triptych, for a campaign about immigrant rights organized by the Committee on Chicano Rights in San Diego. The man in the poster angrily grasps in one hand the pages of President Jimmy Carter's immigration plan and points an accusing finger with his other hand. He wears a headdress that suggests Aztec or Mayan civilization to indicate that he is indigenous to the land (fig. 31).

Merging text and image, the poster is a pedagogical engagement with the audience that breaks the barrier between viewer and image. This is accomplished in several ways. The figure fills the frame but is cut off at the chest, and there is no background, placing the figure in the same space as the viewer. The image also reaches out to the viewer by extending the arm beyond the frame of the drawing. In addition, the darker shading on the figure's right side and the foreshortened perspective allows the finger to confront the viewer, a strategy echoed in the man's angry eyes and mouth, flared nostrils, and exposed teeth. Quite literally, the image in the poster points to the world outside its own borders and accuses a specific audience with the intention of provoking social change. Blurring text and image, content and message, the poster does not function as the modernist object of contemplation whose only frame of reference is Art. Instead, the composition creates a sense of discomfort that reinforces the message of both exclusion and belonging through the "appropriation and inversion of icons from advertising and entertainment."[66] It indexes the viewer and is contingent on an engagement with the social world. Using John Wayne's moniker for a stranger in John Ford's movie *The Man Who Shot Liberty Valance* (1962), along with the iconography of the military recruitment poster, López "makes a joke out of the icons of the dominant culture and uses laughter and ridicule to 'uncrown power' and build insurgent consciousness."[67]

Although the Committee on Chicano Rights was "somewhat reluctant" to use the image because they could not get past its forceful composition to appreciate López's wit and sarcasm,

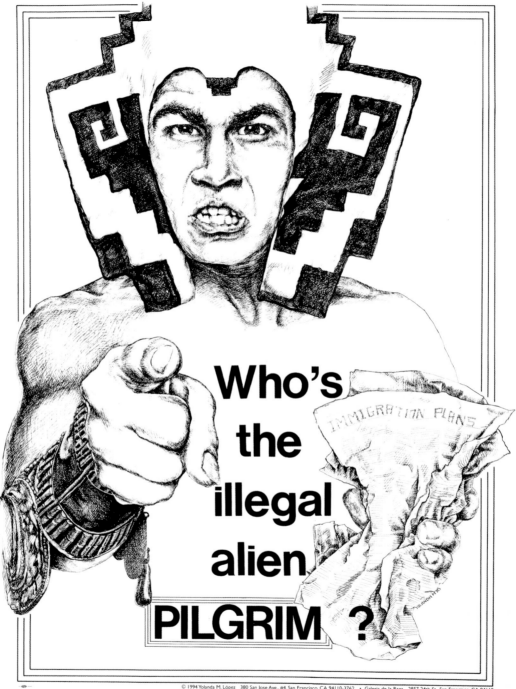

Who's the illegal alien PILGRIM?

IMMIGRATION PLANS

the offset print first circulated in the early 1980s. It has been reproduced in a variety of print media over the past thirty years in the context of challenges to other immigration policies and activities on the U.S.-Mexico border, including the challenge to Proposition 187. The poster continues to circulate because it proclaims an oppositional consciousness that talks back to power by subverting conventional wisdom and challenging American historical amnesia. Moreover, it champions ideological and political change: we are implored to think differently about Mexicans and Europeans and encouraged to revise existing immigration law to account for this new historically based vision.

The poster reverses the xenophobic order to "go back to Mexico," a directive that forgets that prior to 1848 the states of California, Arizona, Nevada, New Mexico, and Texas along with parts of Colorado, Utah, and Wyoming were territories of Mexico. When López created the ink drawing, Chicanos were protesting the Carter administration's plan to build a fence along the southern border of the United States, divide immigrant communities by granting different forms of amnesty, and issue worker identification cards. The figure's left hand, crumpling papers labeled "Immigration Plans," suggests that the contemporary fixation on closing the U.S.-Mexico border denies the history of displacement and genocide of indigenous peoples. Although López took the figure's composition from an advertisement for Azteca Beer and not from the World War I and II posters that played on notions of patriotism and masculinity to encourage enlistment, the familiar iconography of an assertive finger-pointing man presents an accusatory challenge to Manifest Destiny and its racial supremacist undertone (fig. 32). The stylized headdress signals a claim to autochthonous status that accompanies the question, turning around the symbolic reference to John Wayne, icon of Western frontierism, nativist protectionism, and xenophobia. It also suggests the Chicano idiom "We didn't cross the border, the border crossed us," a folk expression that has gained wide popularity since the 1960s.

In this work, López suggests new masculine subjectivities and an alternative manhood. Contemporary organizations for young, urban Latinos are inspired by *Illegal Alien* because of its defiance. The stance in the poster is not available in the public portrayal of Latinos that emphasize dangerous youth engaged in illegal activities. Instead, the man in the poster is

Figure 31. Yolanda M. López, *Who's the Illegal Alien, Pilgrim?*, 1978. Offset lithograph, 22 x 17½ inches.

Figure 32. Yolanda M. López, poster study for *Who's the Illegal Alien, Pilgrim?*, 1978. Mixed-media collage on paper, 23 x 17½ inches.

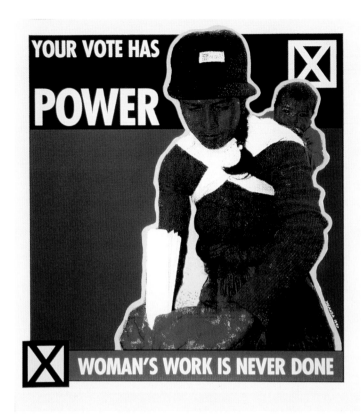

Figure 33. Yolanda M. López, *Your Vote Has Power*, from Women's Work Is Never Done series, 1997. Silkscreen, 20 x 24 inches.

incensed because of injustice done to indigenous peoples as well as the lies perpetuated to maintain the myth of Mexican foreignness and illegality.[68] The male figure in the poster also challenges the indigenization of European Americans, and by his insistence on a fuller historical perspective he becomes a source of knowledge. This image of an intellectual native male is rare and empowering for Latinos. His defiance is not frivolous or self-destructive, and thus it is accessible to youth as a possible response to such myths. Just as young African American men were empowered by the defiant images created by Emory Douglas, or, later, by the images of Malcolm X and Mumia Abu-Jamal, Latinos identify with the angry indigenous man in the poster because he inspires resistance to imperialism and racism, not acquiescence. The poster's image speaks of possibility. In this case, López's work is a cultural intervention against assimilation, whereas her other works intervene against patriarchy, Catholicism, and invisibility.

It is also a work that indicates López's fondness for the visual and linguistic pun. The poster's humor comes from the ironic twist. European settlers are reimagined as "illegal aliens." Moreover, the very word used to assert American heritage, "pilgrim," becomes the marker of the migrant or nonnative status of Europeans in the Americas. As in this case, most of her art uses humor to soften the intensity of the message. For instance, the print *Your Vote Has Power* presents an Ecuadoran woman placing her ballot in a box. She carries a child on her back. López wanted to create "the most frightening thing" that governor Pete Wilson could imagine during his campaign to support California Proposition 187 (fig. 33). She used a picture of "a fertile Latina who votes" because the statewide proposition would have restricted immigrant access to education and medical and social services.[69] The text turns the old proverb on its head

and does not reference the monotonous household labor of women but their engagement with democracy. In López's series, women's labor is heroic and vital and forces us to reconsider their daily cleaning, cooking, and child-rearing tasks.

The decade López spent getting a political education in the Bay Area shaped her artistic vision and visual language. It was the period in which she explored the function of images. Her formal training in the arts allowed her to strengthen her convictions, pay closer attention to her sense of humor and wit, and work full time in the studio, a luxury she would enjoy only as an MFA student at the University of California, San Diego. As Shifra M. Goldman and Tomás Ybarra-Frausto note in their groundbreaking overview of Chicano art history, López did "not simply enter the mainstream, but expropriated it to [her] own ends."[70]

When asked about her intensive political education, López does not rush to hyperbole. Although she was at the center of some of the most heated political struggles of the 1960s and 1970s, she recalls it as a "sweet and risky moment in time [when] we yearned for nobility [and] courage. We wanted to experience the human dignity reflected back to us in faces that we recognized as us."[71] It was a period in which she began "shedding conventions," and while historical research indicates that significant transformations came out of the TWLF, La Raza activism in the Mission District, and the battle for Chicano Park in San Diego, López claims she was "crossing small lines" into nonconformity as a feminist, as a Chicana, and as an advocate for racial, political, and economic equity.[72] Because she married theory and praxis, because she confronted image and producer, and because she did not sign her work, López participated in a new way of thinking about political art, political artists, and the politicization of the arts. Her oppositional consciousness supported a broad understanding of politics that would tease out the errors of Chicano art historiography. Her work would force a new periodization that does not announce the end of intense or overt political messages in 1975. In addition, along with other feminist artists, she would force an expansion of the boundaries of political art by bringing private matters into public view and insisting that the notions of womanhood and self are essential to authentic liberation. However, it is a dramatic yet subtle conceptual form, easily mistaken for romanticism, that is at the center of her artistic production in the next several decades.

FINDING A LANGUAGE
DECONSTRUCTION, SEMIOTICS, SOCIAL CHANGE

As López describes it, the opening reception for her MFA exhi-
bition was a "truly fabulous" party. The galleries were filled
with the music of Trio Moreno, an all-female singing family
whose presence visually echoed the series Tres Mujeres/Three
Generations. People danced and talked, and a table of food and
drink enhanced the festive atmosphere in the Mandeville Art
Gallery of the Mandeville Center for the Arts. More important,
for López, the gallery was filled with Chicanos and Chicanas
from southeastern San Diego and Logan Heights, easily outnum-
bering the faculty and students from the campus. López notes
that the crowd wasn't just happy to celebrate her accomplish-
ment, "but they were happy for us"—for their ability to inhabit
an otherwise foreign and unaccommodating place. "There was a
lot of joy" in that moment of social transformation.[1] This atten-
tion to body and space, representation and belonging, was also
part of her artistic expression on exhibition that evening, and in
the decades to follow these themes would become strong under-
currents in her investigation of images. But on that evening
López rejoiced in the palpable response to her work, not simply
because a sensational opening can flutter the stomach, flush the
cheeks, and boost the ego of any artist, but because a Chicano
and Chicana audience is central to her artistic production.

The exhibition was also marked by a successful union of her
social concerns and her formal artistic training. Although her
direction as an artist grew out of her activism, the arts faculty
at the University of California, San Diego, provided López with
a language with which to question avant-garde trends and the
modernist logic of art for art's sake. López credits Martha Rosler
and Allan Sekula for guiding her during graduate school. These
two artists, both interested in photography and known for their
critical writings on art and the role of the artist, condemned the
art-market system and documentary photography and empha-
sized the political function of art and the political agency of the
artist and the viewer. Their work, therefore, is generally consid-
ered more overtly political than that of conceptualists in New

York.[2] They were both part of the Left and the antiwar movement of the 1960s. Moreover, Rosler was a participant in the feminist movement, and her work, which also includes video and performance, intertwined anti-imperialist and antisexist concerns, particularly in her engagements with "the polite world of mainstream magazines, of newspapers and television."[3] In general, it was their view of the dialogic function of art that marks Rosler's and Sekula's distinction from other conceptual artists such as Joseph Kosuth, Marcel Broodthaers, Daniel Buren, Hans Haacke, and Lawrence Weiner. Both Rosler and Sekula were uncompromising in their attention to widening the audience beyond the gallery and studio circuit, and they sought to communicate with spectators as active agents rather than as docile, obedient, or uninterested viewers.

Conceptual and feminist art resonated with López's interest in the meaning of images, context, and social change. And while the arts faculty relied on Faustina Solis, a Chicana professor and administrator who joined the MFA committee at the last moment, to understand the significance of the Guadalupe series, López's MFA exhibition convincingly demonstrated her ability to destabilize conventional images through manipulation of the image. This technique was evident in each series created for the MFA exhibition: the Guadalupe triptych; Tres Mujeres/Three Generations, which consists of nine monumental drawings of the women in her family; and ¿A Donde Vas, Chicana? Getting through College, also known as the Runner series because of its sequential paintings of the artist running across the campus. Together they offered a new visual vocabulary for and about Mexican-origin people.

López and René Yáñez, curator of the exhibition, worked to reconfigure the modernist building into another type of space that would serve López's sense of responsibility to Chicano and Chicana audiences and her conceptual style.[4] The collaboration between El Centro Cultural de la Raza of Balboa Park and the university allowed López to organize and invite busloads of Mexicans and Mexican Americans to UCSD's Mandeville Center for the Arts. In addition, Yáñez broke the rules of museum design and transformed the white box of the art gallery by acknowledging the cultural specificity of sound, food, and color, a display aesthetic that would become a signature of Chicana/o exhibition practice by the early 1980s.[5]

He also added an installation made to represent López's studio, another strategy that further supported the artist's deconstructionist and semiotic training from Rosler and Sekula.

> He had me take some of the pictures and sketches and whatnot that I did in my studio, and sort of had a place where somebody could go—several people could go and sit down, sit at a table, a worktable that I had. And we got some brushes and paint [to demonstrate] . . . what is going through a mind of an artist; . . . all my little sketches and cutouts and doodads, and I think we even had my Wonder Woman comic book out there.[6]

The installation of her studio was intended to demystify the artistic process and abolish the notions of the artistic genius, originality, and immanence. By showing the tools and ideas López used to create her work and by drawing the audience's attention to the production of the work, the installation underscored how conceptual art "denies the primacy of the object" but also how semiotic analysis makes apparent the signifier and the message generated by the signifier.[7] Sekula's discussion of art as a "mode of human communication" aptly addresses the semiotic aspects of the installation:

> Suppose we regard art as a mode of communication, as a discourse anchored in concrete social relations, rather than as a mystified, vaporous, and ahistorical realm of purely affective expression and experience. Art, like speech, is both symbolic exchange and material practice, involving the production of both meaning and physical presence.

Thus, if the audience were to "assume the trappings of a charismatic stardom" and view López or her work romantically, the installation reminds the viewer of the play, intention, labor, routine, and context of the works.[8] Moreover, the comic books and Xerox copies of the classic portrait of Guadalupe that are on the table signal to the audience that the work is not isolated from racial, cultural, gendered, and material histories.

The artist also played with the dialogic quality of semiotics and performance by wearing a Guadalupe dress styled after a Calvin Klein outfit and sewn by her mother (fig. 34). The exhibition deliberately and playfully provoked an internal

conversation, a dialogue between the object and the viewer. Her performance as Guadalupe in contemporary and fashionable clothes also incited a public exchange between the object, in this case, López's embodiment of Guadalupe, and the viewer. López does not describe her costume and performance as a conceptual work similar to the stagings in New York against arts institutions, perhaps because her focus was the audience rather than the museum. Nevertheless, the bright pink Guadalupe dress openly engages the audience, functioning in the mode of conceptual art, by momentarily shifting the viewer from introspection and isolation. It "refers to something beyond itself"—contemporary Chicana womanhood, Catholicism, patriarchy, and fashion, to name a few possibilities.[9]

López's MFA exhibition at the Mandeville Center for the Arts was a staging of political engagement that was manifest by the collaboration between the university art gallery and the Chicano arts organization. In that moment, when Latinos filled the gallery with their laughter, dancing, and singing, the site changed the meaning and form of inclusion. Even after the civil rights movement and affirmative action changed the demographic profile of the college campus, Latinos made up only a small portion of the student body. Yet, as in most universities, it is likely that they were present as grounds maintenance workers, janitors, and clerical staff. The opening reception momentarily shattered these restrictions as Latinos were welcomed and celebrated. It was an innovative style of political engagement, one that was dramatic and easily mistaken for romanticism, exoticism, or entertainment, and one that stood in contrast to the confrontational strategies López learned in the Bay Area. But the inclusion of food, music, and Mexican bodies was a clever revision of institutional exclusion and control that was not lost on the faculty, who seemed out of place and uncomfortable.[10] The politics of self-representation and inclusion was based on a rejection of museum practices and on an invocation of the "contingent" nature of art.[11] The place and time of the work informs its meaning and the art refers to its context, rather than adhering to the modernist notion that art refers only to itself. While the deconstructionist artists on the faculty welcomed the conceptual approach that framed the artist and the works, they showed some anxiety about a shifting boundary of inclusion or the culture that López referenced with her framing. One professor warned her against the use of

Figure 34. Yolanda M. López, in Virgin of Guadalupe dress, with René Yáñez and his nephew Oscar Yáñez at López's MFA opening, 1978.

cultural references because it would position her as an "ethnic artist," a derogatory term he employed to distance the work from modernism's insistence on universal truth and its discovery or on the search for elements that unite humanity.[12]

López would continue to reformulate image and boundaries over the next several decades. Her work interrogates images of Mexicans and Chicanos but also challenges the context in which fine art is displayed and the assumptions about who should be invited into such elite spaces. Although she would not claim the community-based arts organization as her exclusive site of exhibition (a strategy advocated by Montoya and Salkowitz Montoya in 1980), she consistently produces work that is conceptually accessible and culturally relevant to Mexican-origin audiences.

TRES MUJERES/THREE GENERATIONS

When López returned to San Diego, her childhood neighborhood, Barrio Logan, had already won its battle against the city for a park in the community. Beyond this victory, the transformation of the space would require work, and her position with the Chicano Federation allowed her to play a role in the completion of this project (fig. 35). Although she participated in the creation of Chicano Park, López did not gravitate toward the "indigenous identification with the land [that] infused the multiform physical embellishments and cultural enactments" of the park.[13] She was never invited to paint a mural, but it is unlikely that her aesthetic style would have matched the indigenous motifs, symbols, and themes celebrated in the murals of Chicano Park and elsewhere in the 1970s and early 1980s. Certainly, she valued and understood her family's indigenous heritage, but her art did not reproduce romantic or sentimental images of Mesoamerican people and culture. Instead she aimed to call attention to the social construction of indigeneity among Chicana/os. The spatio-political battle enacted through(out) the park did not match the art criticism she was learning from Rosler and Sekula. Moreover, the patriarchal family romance in park murals, such as the one executed by José Montoya and the Royal Chicano Air Force, *Farmworker Family* (fig. 36), depicting a man standing behind a woman and child with a protective gesture toward them, did not coincide with her feminist

Figure 35. Yolanda and Margaret at Chicano Park Run, San Diego, 1977.

Figure 36. José Montoya and the Royal Chicano Air Force, *Farmworker Family*, 1975. Pro-line vinyl on acid-etched concrete, 30 x 35 feet. Chicano Park, San Diego, California.
Photograph courtesy of Centro Cultural de la Raza, San Diego.

orientation. Rather, she took up what Laura Pérez identifies as the body of Chicanas and Chicanos as the site of recuperation.[14] Chicana artists in the 1970s reclaimed female figures from family and communal history, a strategy that many feminist artists in the early 1970s employed. However, López was less interested in the excavation of historical figures. Her work filled a void and visually recorded what had been overlooked and absent in the landscape of popular images: ordinary women.

While studying at UCSD López continued to develop a feminist voice, although she did not become involved in the feminist arts collectives in Southern California.[15] Consistent with the many campaigns of the women's movement that struggled for control of the female body—for reproductive rights, control of reproductive health care, and nonexploitative representations of women and girls—López focused on the bodies of contemporary Chicanas and Latinas as the site of liberation. Even though the feminist artistic expression of the 1970s took up new subjects and themes such as body and image, relationships, daily life, and women's labor, it was Chicana feminists and other U.S. Third World feminists of color who addressed race, skin color, hair texture, biraciality, and the racist dimensions of popular representation or stereotyping. Women artists of color such as López, Yreina Cervántez, Laura Aguilar, and Christina Fernandez consistently turned to self-portraiture to explore issues of body, beauty, historical presence, and inclusion.

Just as "ordinary women" were the primary figures of López's MFA exhibition, Chicana artists such as Ester Hernández, Celia Rodriguez, Juana Alicia, Barbara Carrasco, Margaret Garcia, Yreina Cervántez, and Isabel Castro also produced straightforward images of women in the 1970s and 1980s. According to Maria Ochoa in her analysis of Chicana art collectives, the quotidian and a different rendering of *mestizaje* were common themes in Chicana art. For example, Mujeres Muralistas of the Mission District in San Francisco and Co-Madres Artistas of San Diego rejected the "narrowly defined articulation of mestizaje culture [that] included a glorification and romanticization of the Chicano family and the traditional role of women within the family."[16] Instead of Jesús Huelguera's popular image of "the semi-nude figure of the Aztec princess from the Iztaccíhuatl/ Popocatépetl legend, [held] by a gloriously arrayed warrior prince," their murals, paintings, installations, and drawings of

women did not reference a heterosexual family or relationship.[17] These artists' compositions of everyday images of women spoke of a new subjectivity that rejected the racial and gender stratification in the United States and within Chicano communities. Some artists such as López, Hernandez, and Judith F. Baca "focused on class and worker solidarity as central to liberation," illustrating the intersection of race, gender, and class.[18] In general, the work of Chicana artists depicted women as the source of their own power and agency, and this new image of Chicana womanhood was reflected in art that documented historical figures, family members, actresses or popular characters, and celestial feminine beings.

In order to analyze the contribution López makes to feminist and Chicano art histories, I focus on two series, Tres Mujeres/Three Generations (1978) and ¿A Donde Vas, Chicana? (1978). Both were part of her MFA exhibition, and with the exception of Betty LaDuke's analysis of these works in her textbook, *Women Artists: Multi-Cultural Visions*, art criticism on these two series is rare. The naturalistic, figurative style probably caused some of this silence from critics and art historians. Indeed, López's visual language pushes up against the conceptual strategy of her work, and in one exhibition her work was categorized as figurative. In *Mano a Mano: Abstraction/Figuration*, curator Rolando Castellón contrasts figurative works with abstract ones to "dispel the stereotype that Latin American art derives mainly from a history of figurative folk art."[19] Chicano figurative artists such as López were the fabricated straw men for the argument. Misreading how her work questions the folkloric and the picturesque, Castellón juxtaposed López's *Nuestra Señora Coatlicue* with Jerry Concha's *Yahmenami*. By casting *Nuestra Señora Coatlicue* as merely figurative, Castellón failed to account for López's deconstruction of the Guadalupe image, the reformulation of the historical narrative, and the radical critique of patriarchy and Catholicism.

In Tres Mujeres, López used another strategy, one that recovered "ordinary women" from silence and cast herself, her mother, and her grandmother as new subjects of Chicana womanhood. For Tres Mujeres, each model was instructed to strike a comfortable pose, which López captured in a photograph. Then each model was asked to copy the original poses of the two other women. For example, López posed standing with her hand on her hip, casually placing her weight on one foot (fig. 37); her

Figure 37. Yolanda M. López, *Self-Portrait*, from Tres Mujeres/Three Generations series, 1975–76. Charcoal on paper, 4 x 8 feet.

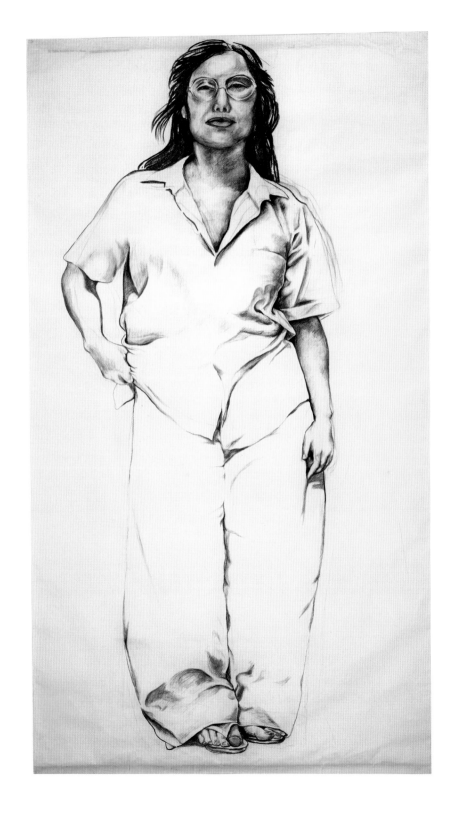

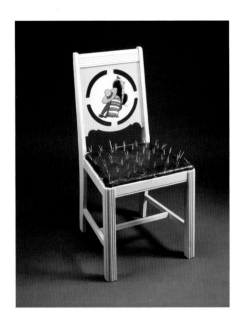

Figure 38. Yolanda M. López, *Mexican Chair*, 1986. Acrylic paint, toothpicks, and wood on kitchen chair, 37 x 15 x 17½ inches.

mother and grandmother were asked to copy this pose. Inspired by sociological theory that argues that body language conveys one's personality, sentiment, and "unspoken attitudes," López wanted to illustrate the inner being of her family and engage them in a dialogue with one another.[20] Working from the photographs of the portrait sittings, López created nine larger-than-life charcoal drawings on four-by-eight-foot pieces of butcher paper. In the MFA exhibition brochure, López wrote:

> [The series] represents one of the first systematic efforts on my part to explore the presentation of Raza women as we see ourselves. It is a subject that has long interested me as an artist. And it is in general the subject matter of this exhibition. . . . A common Chicano/Latino experience in contemporary American culture is the lack of positive visual representations of Latin Americans as normal, intelligent human beings. This omission and the continued use of such stereotypes as the Latin bombshell and the passive long suffering wife/mother negate the humanity of Raza women. . . . My intention was to consciously work against traditional commercial stereotypes.

Nearly ten years later, she would focus her analysis on commercial media in the video *When You Think of Mexico* (1985), in the installation *Things I Never Told My Son about Being a Mexican* (1985), and in the mixed-media sculpture *Mexican Chair* (1986), in which she satirized the image of the sleeping Mexican by adding cactus spines to the chair seat (fig. 38).

In the Tres Mujeres series, López sought to offer new images of Chicanas and Latinas informed by feminist and antiracist politics. The nine monumental portraits register women of color as they are in daily life, and their simple, unadorned clothes and shoes, nonprovocative poses, and plain expressions are meant to signify their intellect rather than their sensuality. Not only are images of Chicanas and Latinas a rare part of public discourse, but they are also generally limited to the quaint or picturesque, the oversexed woman or the passive follower. The artist did not wish to contribute to the objectification of Chicanas and Latinas, and thus she deflects a sexualizing gaze through composition and form.

Female veneration is an obvious strategy achieved by the massive portraits that make up Tres Mujeres. Like many women artists of the period such as Flo Wong, Jean LaMarr,

Faith Ringgold, and Betye Saar, López rejected the insularity of Greenbergian formalism and "employed strategies that had hitherto been downplayed, if not outright exorcised, from modernist art."[21] Consistent with both feminist art and the brand of conceptualism espoused by Sekula and Rosler, the intended address of López's work thus extends beyond institutional critique, aspiring to intervene in the social and political, and in the representation of Chicanas and Latinas in particular. By portraying the hidden or unspoken dignities of working-class Chicanas, as art historian Guisela Latorre observes, the artist establishes a precedent for the depiction of "ordinary women" in the Guadalupe triptych.[22] López's use of simple line compositions on butcher paper in Tres Mujeres also constitutes a critique of traditional portraiture and the leisure associated with sitting for one's portrait. López's grandmother and mother had neither the time nor the money for such portraits, and by drawing them on butcher paper López creates a dialogue with the history of American portraiture, deeply democratizing it at the level of both content and medium (figs. 39, 40).

Moreover, the composition is meant to signify the power of Chicana corporeal presence. As López notes, you cannot dismiss the images. "With this series I came to profoundly understand how such a simple device as scale can transform the strengths of ordinary people to heroic considerations."[23] The monumental drawings demand attention, but more than that, for Chicana viewers they are mirrors that affirm the self that is otherwise obscured by commercial stereotype. Furthermore, the voyeuristic gaze is denied or curtailed by the women's stance and their ability to look down on the viewer. That is, López is able to undercut voyeuristic pleasure through dimension and composition. The female figures do not allure men or conjure heterosexual fantasies, and the women's posture illustrates their confidence; there is "no invitation to project our own fantasies upon them."[24] Instead López expresses visually what feminist film critic Laura Mulvey addresses in her groundbreaking analysis of cinema's preference for the male gaze. Originally published in 1975, Mulvey's work describes how cinema and mass media create a gaze that constructs women as a fetish or spectacle and thereby assumes that the gaze is (heterosexual and) male. She calls for a new visual strategy that resists sexism and the objectification of women.[25] By doing nothing to suggest sexual desire or

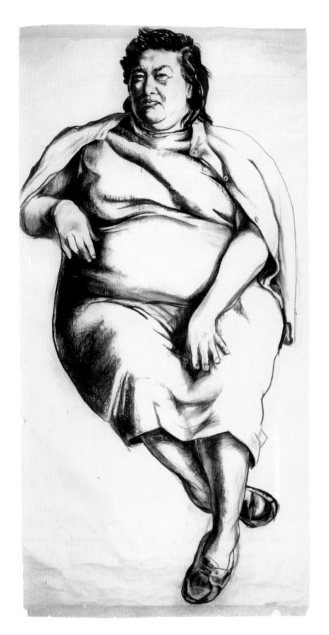

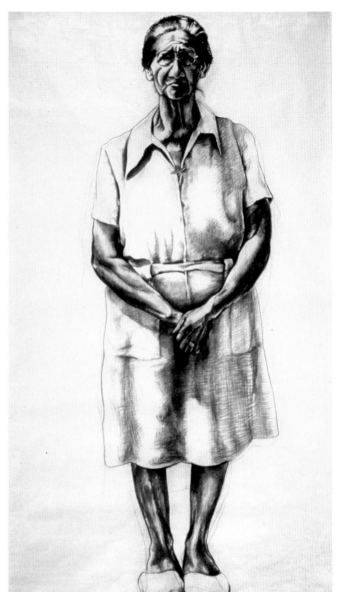

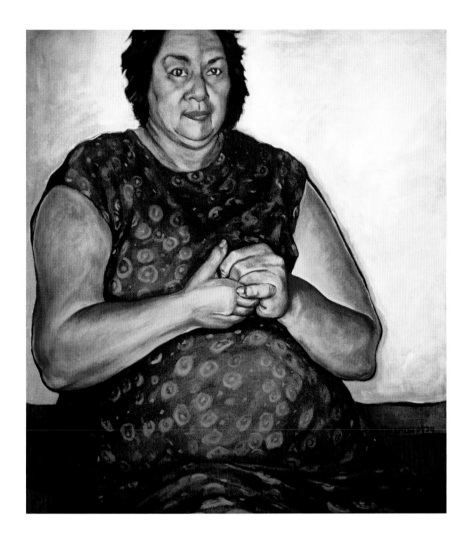

titillation, Tres Mujeres answers Mulvey's feminist call. As in the 1974 acrylic painting *My Mother*, the quotidian and the corporeal are honored (fig. 41).

In addition to their confident stance, the portraits further destabilize common notions of Chicana womanhood by offering no references to place. Whether standing or sitting, the figures appear to float in space as if the women exist nowhere and thus everywhere; even the chair is missing from the portraits of the women sitting. Foregoing a narrative reference that would locate the women in a specific context, López is able to offer the images as community portraits. This intention is clarified when

Figure 39. Yolanda M. López, *Mother*, from Tres Mujeres/Three Generations series, 1976. Charcoal on paper, 4 x 8 feet.

Figure 40. Yolanda M. López, *Grandmother*, from Tres Mujeres/Three Generations series, 1976. Charcoal on paper, 4 x 8 feet.

Figure 41. Yolanda M. López, *My Mother*, 1974. Acrylic on canvas, 36 x 48 inches.

the artist describes *Grandmother*; López comments, "She is my grandmother. She is all our grandmothers."

The formation of a Chicana matrilineage was important to López and other Chicanas working to compose or excavate female cultural ancestors as a challenge to the exclusionary masculinist visual language found in Chicano art.[26] Ester Hernández was the first to depict a Chicana Guadalupe, Santa Barraza recovered Malinche (the translator for Hernán Cortés), Yreina Cervántez imagined herself as Frida Kahlo, and Diane Gamboa documented punk Chicanas from East Los Angeles. As does Gamboa, López constructs Chicana subjectivity from contemporary experiences. During the 1970s she attended a slide show of women's images from fashion magazines sponsored by Women Against Violence Against Women, a presentation that she says changed her life. Art historian Annette Stott notes, "As a result, [López] began studying the visual representation of women in popular magazines from *Vogue* to *Penthouse*. With an increased awareness of the ways in which popular media exploit, objectify, and victimize women, she also examined the visual culture of the Chicano movement. This exercise revealed that women accounted for a very small fraction of the movement's imagery."[27] López bitterly observes that not even Dolores Huerta appeared in print media and visual culture; it was Guadalupe who consistently represented womanhood within the Chicano movement. She was intent on expanding the visual vocabulary of the Chicano movement, since the female figure was often missing or portrayed as subservient to and dependent upon men.

For López, murals like *Ghosts of the Barrio* (1974) and *Viva la Raza* (1977) came to represent female invisibility and patriarchy. Painted at Ramona Gardens, a public housing development in Los Angeles, *Ghosts of the Barrio*, by Wayne Alaniz Healy, depicts four contemporary men hanging out on a front porch, joined by translucent figures of the Revolutionary, the Indigenous Warrior, and the Conquistador (fig. 42).[28] The contemporary faces have a striking resemblance to the ghostlike figures, suggesting a lineage or linkage across time and space. Using the murals during slide-show presentations to illustrate her argument about a male pantheon in Chicano visual culture, López asks, "Where are the women in our history and contemporary communities?"[29] Her second example, *Viva la Raza*, illustrates an

Figure 42. Wayne Healy, *Ghosts of the Barrio*, 1974. Mural, 18 x 26 feet. Ramona Gardens, Los Angeles, California.

Photograph by Nancy Tovar. Courtesy The Nancy Tovar Murals of East L.A. Collection, UCLA Chicano Studies Research Center.

answer: three indigenous male figures are engaged in conversation while a kneeling female with her back turned to the men prepares corn. As López notes, this single woman literally has her back to the new Chicano history and future.

Tres Mujeres carefully constructs the matrilineage that was previously unimagined by Chicano public art. This attention to female lineage is announced in the title of the series and the individual works, and yet the portraits are stripped of typical visual indicators of Chicana womanhood.[30] For example, several titles proclaim that the figure is a mother, but the woman appears without children hanging from her arms, shoulders, or breasts, unlike Dorothea Lange's *Migrant Mother* (1936), which depicts Florence Thompson seated with three of her seven children in a makeshift tent at a pea pickers' camp near Nipomo, California. By contrast, López's mother, Margaret, and grandmother, Victoria, are not needy or domestic. They are seated or standing in the series, and in one instance (*Mother Standing as Artist*), Margaret is posed as someone else and laughs at that prospect. Furthermore, the images are not melancholic, nor are they resigned. The portraits depict neither reproach nor disappointment, but playfulness and female banter, a skill for

which López is known and which she learned from her family. These women are comfortable in their own skin, even when the mother challenges the artist's hand-on-hip pose, gently toying with her daughter's naïve self-confidence.[31] Thus while the title proclaims two of the women as mothers, the images do not conform to popular ideas of domesticity and motherhood. The only narrative anchor for the viewer is the matrilineage of three generations of women.

Matching the visual challenge to patriarchy's heteronormative constructions of Chicana womanhood are the titles *Mother Standing as Artist* and *Grandmother Standing as Artist*. In these two cases, López does not identify herself as "daughter" or "granddaughter" but as "artist"; thus the symbolic law of the father is disavowed. López states that she was using titles that would indicate the frame of reference or creator, similar to the deconstructionist strategy in photography in which the frame is deliberately depicted in order to draw the viewer's attention to the author and thus avoid any illusion of naturalism or realism.[32] The deconstructionist move also supports a feminist critique and autobiographic inspiration since López's households during her childhood and adulthood did not depend upon the presence of men: her grandfather died when she was 11, her mother raised the girls without the assistance of their father, and López herself decided to have a child outside of marriage. In López's experience, mothers are independent, and thus the images do not specifically link a woman to a man. However, the series is not simply a voice of her autobiography. It is also a feminist rejection of the family romance in which the adult male figure protects an adult female figure and a child, a common strategy of Chicano visual culture that is exemplified in *Farmworker Family* (see fig. 36). Tres Mujeres, therefore, is an argument for female independence, longevity, and collective power. This new subjectivity and vision of beauty, authority, and intelligence is proposed for Latinas of all ages.

¿A DONDE VAS, CHICANA?

The series ¿A Donde Vas, Chicana? is the only deliberately autobiographical work by López. Also larger than life, the sequence of images of the artist running through the University

Figure 43. Yolanda M. López, *Runner: On My Own!* from ¿A Donde Vas, Chicana? Getting through College series, 1977. Oil and acrylic on paper, 60 x 144 inches.

of California, San Diego, is a verbal and visual pun about her journey as a student.[33] While enrolled in the graduate program, López took a physical education class because she was over-weight and inactive. As she started the course of exercise and running, she delighted in the changes in her body: her endur-ance and stamina increased, along with her sense of control and self-discipline. The seven self-portraits of the artist running through various campus landscapes visually record her "getting through college." The exhibition of these pieces in chronolog-ical sequence compels the viewer to follow the runner moving through and off the campus, literally leaping from the space of the portrait, a trajectory that implies her movement into the future. The sense of achievement and magnificence is also rein-forced by the subtle coloration of the runner's clothes, which shift slowly into the color scheme of Guadalupe: blue-green shorts and salmon-pink shirt. The final image in the series, *Runner: On My Own!*, announces victory, completion, and future possibilities (fig. 43). The chronicle of her time on campus, however, engages a compelling deconstructionist narrative and thus functions beyond the autobiographical.[34]

The image of a woman running counters the historical preference for images of women at leisure and the patriarchal assumption that women avoid vigorous activity. It also challenges the expectation that athletics is a male domain.[35] In the contemporary context, the media create cultural heroes out of athletes, a form of worship to which women have limited access. The monumental size of the ¿A Donde Vas? images reformulates this history and culture of worship. Like Tres Mujeres, this series consists of massive paintings that demand attention, and the composition of the runner's disciplined body, which shows no sign of strain, is achieved by the classic technique of using pigment and underpainting. This technique further creates the commanding presence of the works. López had the idea of creating instant murals with the works by pasting them on pillars and walls in Barrio Logan.[36] The placement of the paintings in public space would have further supported her intention that the images command the attention of viewers, although she did not follow through with this public project. Unlike the figures in the matrilineal series, the runner never looks directly at the viewer. Yet she compels the visual engagement of the spectator because the runner is concentrating on her movement, her body, or an inner question. Her thoughtful gaze draws in viewers as fellow meditators.

While inward meditation matches the modernist intention of the campus design in the background of the portraits, the paintings signal the disjuncture between modernism and conceptual art. Devoted to modernist architecture and known as an example of San Diego Modernism, the campus embraced a simplification of form as well as formal and informal landscapes. The terraces, courtyards, and walkways of the campus were designed to encourage people to linger and share conversation as they moved through or past unadorned, restrained, geometric concrete structures. In the modernist tradition, the color palette, building materials, and simple lines were functional rather than ornate, and the original master plan envisioned different styles for each cluster of buildings, although a design emphasizing conformity and harmony was eventually selected.

The series serves as a critique of the modernist emphasis on color, texture, and technique, which on the San Diego campus produced a consistently bland appearance by stripping the landscape of ornamentation and using concrete to

create continuity between buildings. Architect A. Quincy Jones designed the Mandeville Center for the Arts, for example, with simple geometric shapes and indoor and outdoor areas where students and faculty could perform, work, or relax. Ironically, Jones did not consider the conceptual emphasis of the art department, and students, including López, found little use for the exterior patios. In fact, the building serves as an allegory for the modernist impression of the artist. Jones depicted artists in his scale model of the building wearing "berets" and painting at "little easels."[37] López conveyed this unrealistic vision by deliberating composing the buildings in disproportion to the runner. Her manipulation of shadow also gives the campus buildings an eerie quality. The unnatural composition echoes the discord between a modernist architect's impression of the students and the reality of a school of conceptual art.[38] The building symbolizes all that modernism proposes—the imagined transcendent qualities of shape, form, color, gesture, and texture—and that which conceptual art uncovers as myth: the individualism of the artist and the apolitical nature of art (fig. 44).

Her two professors, Rosler and Sekula, found that abstract expressionism, a modernist artistic style that rejects representation and narrative, had little place in the interrogation of power and oppression, particularly global capitalism. The deconstructionist orientation at UCSD was intended to unmask exploitation and control through the analysis of images. As Martha Rosler notes in her examination of pop art, another style challenged at UCSD, feminist art embraces the "renarrativization of art," renouncing the "passivity" of styles that do not dialogically engage the viewer or society.[39] Sekula, who studied with John Baldessari in art and Herbert Marcuse in philosophy,[40] did the same through deconstructionist and semiotic analysis, calling for an art that "documents monopoly capitalism's inability to deliver the conditions of a fully human life."[41] López expanded the materialist critique and semiotic training, which was influenced by Roland Barthes and Michel Foucault, to account for race. She also considered the reader of the sign, particularly the Latino spectator, in her semiotic analysis of Chicana images. The reader of the sign was part of the context of the image.

At UCSD, López reinforced her notion of art as message. Her training supported her prior understanding of the role of the artist because Sekula and Rosler took a critical view of social

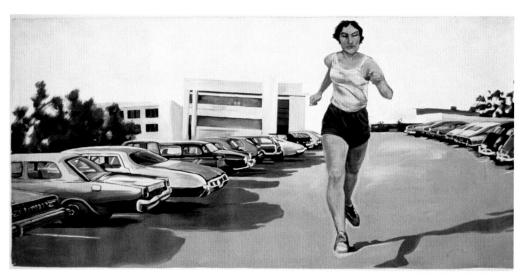

conditions. They were participants in the conceptual approach to art that examined the art-market system and its commodification of art as well as the role of art in maintaining political, economic, and social domination. In short, their conceptually based criticism of capitalism matched the anticapitalist, antiracist, and antisexist politics López developed in the San Francisco Bay Area. These tools allowed her to further understand how capitalism cripples society through false promises of liberation. The modernist building of the Mandeville Center for the Arts, which housed the fine arts department, represented the failure of abstract expressionism, pop art, and the avant-garde to provide tools for social transformation.

The influence of Rosler and Sekula is evident throughout López's career, and one of the most powerful artistic and intellectual dialogues is between her *Runner: Third College Parking Lot* (fig. 45) and Rosler's Rights of Passage, a series that captures human stagnation and alienation and the false promise of abundance in panoramic photographs of traffic jams, placeless landscapes dotted with billboards or industrial waste, and never-ending road construction. While traveling in New York and New Jersey, Rosler created all of the photographs from the front seat of a car.[42] Both artists are critical of car culture and the claim to freedom of movement. However, unlike Rosler's photographic project that documents the view from a traveling vehicle apparently heading nowhere and located in an anonymous space, López's *Runner* orients the viewer to a specific modernist architecture of the campus and a specific aspect of car culture: the parking lot. The larger-than-life runner comes toward the viewer, easily jogging past stopped vehicles that look worn and old, tired and lifeless—a contrast to the vibrant and strong body that strides through the image. But by running through the parking lot, López reminds the viewer of the requirement of the automobile industry—cash and gas are the necessary means to the promise. She is also making a double-edged critique of the automobile and the petroleum industry because the runner can get from "point A to point B" without these things. She depends on no one. She arrives at a place of power by her own means, whereas the automobile becomes the false panacea, the form of escape that offers nothing but traffic jams, distance, and wasted time, as Rosler documents in her photo series.

Figure 44. Yolanda M. López, *Runner: Mandeville Center for the Arts*, from ¿A Donde Vas, Chicana? Getting through College series, 1977. Oil on acrylic on paper, 48 x 72 inches.

Figure 45. Yolanda M. López, *Runner: Third College Parking Lot*, from ¿A Donde Vas, Chicana? Getting through College series, 1977. Oil on acrylic on paper, 48 x 144 inches.

This work is important because it illustrates the artist's agency in the face of a car culture that did not function for her or her family. López grew up with a palpable experience of transportation as wasted time in San Diego, a town in which city planners would not build roads to accommodate the working-class residents who provided services to industry during the war and the postwar boom. The roads were not direct paths between workers' homes and places of employment, and public transportation involved two or more hours of travel. The car, for López and her family, was not an option, and the public transportation system in San Diego never delivered speed, efficiency, or comfort. Vehicles and the oil industry could not be trusted by working-class and Mexican-origin residents of San Diego.

This particular aspect of López's experience as a racialized woman with multiple subject positions is the intellectual site of departure from her deconstructionist and semiotic training. López understood the various social codes, such as gender, ethnicity, skin color, language, and nationality, that work in conjunction with capitalism to create oppression. She also understood the conditional terms of inclusion, particularly for women, a topic she cogently took up two decades later in *The Nanny* (1994) (fig. 46). This installation points out that Mexican women are invisible but essential laborers and critically explores how they are cast as symbols of Mexican history, culture, and grandeur. The installation is brilliantly analyzed by Laura E. Pérez, and thus my discussion of it is brief.[43] The installation comprises three images: on the right is an advertisement for Eastern Airlines travel to Mexico (from a 1961 issue of *National Geographic*) and on the left is one for the wool industry (from a 1991 issue of *Vogue*). "In both corporate advertisements, the women of color are vendors," and in the Eastern Airlines ad, the dark-skinned woman literally bows to a light-skinned brunette who wears an embroidered skirt and a shawl.[44] Cultural appropriation is also reinforced in the wool industry advertisement, in which a high-heeled, light-skinned woman holds a large slice of watermelon as she gaily strides across a cobblestone street. In the shadows is a dark-skinned woman holding on her head a large sombrero-like basket filled with watermelon pieces. The text of the ad suggests that the vendor is not feeling new or comfortable or having fun. While the tourist appears "free, chic, and desirable," the indigenous woman is "literally in the other [woman's] shadow."[45]

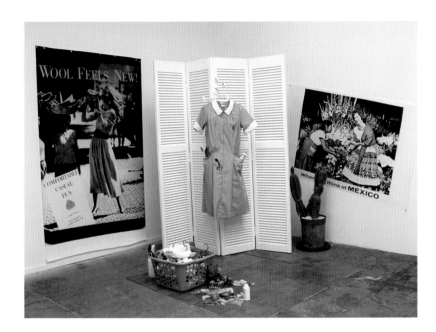

Figure 46. Yolanda M. López, *The Nanny*, from Women's Work Is Never Done series, 1994. Mixed-media installation.

López uses the center of the installation to further unmask the racialized and gendered dimensions of labor as well as to offer another example of subservience, one that is much closer to home. The center is filled with a white folding screen, a nanny's gray uniform that López has adorned with symbols, and a laundry basket filled with clothes. Near the basket are toys and a color reproduction of the airline advertisement, bottles of cleaning solution, and clay figures. According to Pérez, the installation addresses "domestic labor, gender, cultural difference, and ethnicity in the visual language of actual media materials that stage the historical asymmetry of power relations between [women of the] so-called first and third worlds."[46] The point I emphasize is how López expands the deconstructionist approach to media by questioning the production of race and gender. Whereas deconstructionists would have seen her use of advertising as a rejection of "the fundamental discourse of capitalism," they might have overlooked the ways in which the white women in the ads simultaneously appropriated and degraded Mexican culture and Mexican women.[47] Thus, even as she refined through graduate training her visual deconstruction of images, López continued to investigate the matrix of domination and the coterminous identities of race, class, gender, nationality, and, to some degree, sexuality.

GUADALUPE AS FEMINIST PROPOSAL

"In 1978," recalled Yolanda López during an interview, "there were no images of Latinos or Chicanos in the mass media. As for the movement media, the Virgin of Guadalupe was the most prevalent, continuous image of a woman."[1] Indeed, when López began the investigation that resulted in her MFA project, the Virgin was appearing on murals and storefronts, on banners at rallies and demonstrations, and even on cars as hood ornaments and exterior detailing. She was also vital in private domains, holding a central place in home altars, and in body adornment, tattooed on backs and arms and engraved on religious medallions. Nevertheless it was not until the mid-1980s, after López had completed the mixed-media collages that reformulated the icon of the Virgin, such as *Eclipse* (1981) and *Virgin at the Crossroads* (1981), that the image of Our Lady of Guadalupe permeated public space beyond Mexican and Chicano barrios, showing up on everyday clutter such as key chains, pot holders, ashtrays, coffee mugs, and bookends.

Chicana lesbian philosopher and poet Gloria Anzaldúa states that "*la Virgen de Guadalupe* is the single most potent religious, political, and cultural image of the Chicano/*mexicano*," pointing to the Virgin's three intersecting domains as the reason for her wide-reaching authority.[2] In her corpus of feminist writing in which she developed her theory of *la frontera* (the borderlands) and the new mestiza consciousness, Anzaldúa was seeking to understand the female figures, such as La Malinche, La Llorona, and Guadalupe, that shape and confine Chicana womanhood. She identifies the source of Guadalupe's power as the overlapping domains—religion, politics, and culture—that influence women's lives. Both artist and writer thus examined the hold Guadalupe could have on nonreligious women, although López's investigation began nearly a decade before the publication of Anzaldúa's book. López was interested in the cultural meaning of the icon: "I looked at this religious icon of the Virgin, who was a symbol of Mexican nationalism, to see what it did for us as women."[3] While other aesthetic investigations emerged in part

from personal experience, in this case López was not operating from autobiographic familiarity. In fact, she had no religious or spiritual connection to Guadalupe and had abandoned Catholicism several years earlier, when a priest refused to provide last rites for her sister Mary, who died in a car accident.

Her manipulation of the iconography of Guadalupe allowed her to destabilize patriarchal and Catholic expectations of women, but from a semiotic position it did much more. López was fascinated by the image because of its contemporary power, not because she found this apparition of the Virgin Mary personally or spiritually meaningful. Her intent was not to explore Guadalupe's divinity but to deconstruct the image "to see how we represent ourselves."[4] She offered a "proposal" of alternative images and subjectivities for Chicanas. It was a bold move, even during a time in which Chicana activism flourished. Therefore, while Chicanas such as Dolores Huerta were organizing farm workers in Delano, California, and Vicki Castro, Tanya Luna Mount, and Paula Crisóstomo were galvanizing high school youth to control their education in East Los Angeles, representations of Chicana women were scarce and largely limited to the *señorita*, a word López uses to describe the image of the smiling, double-braided, young Mexican maiden wearing peasant clothes.

This chapter is organized around one question: What is López's work on Guadalupe able to accomplish? An interdisciplinary lens exposes her work as a Chicana feminist proposal, as Western art, and as spiritual expression. The Guadalupe series includes the triptych, the mixed-media collages, the photographs taken by artist and colleague Susan Mogul, and paintings completed between 1978 and 1988. Although López did not intend these works to function as religious icons, I am concerned with the critical reception of López's work and its placement within and contribution to the evolving tradition of Guadalupan devotion and Chicana spirituality.[5] Certainly the Guadalupe triptych resonates with viewers, particularly art critics and curators, as demonstrated by their frequent review and reproduction of the oil pastel drawings. However, the entire body of work on Guadalupe demonstrates López's development as a conceptual artist and as a U.S. Third World feminist while also suggesting why Chicana and Latina feminists can find deeper spiritual and theological meaning in her work.

ECLIPSE

As a participant in the Chicano movement, López was exploring representations of womanhood, and like other notable Chicana feminists, such as Anzaldúa, Cherríe Moraga, and Norma Alarcón—to name a few—she was not satisfied with the popular images within Mexican American communities and those promoted by the media. Her reconfigurations of the Virgin of Guadalupe proposed multiple-subject positions for Chicanas. While the accommodation of several identity positions is evident throughout the body of work known as the Guadalupe series, one collage, *Eclipse* (1981; fig. 47), along with an earlier study for it, stands out because it clearly portrays Chicana hybridity

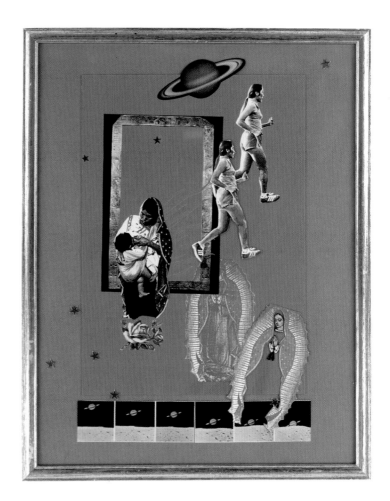

Figure 47. Yolanda M. López, *Eclipse*, from the Guadalupe series, 1981. Mixed media, 20 x 32 inches.

and multiplicity.[6] The duplication of images in *Eclipse* articulates the complex experiences of Mexican-origin women who cannot be reduced to a "singular universal woman" imposed by Euro-American first-wave feminism or by patriarchy in the home and in society at large.

The mixed-media collage is composed of two sets of doubled female figures, but the pairings are not immediately obvious. One set consists of the young runner and her duplicate; the other consists, as cultural critic Angie Chabram-Dernersesian notes, of "disparate Guadalupes": "the universally recognizable *Virgen*" (who is herself doubled) and the Mayan woman robed in the star-spangled cape with an aura of pink light or flame emanating from her side. This woman, who is the contemporary indigenous counterpart to Guadalupe, is dressed in a *huipil*, which she has lifted in order to offer her breast to the nursing child.[7] The image of the young Chicana comes from the series *¿A Donde Vas, Chicana?* and the Mayan woman is a smaller reproduction of *Madre Mestiza* (fig. 48).[8]

A Mayan stele geometrically repeats the border that frames the image. López explains that the stele signifies Chicanas' ancient heritage in the Americas, and the runner and the mother depict the contemporary trajectory of Chicanas' *mestizaje*. In the bottom register is a series of black-and-white time-lapse photographs of Saturn as it is eclipsed by another planetary body. Similarly, the Mayan woman, "a real mother," eclipses Our Lady of Guadalupe.[9]

The young woman and the mother are both juxtaposed to the Virgin of Guadalupe who is also doubled, but one image is a shadow of the other. The Guadalupe image in the foreground falls away from the stele frame. This doubling, or multiplicity, is precisely what is omitted in the original rendering of *la virgencita*—Guadalupe's physical body is almost completely covered by her gown and cape. Only her hands and face appear from beneath the cloth. Although her knee is bent, the excessive fabric seems to restrict her, making it difficult for her to move. This enforced immobility suggests that the Virgin and women taught to emulate her are restrained by Catholicism and patriarchy. (In fact, in *Walking Guadalupe* [1984], López would release the icon from that "whole yardage of cloth.")[10]

In contrast to the constrained Guadalupes, the young woman is running and her brown legs and arms are exposed. She

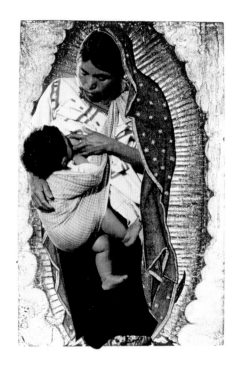

Figure 48. Yolanda M. López, *Madre Mestiza*, 1978. Mixed-media collage, 6 x 8 inches. Study for the Guadalupe series.

literally has one foot inside her cultural heritage as depicted by the stele frame, and a larger color image of Saturn hovers above her head as if to suggest a future orientation. The indigenous mother is also engaged in action. She is standing and nursing a child, which she carries in a sling. Although her child obscures from view her lactating breast, the child's and the mother's gaze, as well as the hand that supports the breast, direct the viewer to her "physical attributes."[11] Furthermore, the healthy size of the child indicates that this is one of many nursing events, symbolically exposing over and over again the mother's body. However, the cherubic legs of the child and the repeated activity of breastfeeding confound any objectification of the woman's body, and the social experience of this activity invites a sense of pleasure and comfort. The Chicana running across the image is unencumbered by clothes, child, or maternal duties. The runner's strength provides her with a sense of control and direction and indicates, as scholar Angie Chabram-Dernersesian argues, a third Chicana subject position, one that can also break from heteronormativity.

Visually, it is the relationship between the two Guadalupe images that creates a sense of movement. The Virgin appears twice, as noted above, but the shadow-image is located near the center of the collage and the second is lower, as if it has fallen.[12] The doubled Guadalupes are drifting away from the Mayan stele and toward the border. In the study for *Eclipse*, the cape of the fallen Guadalupe has been cut away, exposing the shadow-image behind it; in *Eclipse*, López has removed her gown, revealing the tan background as well as the photograph in which Saturn is nearly obscured by a horizon. In both cases the image is hollow. Cut loose is the empty signifier of passivity and submission; it has no meaning in the lives of real women. As López explains, "The Virgin was not a symbol that could carry us through on our road to justice and social equality."[13]

Systematically working against romanticism, López does not offer the contemporary woman as the new ideal female figure. None of the women occupies the center of the collage, although the nursing mother is closest, and the rose beneath her figure is López's gesture of homage, found throughout the Guadalupe series and elsewhere. The doubled jogger is leaving the central space, and in one more stride she could possibly leave the frame entirely. The aura emanating from the Mayan woman warms

the runner's back, or propels her forward. López "discards [the Virgin of Guadalupe] as a viable [image] for contemporary Chicanas/Mexicanas," and she invites the reformulation "inspired in everyday work and play" as well as in physical activities independent of men.[14] Directing the viewer to pre-Conquest images of womanhood, López reinforces a hybrid culture that retains what is useful and rejects what is not.

The collage is a series of visual multiplicities and doublings that create through an "intertextual dialogue" a new Chicana subjectivity or identity.[15] The "proposal" for a multiple Chicana womanhood is also elaborated in *Virgin at the Crossroads* (1981) (fig. 49). López created this mixed-media piece, along with *Eclipse*, after the Guadalupe triptych, as she continued to explore images of "living breathing women" who portray self-awareness, confidence, and knowledge. The title of the collage refers to an African American legend in which blues musician Robert Johnson made a deal with the devil down at the crossroads. For Johnson, the crossroads was a site of possibility, seduction, and danger. López's title, therefore, refers to a turning point or a place where decisions are made, visually expressed in the left register by a long desert road and a solitary approaching vehicle, its headlights illuminating the darkness. In the right register is the image of Guadalupe with the face of an adolescent. López transforms the aureola into a golden hue and the gown into a wash of rippling pink and purple fabric; white cuffs enclose darker hands and the black sash under the breastbone has been eliminated. Although López is troubled by the Western visual record of the Virgin Mary and her apparitions, which emphasize the woman's youth—"you never see an older virgin"—this childhood face is not meant to reinforce a contemporary obsession with prepubescent girls or historical depictions of the Virgin's adolescence. It is used to indicate innocence. In the foreground stands a dark-skinned woman wearing slacks, a turtleneck, and gold sandals, and her long hair drapes over her shoulders. Although the clothes are now outdated, she is sharply dressed. But similar to Alma Lopez's *Our Lady* (1999), this woman is defined not by her clothes but by the expression on her face; her composure is confident, assertive, and "self-possessed." She stands on a snake, with her hand on her hip, facing the viewer.

López recalls that she found the source for this image in *National Geographic*. The caption stated that the woman was a

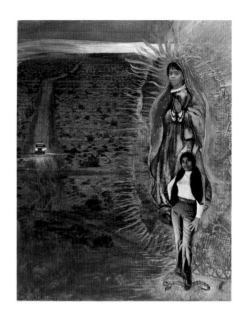

Figure 49. Yolanda M. López, *Virgin at the Crossroads*, from the Guadalupe series, 1981. Mixed media, 12 x 16 inches.

Mexican prostitute, offering only her posture as evidence for this claim. Immediately struck by the contradiction—a woman cannot be "self-possessed and still be thought of as a good woman"[16]—she was determined to explode the unrealistic and unhealthy dichotomy that Latinas are forced to emulate. The young Mexican or Chicana stands on a snake, the Western Christian symbol for forbidden knowledge, which includes sexuality and self-awareness. By placing her foot on the snake, the young woman takes charge of herself as a sexual being, implying a new example for womanhood. It is the use of "ordinary women" that is both powerful and risky, since the patriarchal response to "ordinary women" is objectification.[17] The multiplicity and doubling found in the two mixed-media collages sanction contemporary Chicanas because of the content of the pieces, particularly when understood within the context of López's oeuvre. Her prior reformulation of Guadalupe into herself, her mother, and her grandmother allows the contemporary representations of Chicanas in *Eclipse* and *Virgin at the Crossroads* to function as empowering symbols; it does not function solely as an appropriation of the Virgin's iconography.

A NEW "PROPOSAL" FOR CHICANA WOMANHOOD

López "manipulated the visual language of Catholicism" to generate multiple identities for Chicanas and validate working-class women's experiences.[18] In doing so she challenged traditional gender constructions, patriarchy within the Catholic Church, notions of whiteness and beauty, and capitalist alienation. The reformulations of Guadalupan iconography can be read as the new mestiza consciousness that Anzaldúa later writes about in her exploration of Chicana subjectivity. It is an image that requires a polyvalent meaning, gliding between feminine sanctity, working-class empowerment, sexual freedom, and Chicana activist inspiration. And while the López triptych, especially the self-portrait, is one of the most popular compositions in Chicano art history and criticism, the field has not sustained an analysis of its Catholic imagery or pictorial language, as art historian Charlene Villaseñor Black notes.[19] In 1982, historian of religion David Carrasco noted that "Chicano studies has generally obscured the significance of religious dimensions of Chicano life."[20] This exclusion made it difficult for scholars of

Chicano experience to comprehend the "intertwining of religious meanings," including Catholicism and Mesoamerican cosmology present in Mexican-origin communities.[21] Therefore, I take seriously the claim that "we should not dismiss López's manipulation of the language of Catholicism as the object of scholarly inquiry."[22] To this inquiry, I add indigenous pictorial codes and notions of the sacred.

By interpreting the symbols and figurative composition of the sixteenth-century portrait of Guadalupe from the perspective of Western Christian iconography and cultural traditions, the rendering aligns her with the Virgin Mary, the source of the apparition. Theological references to Mary include the Virgin Bride, Mother of the Church, Second Eve or Mother of All Humanity, Intercessor, Queen of Heaven, Mater Dolorosa, Woman of Valor, Black Madonna, Woman Clothed with the Sun, and Leader of the Heavenly Choir, among others.[23] She is known for her obedience to God, the succor she offered her son, and her restraint. Many of these characteristics of Mary are duplicated in the Guadalupe portrait that hangs in the Basilica in Mexico City. The clasped hands indicate prayer and homage to a person of status, a gesture dating approximately to the twelfth century. Her radiant light marks her as the Immaculata, as distinct from the Madonna with Child, and her perch on the moon, used throughout Christian art, also indicates her exceptional grace.[24] Each aspect of the figurative composition is symbolic of her humility and obedience: her head is covered, her eyes cast down, and her face turned slightly away from the viewer.[25] The story about Guadalupe reinforces her role as Mother of the Church (she instructs Juan Diego to build a temple in her honor), as Intercessor (she promises to protect and defend Juan Diego, his people, and all the inhabitants of his land), as Mother of Humanity (she calls herself his loving mother and offers to protect and nurture the people), and as Woman of Valor (she offers her compassion for the plight of the native inhabitants, she insists that a humble indigenous man is worthy of her message to the bishop, and she promises to repay Juan Diego for his labor).

Admittedly, Guadalupe has always existed in tension. She is both an evangelizer and a force of resistance, appealing to multiple interests, social classes, and cultural groups since the late sixteenth century.[26] In fact, some theologians argue that

the image of Guadalupe "communicates through the signs and symbols of the indigenous spiritual and cultural world."[27] They suggest that the use of color, aura, stars, and winged angel allowed indigenous people to see representations of their own deities, such as Quetzalcoatl, and therefore position Guadalupe as their protectress against colonial domination.[28] The various devotional expressions and interpretations of Guadalupe, nevertheless, "have not altered women's inferior status within the Church."[29] López found the entire composition troubling, especially the demure expression. The yards of fabric and the angel were symbolic of control and subservience since both prevented Guadalupe from moving.

The matrix of concepts that López proposed for Chicana womanhood required her to work in a format that would emphasize an assemblage of images. She originally designed a series of five portraits, of which only three were executed. López immediately conceptualized the trio as a coherent, interdependent work in the format of the triptych, although "the three oil pastel [drawings] have never been mounted or framed together."[30] Her semiotic gesture toward the triptych accomplishes several things. First, López is able to associate the work to the triptych, a devotional art form composed of three hinged panels, which were produced after the fifth century and throughout the Golden Age and beyond.[31] Second, the conceptual reference to the triptych reinforces the overarching emphasis on multiple identities for women. That is, the triptych allows López to expand notions of beauty, gender, culture, and belonging by depicting through portraiture several rather than one image of womanhood: an elderly female, a plump woman at work, and a young runner. All have brown skin and dark hair; none is glamorous. They have wrinkles, flab, and muscle—and these features are not exaggerated. Finally, López works against the Western tradition by individually naming each piece, this time developing U.S. Third World feminist thought.

The individual naming of each drawing voices López's critique of a society that allows women of color to become invisible or go unnoticed. In discussing the title for her grandmother's portrait, López states, "I didn't want her to be anonymous so I put her real name there."[32] Naming each portrait emphasizes the distinctiveness of each woman and image, but the conceptual format of the triptych, along with

the composition, reinforces the interconnection between the women and the works of art. López did not intend the viewer to create a generic or a singular image of Chicana womanhood; the works are metaphorically hinged and are not intended to stand alone. Furthermore, López created three works of equal size, unlike the Christian trio of images in which the central panel is largest and the spiritual anchor on which the other two panels depend. This compositional strategy was part of López's exploration of matriarchy and generations in Tres Mujeres, and the Guadalupe triptych is similarly a reference to a past, present, and future as it also crosses three generations of women's lives. Using the triptych and expanding its form, López challenges Western thought that values individuality over community. For her and for other U.S. Third World feminists, this simultaneous position of self/other is the foundation of identity formation, creative expression, solidarity, and collective action (as in the work of Gloria Anzaldúa and Chela Sandoval). Therefore, while the self-portrait has achieved the most circulation through reproduction, exhibition, and critical reviews, according to López's proposal no one image of Chicana womanhood is more valuable than the others.[33]

Offering her interpretation of why *Portrait of the Artist as the Virgin of Guadalupe* is extremely popular, López remarked, "Because it's exuberant, and I don't think there are many exuberant pictures of us within the Chicano visual library" (fig. 50).[34] In the context of Chicana/o art of the late 1970s and early 1980s, few works depict active or energetic women. The black-and-white photograph *Patssi Valdez* (1980) by Harry Gamboa Jr. portrays a woman whose direct gaze pushes through the viewer and gestures to the depths of her power, even though her body is still.[35] Ester Hernández's etchings, *La Virgen de Guadalupe Defendiendo los Derechos de los Xicanos* (1975) and *Libertad* (1976), depict enthusiastic females who energetically kick or chisel their world. On the popular front, the image of the Mexican spitfire has been criticized for suggesting sexual exuberance. The pleasure in López's drawing emerges from the body, but it is not created for someone else. Her corporeal pleasure exists for herself alone.

Running is physically exhilarating because it produces endorphins that stimulate the brain's pleasure receptors. Yet the piece also suggests the emotional, psychological, or spiritual joy found

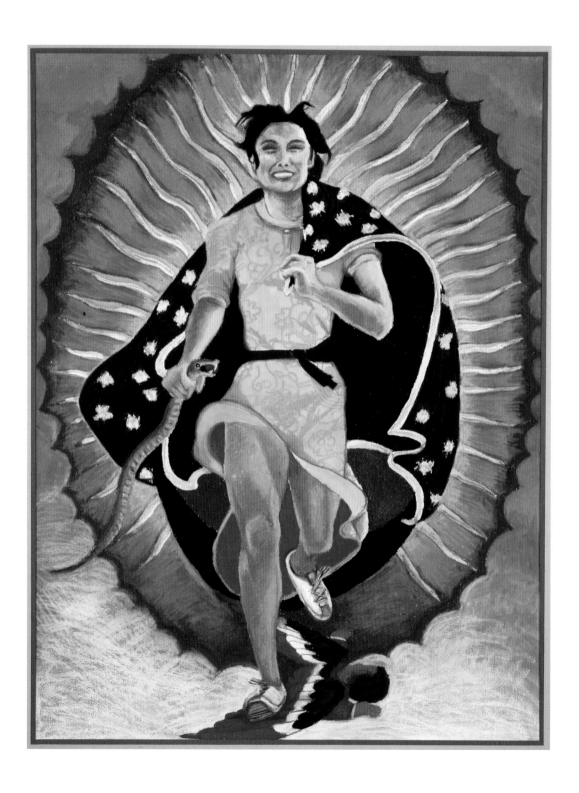

in the ability to take charge of one's life, especially one's sexuality, symbolically represented by the snake in the runner's right hand. The strength and power of the runner are conveyed by her muscular legs, by the length of her stride, and by her effortless suspension in midair as she leaps over the angel, although López's intentional shortening of perspective has been misunderstood by some critics.[36] By having the woman jump off the moon and over the angel, López implies that Chicanas are free of the anchors that hold them down and can step away from oppressive social codes that limit their expression.

López's second entry into the Chicana/o visual library, *Margaret F. Stewart: Our Lady of Guadalupe* (1978), offers a portrait of labor (fig. 51).[37] Unlike the feminist art of Judy Chicago, Miriam Schapiro, Faith Ringgold, and Consuelo Underwood Jimenez, who turned to handicrafts typically made by women, López's portrait depicts her mother *at* work. Margaret Stewart is seated behind an industrial sewing machine, and she is making her destiny, symbolically rendered by the gold-starred cloak that she sews for herself. Although the mother's body is rotund and her sexuality is not foregrounded—the snake is tightly coiled around the arm of the machine and stuck by pins—López honors her beauty by surrounding her with the brightest and most radiant mandorla of the triptych. López recalls that during her childhood, her mother was "beautiful and meticulously groomed."[38] The portrait is thus intended as a new proposal for beauty, one that does not depend on glamour and youth, whiteness and leisure, thin and curvaceous bodies. Stewart looks up from her glasses but does not directly engage the viewer, and like the angel looking out from under the cape, who appears bored and somehow extraneous, she has eyes that are unreadable. This is not a romantic vision of labor, however, and López documents the toll that hard work and long hours have taken on her mother's body. Margaret stoops over behind the industrial machine, knocking the wind out of any sentimental notion of women's work. Nevertheless, in rejecting the passive and demure Guadalupe, López illustrates a new feminine sensuality—the unadorned and nonglamorous body (fig. 52).

If the first two portraits, *Portrait of the Artist as the Virgin of Guadalupe* and *Margaret F. Stewart: Our Lady of Guadalupe*, illustrate the lived realities of Chicana womanhood, the third, *Guadalupe: Victoria F. Franco* (1978), addresses death (fig. 53).

Figure 50. Yolanda M. López, *Portrait of the Artist as the Virgin of Guadalupe*, from the Guadalupe series, 1978. Oil pastel on rag paper, 22 x 30 inches.

Figure 51. Yolanda M. López, *Margaret F. Stewart: Our Lady of Guadalupe*, from the Guadalupe series, 1978. Oil pastel on paper, 22 x 30 inches.

Figure 52. Yolanda M. López, *Margaret F. Stewart*, 1978. Black-and-white photograph. Taken at U.S. Naval Training Center, San Diego, California. Study for *Margaret F. Stewart: Our Lady of Guadalupe*.

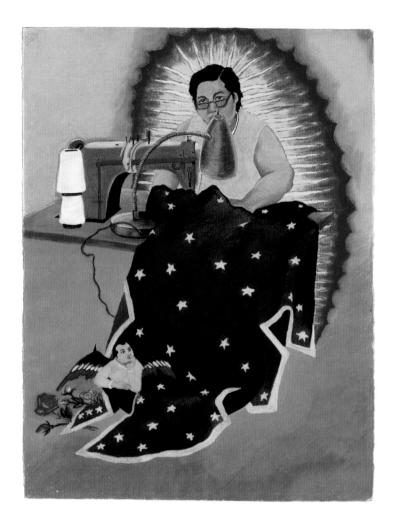

With her graying hair pulled back into a bun, Victoria is calmly seated on a stool covered by the star-studded cape, her feet delicately crossed and resting on an unfinished wood plank floor. In the background, the angel waits to crown her with an arch of roses. To upset any hint of sentimentality for *las abuelitas*, who already hold a place of honor in Mexican and Chicano communities, Victoria grasps the skin of the snake in one hand and a large knife in the other. For López, the snake was part of the Virgin's iconography, as the church in San Diego where she was baptized has a statue with the Virgin standing on a globe and trampling a snake.[39]

The artist's polyvalent semiotic approach is most clear in Victoria's portrait.[40] From the Western perspective, the snake is a symbol of temptation, deceit, and all that encourages free will and the fall from grace. Much of this association comes from the Biblical narrative in which Satan appears to Eve in serpentine form and encourages her to take from the tree of knowledge, an action that causes her and Adam to be expelled from Eden. Western societies associate the snake with fear, darkness, and evil. In Mesoamerican symbolism, the snake represents the cycle of life and death, or rebirth and renewal. Snakes are revered for their ability to shed their old skin, a process that leaves them with glossy new scales. Having skinned a diamondback rattlesnake, one of the most dangerous serpents, Victoria controls knowledge and has initiated her own rebirth. Both interpretations match López's observations of her grandmother in her final years. In her grandmother's portrait, she says, "the snake is flayed. It symbolizes the end of life. She's holding the knife herself, because she's no longer struggling with life and with sexuality. She has her own power. It's neither sad nor celebratory."[41]

López is adamant in her determination to avoid sentimental, nostalgic, or romantic images. Chicana/o art historians frequently interpret the use of indigenous symbols and references to a Mesoamerican heritage as a sign of resistance

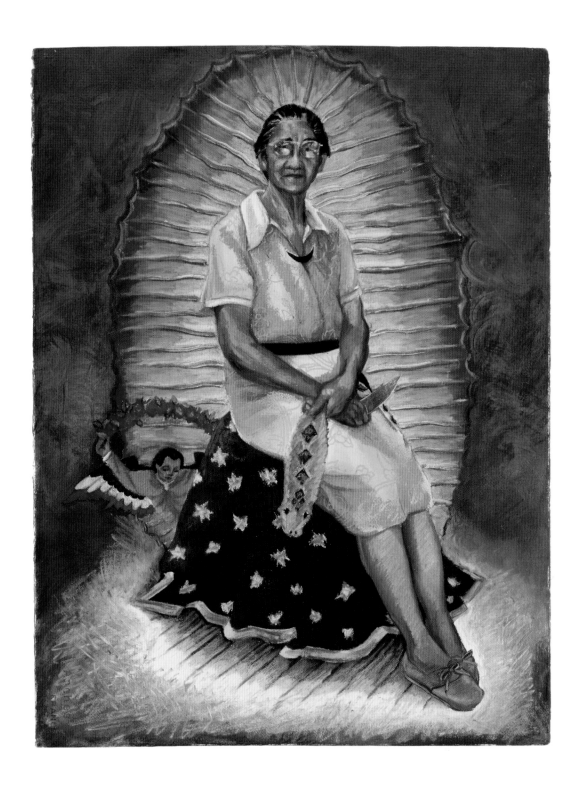

against the pressure to assimilate, and López's work has functioned to support this interpretation. However, while the Guadalupe triptych recalls pre-Columbian culture, it does not pretend, for example, that *la abuelita* is a spiritual connection to an undifferentiated ancient past or to utopian Mexican traditions.[42] Certainly López finds value in the Mesoamerican cultural symbol of renewal, but she is not presenting pre-Conquest civilization as an ideal site of cultural heritage.[43] Victoria Franco has power because of who she is, not as a romantically constructed *abuelita*. Rather than mythologizing the indigenous, it is more useful to explore a Chicana feminist paradigm to comprehend the multiple subjectivities present in López's work that refer to indigenous goddesses (Tonantzin, Coatlicue, Coyolxauhqui), Catholic figures (Guadalupe, the Virgin Mary), and hybrid forms.[44]

In López's hands, the hybrid takes the form of the palimpsest. The layers beneath the contemporary Chicana are still legible. By writing over the ancient female deities and the Catholic icon, she complicates and enriches the pictorial library rather than eliminating completely the other symbols and meanings. The top layer of the palimpsest offers potent new meanings, retaining only those qualities that support the authentic liberation of Chicanas.

Nuestra Madre (1981–88) is another powerful example of the palimpsest (fig. 54).[45] In this large painting López successfully joins indigenous female goddesses with Guadalupe, or in López's words, exposes the "thin veil of Christianity" that covers the Nahuatl deity, Tonantzin or Coatlicue. Similar to Chicana muralists, who were the first to employ indigenous figures and culture for "reasons that ventured beyond the nationalist paradigm of el movimiento," López articulates a pre-Columbian matrilineage that challenges the exclusionary masculinist language found in early Chicano art.[46] *Nuestra Madre*—and to some extent the Guadalupe series, the entire group of works that explore the image as a vehicle for popular culture and that López examined for a decade—is a rejection of racial purity through its invocation of mestizaje and a declaration of indigenous survival in the hybrid form. Painted over several years (1981–88) but exhibited in 1983 at Galería de la Raza in San Francisco while it was in progress, *Nuestra Madre* is a hybrid figure that López identifies as more relevant to her experience and spiritual grounding

Figure 53. Yolanda M. López, *Guadalupe: Victoria F. Franco*, from the Guadalupe series, 1978. Oil pastel on rag paper, 22 x 30 inches.

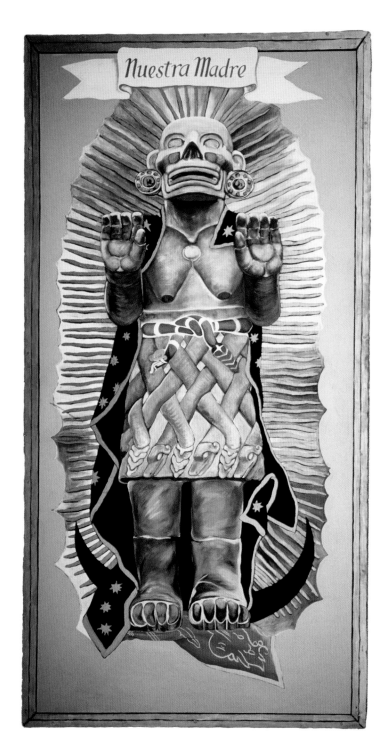

than Guadalupe. It excavates feminine spirituality and suggests a matriarchal divinity for Chicana heritage (fig. 55).

LATINA FEMINIST THEOLOGY OF TRANSFORMATION

Nuestra Madre expresses a transcendent quality. The painting references three female figures: Guadalupe, Tonantzin, and Coatlicue. Iconography from the Guadalupan portrait includes the cloak, remnants of the gown, the moon, and the mandorla. Tonantzin, or Earth Mother, was a general reference to the mother of the Nahuatl god, and López's title is a linguistic association to the ancient mother deity whose site of veneration was Tepeyac, the hill upon which Guadalupe appeared to Juan Diego and where her shrine was later built. Tonantzin is known for a capacity to create and extinguish life; she was a formidable deity that inspired fear and awe. More important for Chicana womanhood, her power is autonomous and is not defined by her relationship to men. Coatlicue, She of Serpent Skirt, is the Aztec creation goddess who gave birth to the moon and stars. Set within a Mesoamerican cosmology in which creators came in male and female pairs and in which deities contain opposing realities (in this case, life and death), she is a holistic being who enjoys and controls the balance in the cosmos. Both zoomorphic and anthropomorphic representations of Coatlicue emphasize her power to renew life because each symbolically references rebirth and regeneration.

In the enormous carving of volcanic rock from the postclassic period, her head consists of two fanged serpents and she wears a skirt of braided snakes and a necklace of human hands and hearts; the robust figure has stocky legs that end in talon feet. But López does not work from the zoomorphic image. The smaller stone carving of Coatlicue is López's pictorial reference for *Nuestra Madre*. It is an anthropomorphic image with a masked face, human hands, legs, and chest (fig. 56).

Wearing a braided skirt of snakes, stylized earrings, and a mask with turquoise inlays, the figure in *Nuestra Madre* depicts the feminine aspect of the pre-Conquest earth goddess Coatlicue. Her sagging breasts, limp from years of lactation, imply that she is an older woman, diverting from the heteronormative patriarchy that sees firm breasts as objects of desire and drooping breasts as ugly. The snake around her waist is a visual echo of the Virgin's sash and the stone carvings of Coatlicue that have a snake tied at the waist. The hybrid Mother of Chicana womanhood is fully sexually aware, as indicated by the mandorla, which represents her grace, and the serpentine skirt, which is a sign of her power and earthly knowledge. The extended arms and hands are a gesture of blessing, perhaps bestowing agency onto other women. The cape of Guadalupe drapes around her shoulders and flows around her body, while a fragment of the gown is at her feet. She stands erect on the crescent moon. A gray banner above her head announces her name in calligraphic script.

In part, *Nuestra Madre* visually narrates Anita Brenner's argument in *Idols behind Altars*, a book that López found inspiring and insightful. According to Brenner, the indigenous civilizations did not disappear with the Conquest but found ways to infuse their spiritual beliefs into Catholic practices and thus hide their "idols behind Catholic altars."[47] But the painting does more than recover Coatlicue or Tonantzin by lifting the veil of Christianity. The fusion of Guadalupe, Tonantzin, and Coatlicue accomplishes a symbolic reconstruction that Chicana feminists and Latina theologians name as authentic liberation. It is by pointing to the collapse of a mutually exclusive or oppositional relationship between the Virgin (the demure, the passive, the obedient) and all other females who are sexually aware, self-possessed, or empowered (the Earth Mother, Coatlicue, the Chicana activist) that López "provides a critical framework" for an effective reconstruction of Chicana womanhood.[48] It

Figure 54. Yolanda M. López, *Nuestra Madre*, from the Guadalupe series, 1981–88. Acrylic and oil paint on masonite, 4 x 6 feet.

Figure 55. Yolanda M. López painting *Nuestra Madre*, with a friend, 1981. Photograph taken at Galería de la Raza, San Francisco.

Figure 56. Yolanda M. López, *Coatlicue and Guadalupe*, 1978. Color Xerox collage, 6½ x 8½ inches. Study for the Guadalupe series.

is a fusion that "contributes to a fuller understanding of what humanization means" because it does not depend on the virgin/whore dichotomy.[49] Remembering the indigenous hermeneutics, which unlike Western thought does not separate the world into good/evil, male/female, or light/dark, López recombines them into a new subjectivity and identity.[50] This is truly López's most transformative proposal.

PARTICIPATING IN A LATINA SACRED ORBIT

López's Guadalupe triptych and series are vehicles for intense personal dialogue and reflection between the viewer and the icons that are referenced. If there is anything romantic about the work, it is a celebratory moment created by the Chicana viewer, particularly the art collector. Indeed, Laura Pérez and Chicana feminist art collectors whom I have interviewed and whom I discuss elsewhere identify a spiritual and theological connection to the Guadalupe series.[51] The work expresses their critical view of Catholic patriarchy but retains the cultural sensibilities they learned in the home as well as their desire to locate, identify, and appropriate female icons. Similar to the ways creative writers such as Gloria Anzaldúa, Lorna Dee Cervantes, Anna Nieto Gómez, Marta Cotera, and others publishing and working in the 1970s were constructing and excavating a Chicana subjectivity, López offers a visual representation of a new Chicana womanhood. More important, given the time period in which López created the Guadalupe triptych and series, she was among the first artists, scholars, and activists to proactively propose an identity. Lacking in her visual narrative is any critique of Anglo feminism and its inability to account for race and racism or Chicano patriarchy and its mythology that feminism is foreign to the Chicana heritage.[52] It is a proposal without apology—*sin vergüenza*.[53] López's contribution to Chicana feminism is twofold, in that she offers the new visual language for such Chicana subjectivity and does so proactively.

For example, in 2001, when Chicana and indigenous spiritual leaders, including artist Yreina Cervántez, scholar and practitioner Lara Medina, and Chumash poet Georgina Sanchez, provided the Los Angeles County Museum of Art with a cleansing and blessing ritual for *The Road to Aztlan: Art from*

a Mythic Homeland, the significance of *Nuestra Madre* was not lost on the group. Although the work was not singled out for a special blessing but was merely included as one of many objects with ritual significance or sacred intention, the group was aware of its power as an image and its participation in the reclaiming of indigenous spirituality and the feminine face of the divine.[54] Conservatives from Orange County had also made a pilgrimage to the museum, but in this case to protest what they perceived as the anti-Catholic nature of López's painting, with its mixture of Christian icons and non-Christian images. To Chicanas and indigenous leaders, however, it articulated perfectly their spirituality, a sacred object that functioned in the same way as the exhibition's pre-Conquest artifacts from central Mexico.

López is occasionally made aware of this appropriation of her work, an aspect she has come to recognize as part of the artistic process. For instance, when López was lecturing in another city, a woman approached to share her spiritual connection with *Portrait of the Artist as the Virgin of Guadalupe*. This Chicana carries a reproduction of the drawing in her wallet, and she takes it out during tense and difficult moments in order to focus her thoughts, rejuvenate her body, and inspire her spirit. It functions, therefore, like a prayer card. Other Chicanas include the image on their home altar as part of their avenue to the sacred.

Similarly, Chicana feminist art collectors are inspired by the Guadalupe series. Reproductions purchased at conferences and other academic venues to which López has been invited to speak have become part of a private yet collective expression of cultural identity. Chicana art collectors speak about their collections of these types of images with intense affection, acknowledging their role as guardian of cultural treasures that have yet to receive attention from public institutions. As religious scholar Lara Medina points out, "Chicanas [are] venturing into often undefined spiritual arenas," and López's work provides visual expression for such uncharted waters.[55]

The reconstruction of Guadalupe has become part of a larger feminist collective spiritual practice. It has become part of the sacred orbit of Guadalupan practices, and although it conflicts with López's intention, particularly her rejection of sentimentality and her confrontation with Catholic patriarchy, it is part of a growing expression of Chicana feminist spirituality. These uncharted expressions of faith, however, do not create a New

Age confluence of appropriated mysticism; they are grounded in the spiritual practices of the Americas, and as Yolanda Broyles Gonzalez posits, they emerge out of the histories of "faithful resistance to a systematic and widespread colonial and 'post'-colonial dehumanization."[56]

From this Latina spiritual and theological orientation, López's work is evidence of salvation and empowerment. In tune with liberation theology, which envisions spiritual salvation on earth, the representations of working-class Chicanas and contemporary indigenous and Mexican women are iconographic demonstrations of power, grace, and dignity. The sewing machine is the new symbol for the divine made real; the elderly woman confidently gazing at the viewer, her dark and wrinkled skin unadorned, is a contemporary source for our adoration; the sophisticated Mexican woman conveys grace through a gesture of assurance; the Mayan mother's breast is an offering from divine authority; and the active and physically healthy young runner indicates power and freedom.

The cosmic hierarchy is also reformulated in this assemblage of ordinary women who become part of the divine. López does not make herself and her family, and by extension all Chicanas, *into* Guadalupe; that is not her goal. Ordinary women are to be venerated, to occupy the same sacred temple as the Virgin. However, Guadalupe is not evicted; she is conjured up and made present again through the viewer's gaze. This underlying layer of the palimpsest is what makes all women sacred and divine, elevating the labor, culture, gender, sexuality, migration status, and the language of Chicanas. The sacred space and presence of Guadalupe and the mundane earthly experiences of Chicanas are merged, and the new place of this holy site is the body of Chicanas, old or young, sexually active or inactive, svelte or overweight.

COLLECTING AND
EXHIBITING MEXICANA

After graduation in 1978, López returned to the Bay Area with René Yáñez, and in 1980 she gave birth to their son, Rio. As a mother, she found that she had less time for painting and drawing. "When I had my son, my thinking time—what I call my daydreaming time—essentially vanished. Since I had been trained as a photographer, I found it much easier to deal with photos."[1] She sought media that were more immediate and inexpensive, primarily turning to photography, slide presentations, videos, and installation, which allowed her creative work to emerge on site rather than in the studio. Her choice of media also matched her conceptual training, and as Lucy Lippard notes, the inexpensive, ephemeral, and rapid materials were also favored by other feminist artists at the time.[2]

Working without a studio, López used her Minolta camera to record daily experience in the Mission District, culminating in a series entitled Life in the Mission (fig. 57). Her conceptual training and photographic style are further evident in the other work she produced during the 1980s and 1990s. That is, when López produced slide shows, a video, and installations, she employed the deconstructionist and semiotic approach that frames the work, acknowledges the author, and recognizes its context. In fact, aesthetics emerging from these theoretical approaches at UCSD privileged photography, video, and installation, and her emphasis on these media illustrates the significance of her grounding in conceptual art. Unfortunately, the series Life in the Mission, as well as the documentary photographs of the 1980s Day of the Dead processions and the opening receptions at Galería de la Raza, for which she frequently served as the photographer for hire, have rarely been exhibited.[3]

López was more successful in exhibiting her collection of Mexicana (pronounced mek-see-CAN-a), the objects and images from popular culture and mass media that she used to create various works. As she explained in an interview with Elizabeth Martínez, "I became very concerned, looking at these images of Mexicans, when I realized that a younger generation of Chicanos

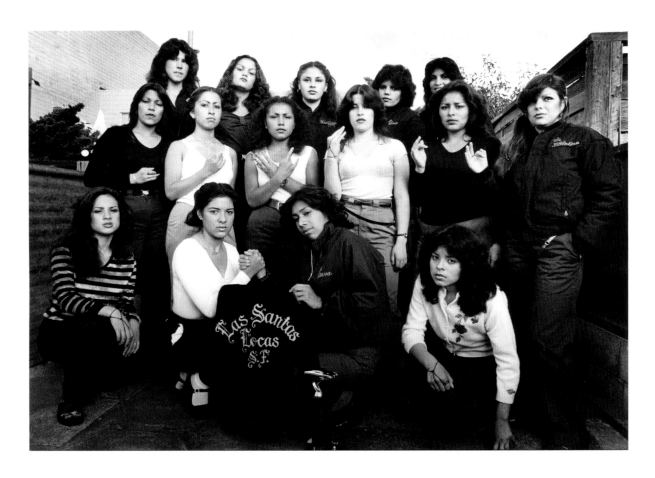

Figure 57. Yolanda M. López, *Las Santas Locas*, from Life in the Mission series, ca. 1983. Black-and-white photograph.

and Latinos had begun to create and use questionable representations as a kind of shorthand in community newspapers and public works."[4] The earliest items in her collection, such as the clocks, furniture, and kitchenware, reflect the efforts of U.S. diplomacy to create a Good Neighbor Policy in relation to Mexico. According to Ricardo Reyes, the symbol of the sleeping Mexican appeared in tourist folk art in the 1930s, painted on ceramic pots and plates in Tonalá and Tlaquepaque, and in the 1950s it appeared on embroidered textiles.[5] In the United States, from the mid-1920s through the late 1940s, the Mason Manufacturing Company of Los Angeles produced the first furniture line with cartoon-style illustrations of Mexican villages. Signed by "Juan," "Juan Intenoche," or "Tinoco" and attributed to a Mexican painter, the company's Monterey furniture line included mustached men with large sombreros, some taking a siesta. Carey McWilliams describes

these and other images of Mexicans as the fantasy heritage of the American Southwest, a mythical narrative that Spanish and/or Anglo settlers, not Mexicans and Indians, established civilization in the region. Certainly, the images, including the so-called Mexican motif, functioned to establish a racial hierarchy.[6] From these items in her extensive collection of Mexicana, López offered a critique of popular representations of Mexicans and Chicanos and implied an alternative historical perspective.

López's collection of Mexicana includes dishes, plates, and glasses with sleepy Mexicans taking siestas in doorways and under bridges, as well as dancing chili peppers, smiling señoritas, and anthropomorphic cacti. She also acquired magazines, novels, and newspaper articles that depicted Mexicans or Chicanos. During the 1980s and 1990s, the collection grew because of her role as a mother. She began to collect picture books, children's clothes, and toys. Although she began to accumulate Mexicana while in graduate school, the collection of this "toxic stuff" took on new dimensions when she shopped at secondhand clothing stores for Rio. In fact, López was surprised by the frequency with which the romantic image of Mexicans appeared on contemporary toddlers' clothes and playthings. Even characters from Sesame Street were enlisted to racialize Mexicans and confirm the superiority of European Americans (fig. 58). Her investigation also expanded to California textbooks.

In some ways, the collection was a vital focus of her artistic production in the 1980s and 1990s. The first project came in the form of a slide presentation, a popular medium in the Bay Area in the 1980s and one that other conceptual artists also explored. As López explains in interviews, the slide show was both performance and conceptual art.

> Originally, "When You Think of Mexico: Images of Mexicans in the Media" started out as a mock art history slide talk. My intention at the time was to satirize the hundreds of art history lectures I've heard which deal with art creations as formalistic objects, never talking about the social-political context in which they were produced or their impact as carriers of information.[7]

Using a lens critical of Greenbergian formalism, the slide show functioned as satirical performance and didactic lesson. Its form

Figure 58. Yolanda M. López, detail of *Things I Never Told My Son about Being a Mexican*, ca. 1985.

was similar to that of the docudrama videos produced by Rosler, although it also resonated with presentations by Bay Area artist-activists. According to Sekula, a number of "cultural workers in the Oakland area were using slide shows didactically and as catalysts for political participation."[8] Bruce Kaiper presented slide shows critical of *Fortune* magazine advertisements, Ellen Kaiper interrogated the domestication of women workers after World War II, and Fern Tiger addressed class conflict in Oakland.[9] Like these slide-show artists, López designed her presentation for specific audiences and immediate outcomes. For López, the slide show was "extremely accessible" because she could demonstrate a "sequencing of images" from mass media sources that would build her argument through repetition and continuity.[10] In the video *When You Think of Mexico*, she also used a continuous loop to exaggerate and parody the images and the image makers (fig. 59). As Lippard notes in her analysis of the video,

> The images range from Frito Banditos (which imply that Mexicans—and revolutionaries in general—are, among other things, out to rob "us"), to the "picturesque and nonthreatening" lazy Mexican asleep under an oversized sombrero and cactus, to religious symbols borrowed to sell food ("one bite and you'll be speaking Spanish"), to skewed versions of Mexican masculinity (a rooster) and femininity ("the hot little Latin").[11]

López's sense of humor is evident when she examines a cornflakes box with images of a Chicana. Although the narrator admits that Chicanas wear their hair parted in the middle, hoop earrings, and peasant blouses, she sarcastically asks, "But all at once?" as if to imply that the image is a farce. Near the close of the video, the narrator focuses on the 1956 movie *Giant*, which was intended to celebrate interracial marriage and a future free of racial tension, but the movie's sequencing of the two grandchildren—one white and one brown—with a shot of a white lamb and a black kid (goat) is problematic for López. The narrator comments, "We are still seen as different species."[12]

Both the video and the slide show allowed her to expand the visual vocabulary of Chicano and Latino audiences, encouraging a discussion about representation and the subtle influence of images—sleeping Mexicans, Spanish señoritas, shifty bandits, and illegal immigrants.[13] They were also a challenge to action.

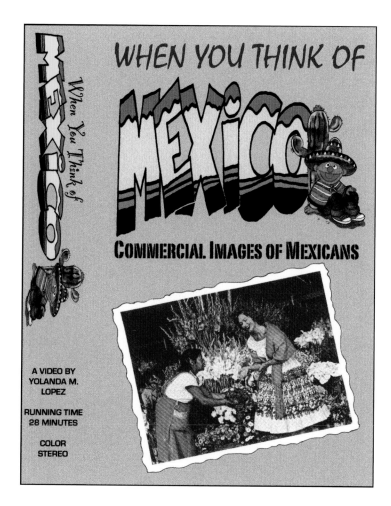

Figure 59. Cover and spine of the video case for
When You Think of Mexico, 1997.

WHEN YOU THINK OF MEXICO

COMMERCIAL IMAGES OF MEXICANS

A VIDEO BY
YOLANDA M.
LOPEZ

RUNNING TIME
28 MINUTES

COLOR
STEREO

Her work was part of the campaign against Frito Bandito,
"the gun-toting, wildly mustachioed, rotund little guy under a
gigantic sombrero" who was created to promote Frito-Lay corn
chips.[14] Refusing a "docile and isolated spectator," the video
seeks to empower viewers.[15] At the end of the video, the narrator
encourages the viewer to speak out: "Talk back to your TV set.
Let the local channel and the national network know how you
feel about what you see."[16] The video ends with a list of addresses
for television and broadcast corporations.

The Mexicana collection was also the foundation for several
installations and projects, including *Things I Never Told My Son
about Being a Mexican*, a wall-mounted, multisite installation of

a range of objects and media stories that portray Mexicans. The installation was a chaotic arrangement of toys, food packaging, books, and newspaper headlines, attached to a yellow canvas or directly to the gallery wall. Frequently a red zigzag line filled the top register of the installation, a cactus tree appeared at the bottom right corner, and barbed wire ran the length of the image in the bottom register. These painted elements are design motifs used to signify "Mexican" culture or a physical boundary. While each installation was slightly different, the objects all came from her personal collection of Mexicana (fig. 60).

The objects were intentionally selected for their mundane or everyday quality so that López could support her argument about the ubiquitous nature of stereotypical images. From the late 1980s through the late 1990s, *When You Think of Mexico* circulated as part of the multiroom installation *Cactus Hearts/ Barbed Wire Dreams*, also composed from the Mexicana collection, which was exhibited at major Chicano arts organizations in California from Sacramento to San Jose. *Things I Never Told My Son* was frequently one room of this multipart installation. While her analysis of the "corrupted artifact passing itself as Mexican culture" is made explicit through the voice-over track in *When You*

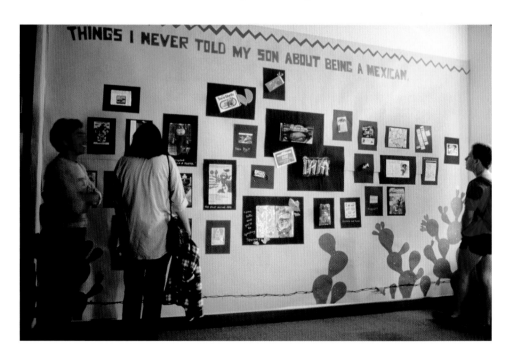

Think of Mexico, the multipart installation *Cactus Hearts/Barbed Wire Dreams* employed profusion, abundance, and repetition of images to encourage viewers to rethink encoded assumptions about idyllic, passive, happy-go-lucky, or lazy Mexicans.[17] In this signature solo exhibition of the 1980s and 1990s, which traveled to multiple venues, López recycles "this false Mexican culture which can be called Mexicana, [and documents how it] lives in the everyday items of our lives."[18]

In her appropriation of the false Mexican culture, López also participates in an aspect of what cultural critic José E. Muñoz describes as disidentification. The rejection of the identity coded by a racist master narrative is part of what López accomplishes in the installation because she also "recircuits" the message to "account for, include, and empower minority identities and identifications." Although Muñoz crafts this concept in his analysis of queer performance artists, the process that López, as a woman of color living in a racist and sexist society, similarly engages is to "crack open the code of the majority," in this case the language of stereotypes. She "proceeds to use this code as raw material for representing a disempowered politics of positionality that has been rendered unthinkable by the dominant culture."[19]

One installation of *Cactus Hearts/Barbed Wire Dreams* in particular conveyed the process of thinking the unthinkable. In 2002 at the University of Dayton, Ohio, López worked with students of art historian Judith Huacuja Pearson to install a two-part site-specific construction of *Cactus Hearts*. According to Huacuja Pearson, the first installation was *Things I Never Told My Son about Being a Mexican*, for which

> students collected and then López put on display those many advertisements, food wrappers, toys, souvenirs and articles of clothing that reproduce notions of Mexicans as lazy, servile, alien or meek. Across a barren southwestern landscape painted on a 40' x 12' canvas tarp, López hung a compilation of common products that reproduce stereotypes of Mexican women as maids and Mexican men as sleepy siesta takers or as other world aliens. All the products have been manufactured in America, packaged as "authentically Mexican," and targeted towards a largely Anglo constituency.

A simple reading of the content of the installation suggests that López documented the racial hierarchy created through media,

Figure 60. Yolanda M. López, *Things I Never Told My Son about Being a Mexican*, 1985. Mixed-media installation, Santa Cruz Veterans Hall.

advertising, fashion, and design. However, as Huacuja Pearson argues, the force of the installation is its dialogic potential.

> Discussions with students explored how cultural stereotypes present notions of the sub-altern (Mexicans, domestic workers, and women in this case) as less educated, disempowered, and socially inferior. Students analyzed how such notions help build a sense of superior identity and empowerment within the mainstream (Anglo-Americans, professional, and men).[20]

As a conceptual work of art, the installation signals a new subjectivity and history, one that is actualized in the students' discussion as they grapple with the meaning embedded in stereotypical images of Mexicans. This new subject position is not completely formed or found in its totality, but López offers a reinscription of Chicana/o self through displacement, misrecognition, and rejection of the raced and gendered code.[21]

Unlike the Guadalupe series in which a proactive Chicana subjectivity is the previously unthinkable Chicana positionality, the installations of *Cactus Hearts/Barbed Wire Dreams* present the caricature, the stereotype, or the dominant culture's fables of Mexican culture as the site from which a new potential emerges. It is the conceptual imaginary made real or the dialogue between the objects and the viewer that brings this new Chicana and Chicano subjectivity to life. This alternative positionality exists in the intertextual space as the viewer is encouraged to witness the objects and representations as absurdities.

The overabundance of sleeping Mexicans, smiling señoritas, and other images magnifies the encoded meaning that López cracks open by strange placement, juxtaposition, and repetition. For instance, the installation at Galería de la Raza included a life-size diorama of a Mission District kitchen filled with Mexicana knickknacks (salt and pepper shakers, stemware, ashtrays, etc.) and the television played *When You Think of Mexico* (fig. 61). The blatant intrusion of the false Mexican into everyday settings compels the spectator to consider the internal penetration of the code of the majority and then disidentify with the images. The candles and salt and pepper shakers shaped like sleeping Mexicans placed in a diorama of a border road also produce a politics of rejection, as the toy trucks filled with the salt and pepper shakers become absurd, a parody of the parody. This

same technique in which a gesture or image is made absurd through repetition is also found in the video.

In the installation, repetition is the means by which López reinforces the original message and encourages a disidentification with the image and the code of the majority. The recycling and reuse underscores the ridiculous nature of the image. Thus, López is able to illustrate how the subtle misrepresentations of Mexicans and Chicanos or the dancing and smiling fruits and vegetables associated with Mexico contribute to "a total visual and cultural environment [of oppression] in which we all operate."[22] These "palatable" images of Mexicans allow the public to "consume" the culture of the despised. At the same time, Mexicana, particularly the subtle images, is contingent upon the "fearmongering campaigns in the media about the overflow of immigrants and their impact on employment, welfare services and the overall quality of life."[23] However, when reshuffled in *Cactus Hearts/Barbed Wire Dreams*, the silliness of Frito Bandito or Speedy Gonzalez is divested of its power to mock Mexicans. Instead it serves as the springboard for an empowered collective identity generated by negation: "That is not me," or "That is not our Mexican culture." As in López's MFA exhibition with its intentional audience, Latinos are the ideal spectators of *Cactus Hearts/Barbed Wire Dreams* and *Things I Never Told My Son about Being a Mexican*. By addressing those who are marginalized as nonwhite and nonnative, López turns away

from the master narrative or Western subject. The referent in these installations is not the one imagined in the public space of the nation, and her conceptual maneuver aligns her work with the art of Asco, James Luna, Fred Wilson, and Betye Saar. They are artists who work to destroy racist representations by taking up the very material and popular culture of racism: from advertising to the utensils of slavery, from institutions of exclusion to the names for commercial products or crayons.[24]

Playing out anxieties about national cohesion and foreign policy in Latin America, the pastel drawing *A Visual Poem for Nicaragua (Homage to Max Beckmann)* also enacts Latino disidentification (fig. 62). In this work, dedicated to the German painter who was a target of the Nazi attack on modern art, López depicts her six-month-old son, Rio, asleep and nude to represent all that is vulnerable and tender. His small body floats in the foreground of the drawing. Behind him, rendered on a different plane, is "a tropical landscape with spiky palm trees and done in strange colors." Through the dark and unnatural coloration and the perspective and scale, López represents a Latin American setting that simultaneously is in danger and poses a threat to its inhabitants.[25] Furthermore, the composition alludes to U.S. imperialist desires in the 1980s to launch an attack on the imaginary dangers of Central America. But López does not wish to promote such an image of Latin America; rather, she parodies the fear that U.S. foreign policy projects onto Central American sovereignty and autonomy.

Her relationship to her son and to motherhood in the United States was also the focus of another installation at Centro Cultural de la Raza in 1988. For the exhibition *On the Spot*, López created Rio's bedroom, a lifelike diorama of the child's playthings and drawings overtaken by images of horror and destruction. The only innocent portrait of him is mounted on a wall of military camouflage. Most of the installation includes toy tanks, grotesque alphabet cards depicting assassinations and terrorist activities, and drawings by Rio enlarged and enhanced by López. For example, in one drawing, a fire-spitting monster and missiles promise to consume the earth, sea, and sky. The violent images are both monumental and overwhelming because of their multiplicity in the space. While some of "the encyclopedia of terror" might come from Rio's imagination, the culture of hypermasculinity that promotes death and

destruction in the guise of military patri-
otism is also a source of the images.[26]
As a mother, López points to the ways
in which toys, cartoons, and Hollywood
movies promote fear and hostility,
and while she rejects the messages of
violence and destruction, her sunny
mural suggests that the utopian dream
world in which alternative masculine
identities are formed is a fantasy. This
reference to the lack of harmony and
inequity leaves the future unresolved, as
we might expect in López's work since
she refuses romantic narratives. The
mother's disapproval and concern are
palpable, but the monsters and military
guns electrify the space, and the persis-
tence of the hypermasculine subjectivity
makes it difficult to avoid. Perhaps she
engages what Sekula identifies as "polit-
ical irony," a strategy that "walks a thin
line between resistance and surrender."
Given the scale and design of the instal-
lation, it is unclear whether the mother
has surrendered to her son's embrace
of militarism and traditional mascu-
linity. As in Patssi Valdez's paintings of
chairs and brooms dancing around the
room, one is never sure whether the
child is safe from harm, or whether the
mother's rejection of war and sexism
is accomplished.

Yolanda López

By repeatedly exposing the false Mexican culture embodied
in her collection of Mexicana, López forces the question "How
then shall Mexicans and Chicanos be represented and how shall
we represent ourselves?" In the space of the answer is a concep-
tual formation of subjectivity, and this is how she locates and
proposes the alternative positionality. This is achieved not only
through the abundance and absurdity of the Mexicana but also
in the intertextual moment when viewers reject the Mexicana and
imagine a new identity for Mexicans, Chicanas, and Chicanos.

"YOLANDA'S GOT A BRAND NEW BAG"

When friends, artists, and strangers donated money to Yolanda M. López to cover medical expenses related to her aneurysm, she was shocked. She had no idea that so many people cared about her. Admitting that this was the first time she understood her value in the Chicana/o community, López determined to make herself healthy. Her surprise did not stem from false modesty. Since she sold few original works and made little money from the reproductions and multiples, López had no market evidence by which to assess her artistic value. Criticism of her art had not been abundant, moreover, and in the realm of art history few scholarly works had assessed it; those that did came nearly a decade after the creation of the Guadalupe triptych that eventually established her iconic status in the Chicano community. And while the triptych is one of the most popular images in Chicano art history and criticism, several interpretations did not match or even acknowledge López's intention.

At the same time, López was aware of the threats and vandalism that had accompanied the exhibition of her work. These included a bomb threat to the publisher of *Fem* for reproducing *Walking Guadalupe* on the cover of the magazine in June 1984; it was reported that the magazine was stolen en masse from newspaper stands throughout Mexico City. Closer to home she heard complaints from local residents about her use of Mexicana in the installation *Cactus Hearts/Barbed Wire Dreams*. The criticism prompted Galería de la Raza to post a sign explaining the artist's intention to expose racist popular culture. Someone threw a rock through the large glass window at Galería de la Raza when she exhibited *Nuestra Madre*. Clearly she had struck a chord. And so, the oscillating winds of art criticism and popular opinion did not help López comprehend her place or value in the Chicano community and the art world. This became apparent only when the proceeds from benefit performances poured in to support her medical and living expenses during her illness. Even so, as this book has demonstrated, the period of artistic production between 1968

and 1998 has been important in that it speaks of the future and offers us new subjectivities.

López's work at the turn of the millennium explores her past relationship to tourist art. *Mexican Bag* (2003) is a painting from her latest series, which is based on the motifs found on leather handbags made for tourists in the 1950s and 1960s (fig. 63). The title riffs off James Brown's hit song "Papa's Got a Brand New Bag," but in this case the artist announces her latest artistic venture rather than her new lover. The painting is a richly saturated image of three white flowers—each rendered in wide brushstrokes that highlight the blossoms with red, pink, and yellow—and swirling green and yellow leaves. The background is a flat, deep brick red. Conceptually, she is exploring the question "What is beauty?" Much like her figurative works that are misclassified as folkloric, this acrylic painting of flowers can be misplaced as a bright and colorful composition of cartoonish flora. And López deliberately forces such a context for the work because it will only further support her investigation of beauty: What is its source, what defines it, and who determines its limits?

Thus the title works on three fronts. First, it pays homage to Brown, whose death occurred during the painting's creation. Second, it references López's new interest in creating conceptual art that considers aesthetic beauty, and third, it traces her ambivalent relationship to tourist art. López critiques fundamental aspects of tourist art, with its cheap construction, blatant consumerist impulse, and circulation of images that promote white racial supremacy. On the other hand, tourist art was her first introduction to Mexican culture, and she finds it pleasurable because of her childhood association with the objects themselves. The recuperation of tourist art echoes the debate in art history over kitsch and rasquachismo, the Chicano sensibility of making do with what is at hand. López plays with the debate by composing the flower motif, not the purse itself. The form is absent from the painting, but the referent to tourist art is conveyed by the rich hues that have come to be known as "Mexican colors"—deeply saturated reds, yellows, pinks, and greens. These are the same types of flowers that appear on ceramic pottery and textiles and thus the flowers are ubiquitous within tourist art, or at least familiar. In López's painting the attention to brushstroke, detail, and the framed composition moves the piece away from the consumable tourist arts that are

Figure 63. Yolanda M. López, *Mexican Bag*, 2003. Acrylic on canvas, 36 x 36 inches.

rapidly produced using as few brushstrokes and colors as possible. Instead of the hurried composition that is often messy, dirty, or simple, her painting is deliberately and carefully composed.

It is as if the artist is playing with notions of authenticity in a realm (tourism) that has pushed the authentic aside for profit, reproduction, and ease. Tourist art is a parody of reality. During López's youth her conception of tourist art changed, moving from an authentic to a fake representation of Mexican culture. It was an imitation at those moments when U.S. myths about Mexicans and Mexicanness overwhelmed López, and it was transformed into toxic stuff that repulsed her when she understood that her family's history and experience had been erased from the national narrative.

In *Mexican Bag* López interrogates notions of belonging and authenticity: What does it mean to be Mexican? Who gets to decide what is Mexican and what is not? Just as López pushes back the boundaries that patriarchy and the Catholic Church place on women, she is also pushing against power and society by asking who has the power to determine a culture, a heritage, or a history and whether or not it is included in a nation's patrimony, museums, or master narrative. Yolanda M. López asks the viewer to consider who we are and what forces shape our identity, community, and criteria for belonging, and then she asks us: Are we sure we can live with it?

NOTES

INTRODUCTION

1. Ester Hernández created the first reconstruction of the Virgin of Guadalupe in 1976. Patssi Valdez's 1972 performance with Asco on Whittier Boulevard in Los Angeles was also a reformulation of the Madonna image.

2. Yolanda M. López, interview by author, March 22–23, 2007. The author's two-day interview with López was conducted in Los Angeles, and the transcript is housed at the UCLA Chicano Studies Research Center Library and Archive.

3. Charlene Villaseñor Black, "Sacred Cults, Subversive Icons: Chicanas and the Pictorial Language of Catholicism," in *Speaking Chicana: Voice, Power, and Identity*, ed. Letticia Galindo and María Dolores Gonzales (Tucson: University of Arizona Press, 1999), 134.

4. See, for example, Rosa Linda Fregoso, "The Mother Motif in *La Bamba* and *Boulevard Nights*," in *Building with Our Hands: New Directions in Chicana Studies*, ed. Adela de la Torre and Beatríz M. Pesquera (Berkeley: University of California Press, 1993), 130–45.

5. Alicia Gaspar de Alba, *Chicano Art Inside/Outside the Master's House: Cultural Politics and the CARA Exhibition* (Austin: University of Texas Press, 1998), 129. For the quotation see Richard Griswold del Castillo, Teresa McKenna, and Yvonne Yarbro-Bejarano, eds., *Chicano Art: Resistance and Affirmation, 1965–1985* (Los Angeles: Wight Art Gallery, University of California, 1991), 256.

6. See Gloria Feman Orenstein, "Recovering Her Story: Feminist Artists Reclaim the Great Goddess," in *The Power of Feminist Art: The American Movement of the 1970s, History and Impact*, ed. Norma Broude and Mary D. Garrard (New York: Harry N. Abrams, 1994), 174–89, and Elinor W. Gadon, *The Once and Future Goddess: A Symbol for Our Time* (San Francisco: Harper and Row, 1989).

7. Yolanda López and Moira Roth, "Social Protest: Racism and Sexism," in Broude and Garrard, *Power of Feminist Art*, 140–57. See also Malaquías Montoya and Leslie Salkowitz Montoya, "A Critical Perspective on the State of Chicano Art," *Metamórfosis* 3, no. 1 (1980): 3–7.

8. For information about Moira Roth's career, see Moira Roth and Suzanne Lacy, "Exchanges," in *Art/Women/California: Parallels and Intersections, 1950–2000*, ed. Diana Burgess Fuller and Daniela Salvioni (Berkeley: University of California Press in association with the San Jose Museum of Art, 2002), 295–309.

9. López and Roth, "Social Protest," 146.

10. Chela Sandoval, "Mestizaje as Method: Feminists-of-Color Challenge the Canon," in *Living Chicana Theory*, ed. Carla Trujillo (Berkeley, CA: Third Woman Press, 1998), 359.

11. In *Civilizing Rituals: Inside Public Art Museums* (London: Routledge, 1995), Carol Duncan demonstrates that the modern art museum is a space that ritualizes the "relentless and irreversible" progress "toward greater abstraction" (108).

12. Duncan, *Civilizing Rituals*, 110, 112. Similarly, David Hopkins offers an analysis of masculinity in his discussion of the New York abstract expressionists and avant-garde artists. He argues that the styles of Marcel Duchamp, Robert Rauschenberg, and Willem de Kooning, as well as Clement Greenberg's art criticism of their work, articulate an "overbearing masculinism" that represented American anxieties during the Cold War and the sexual mores of the time. Hopkins, *After Modern Art, 1945–2000* (New York: Oxford University Press), 37–47, 50.

13. López, interview by author.

FROM *LA FRONTERA*

1. Rosario Enríquez, "The Rise and Collapse of Stabilising Development," in *The Mexican Economy*, ed. George Philip (New York: Routledge, 1988), 8.

2. Robert McCaa, "Missing Millions: The Demographic Costs of the Mexican Revolution," *Mexican Studies/Estudios Mexicanos* 19, no. 2 (Summer 2003): 279–380.

3. Ibid., 368.

4. López, interview by author.

5. According to Robert C. Smith, the first phase of Mexican migration to New York began in the mid-1940s, and migrants came mainly from the Mixteca region of southern Mexico. López's grandparents were somewhat unusual because they arrived before the first major wave of Mexican migration, they originated in Mexico City, and they entered the United States as a married couple. Smith, *Mexican New York: Transnational Lives of New Immigrants* (Berkeley: University of California Press, 2006), 20.

6. López, interview by author. Throughout the interview, López anglicized the names of her mother and uncles. Their birth names are Margarita, Enrique, Guillermo, Roberto, and Miguel, respectively.

7. Yolanda M. López, artist's statement, in *Encuentro: Invasion of the Americas and the Making of the Mestizo*, exhibition catalog (Venice, CA: Social and Public Art Resource Center, 1991), 23.

8. Mary Kusmiss, "Yolanda M. López," in *Connecting Conversations: Interviews with 28 Bay Area Women Artists*, ed. Moira Roth (Oakland, CA: Eucalyptus Press, 1988), 120.

9. López, interview by author.

10. Kusmiss, "Yolanda M. López," 120.

11. The Franco property was near the intersection of National Avenue and 20th Street. A 1937 description of San Diego noted, "The Mexican colony lies between Sixteenth and Twenty-fifth Streets, along Logan and National Avenues." Federal Writers Project, *San Diego: A California City* (San Diego, 1937), 16, quoted in LeRoy E. Harris, "The Other Side of the Freeway: A Study of Settlement Patterns of Negroes and Mexican Americans in San Diego, California" (PhD diss., Carnegie Mellon University, 1974), 114.

12. Most of her knowledge of Mortimer comes from her birth certificate. Originally from Williams, Arizona, Mortimer Felix Fernandez López was thirty-four years old when Yolanda was born. A sheet-metal worker for Consolidated Aircraft Corporation, he left Margaret before the birth of their third child, Sylvia. López's grandmother filled in additional information, describing him as a Yaqui Indian from Arizona, which may have been a challenge to his claim that he was a descendant of Spanish royalty. See Yolanda Lopez Papers, California Ethnic and Multicultural Archives, Donald D. Davidson Library, University of California, Santa Barbara, series I, box 1, folders 5 and 6.

13. Christine Killory, "Temporary Suburbs," *Journal of San Diego History* 39, no. 1–2 (1993): 1.

14. Carlos M. Larralde and Richard Griswold del Castillo, "Luisa Moreno and the Beginnings of the Mexican American Civil Rights Movement in San Diego," *Journal of San Diego History* 43, no. 3 (Summer 1997), http://www.sandiegohistory.org/journal/97summer/moreno.htm.

15. Killory, "Temporary Suburbs," 3.

16. Ibid., 6.

17. Harris, "Other Side of the Freeway," 116.

18. Raúl Homero Villa, *Barrio-Logos: Space and Place in Urban Chicano Literature and Culture* (Austin: University of Texas Press, 2000), 172. Kevin Delgado, "A Turning Point: The Conception and Realization of Chicano Park," *Journal of San Diego History* 44, no. 1 (Winter 1998), http://www.sandiegohistory.org/journal/98winter/chicano.htm.

19. Delgado, "Turning Point."

20. López, interview by author.

21. For more on segregation in San Diego see Killory, "Temporary Suburbs."

22. López, interview by author.

23. Ibid.

24. Ibid.

25. Yolanda M. López, artist's statement, in *Poetic Paradox: Ten Years of Innovation in Latino Art*, exhibition catalog (San Jose, CA: Movimiento de Arte y Cultura Latino Americana, 2001), 34.

26. López, interview by author.

27. Tomás Ybarra-Frausto, "Rasquachismo: A Chicano Sensibility," in Griswold del Castillo, McKenna, and Yarbro-Bejarano, *Chicano Art*, 155–62; Shifra M. Goldman, "Assembling the Capirotada," in *Chicano Aesthetics: Rasquachismo*, exhibition catalog (Phoenix: MARS Artspace, 1989).

28. Villa, *Barrio-Logos*, 165.

29. Killory, "Temporary Suburbs," 10.

30. López, artist's statement in *Poetic Paradox* exhibition catalog, 34.

31. López, interview by author.

32. Ibid.

33. See, for example, Yolanda M. López, "Artist Provocateur: An Interview with Yolanda López," by Elizabeth Martínez, in *Cinco de Mayo: Homenaje a la Mujer Latina*, ed. Kathleen Baca (San Francisco: MECA, 1994),

37–38, originally published in *Crossroads*, May 1993; and Yvonne Yarbro-Bejarano, "Turning It Around," *Crossroads*, May 1993, 15. Also see Leah Ollman, "Centro Cultural's 'On the Spot' Applies to Both Viewers, Artists," review of *On the Spot* by Felipe Ehrenberg, Gronk, Yolanda López, and Esther Parada, Centro Cultural de la Raza, San Diego, *Los Angeles Times*, April 8, 1988, San Diego County edition, B6.

34. López, interview by author.

35. Ibid.

36. Ibid.

37. López, artist's statement in *Poetic Paradox* exhibition catalog, 34.

38. López, interview by author.

39. See also Osa Hidalgo de la Riva, ed., "Chicana Spectators and Mediamakers: Imagining Transcultural Diversity," special issue, *Spectator: University of Southern California Journal of Film and Television Criticism* 26, no. 1 (Spring 2006): 68.

40. One of these portraits, *My Grandmother*, a collage 16 x 18 inches, was included in the major Los Angeles exhibition *Chicanarte* held in 1975 at the Los Angeles Municipal Art Gallery.

41. López, interview by author.

42. When Yolanda was thirty-five, her mother again supported her creativity by giving López her "first drill and a beautiful set of bits." López, artist's statement in *Poetic Paradox* exhibition catalog, 34.

43. Ibid.

44. Yolanda López, telephone interview by Ruben Cordova, April 21, 2002.

45. López, interview by author.

46. Ibid.

47. Ibid.

48. Victoria and Senobio identified as Mexicans, Margaret was ambivalently Mexican American, and some of the uncles embraced Mexico while others did not. López, interview by author.

49. Susan Forrester, *3 Stories: Flo Wong, Jean LaMarr, Yolanda López* (Chico, CA: University Art Gallery, California State University, 1994), 5.

50. López, "Artist Provocateur," 11.

51. This statement accompanies the image *Who's the Illegal Alien, Pilgrim?* in the *Encuentro* show at SPARC in 1991. See López, artist's statement in *Encuentro* exhibition catalog, 23.

52. López, interview by author.

53. Yoon K. Pak, "'If There Is a Better Intercultural Plan in Any School System in America, I Do Not Know Where It Is': The San Diego City Schools' Intercultural Education Program, 1946–1949," *Urban Education* 37, no. 5 (November 2002): 597.

54. Ibid., 597.

55. Ibid., 602.

56. López, interview by author.

57. López, artist's statement in *Encuentro* exhibition catalog, 23.

IN THE TRENCHES

1. Cary Cordova, "The Heart of the Mission: Latino Art and Identity in San Francisco (California)" (PhD diss., University of Texas, Austin, 2005), 220.

2. Lisa Lowe, *Immigrant Acts: On Asian American Cultural Politics* (Chapel Hill, NC: Duke University Press, 1996), 23.

3. Tomás Ybarra-Frausto, "The Chicano Movement/ The Movement of Chicano Art," in *Exhibiting Cultures: The Politics and Poetics of Museum Display*, ed. Ivan Karp and Steven Lavine (Washington, DC: Smithsonian Institution Press, 1991), 129.

4. López and Roth, "Social Protest," 146. For this article, López interviewed Betty Kano and Jean LaMarr about their activism in California. Reflecting on the strategy of being an "artist for the people" or a "facilitator" of the revolution, López and Roth noted that in the 1970s it produced relative anonymity for women artists such as Linda Lucero at La Raza Silkscreen (later renamed La Raza Graphics); Gail Arantani, Nancy Hom, Stephanie Lowe, and Wendy Yoshimura in the Kearny Street Workshop and Japantown Art and Media Workshop; and Rachel Romero, who co-founded with Leon Klayman the San Francisco Poster Brigade, previously known as the Wilfred Owen Brigade (see p. 293 n. 22).

5. Betty LaDuke, "Yolanda López: Breaking Chicana Stereotypes," in *Women Artists: Multi-Cultural Visions* (Trenton, NJ: Red Sea Press, 1992), 104; López, interview by author.

6. Ybarra-Frausto, "Chicano Movement," 140. Intentionally quoting Ybarra-Frausto out of context,

I want to demonstrate that López's work does not match Chicano art historiography. For example, Shifra M. Goldman describes Chicana art as "personal." See Goldman, "'Portraying Ourselves': Contemporary Chicana Artists," in *Feminist Art Criticism*, ed. Arlene Raven, Cassandra L. Langer, and Joanna Frueh (Ann Arbor, MI: UMI Research Press, 1988), 193–95. Goldman and Ybarra-Frausto distinguish between two phases of Chicano art, 1968–75 and 1975–81; the latter period typically is described as less political or confrontational than the former. This periodization cannot account for López's poster *Who's the Illegal Alien, Pilgrim?*, produced in 1978. See Goldman and Ybarra-Frausto, introduction to *Arte Chicano: A Comprehensive Annotated Bibliography of Chicano Art, 1965–1981*, ed. Shifra M. Goldman and Tomás Ybarra-Frausto (Berkeley: Chicano Studies Library Publication Unit, University of California, 1985). Also see Tere Romo, "Points of Convergence: The Iconography of the Chicano Poster/*Puntos de convergencia: La iconografía del cartel chicano*," in *Just Another Poster? Chicano Graphic Arts in California/¿Sólo un cartel más? Artes gráficas chicanas en California*, ed. Chon Noriega (Santa Barbara: University Art Museum, University of California, 2001), 91–115.

7. Betty LaDuke, "Yolanda López: Breaking Chicana Stereotypes," *Feminist Studies* 20, no. 1 (Spring 1994): 119.

8. Cary Cordova briefly notes that Los Siete "played a significant role in the evolution of poster art in the Mission District." In 1970, La Raza Information Center opened next door to Los Siete and started producing silkscreen prints in the back office. Volunteers worked in both organizations and the center eventually developed into La Raza Graphics ("Heart of the Mission," 224–25). Preliminary investigation suggests that Casa Hispana preferred abstract expressionism and figurative styles, which distanced it from La Raza Graphics and Galería de la Raza. Although its name may have implied a Spanish nationalist orientation or a linguistic model for unity, Casa Hispana, like the other emergent arts organizations in the Mission, was a site for the Latin American Left.

9. López, interview by author. See also Hidalgo de la Riva, "Chicana Spectators and Mediamakers," 69.

10. Recent scholarship on López typically does not account for the complexity of her consciousness. Some authors emphasize her Chicano identity, others her Latino and Third World orientation. See C. Cordova, "Heart of the Mission," 4; and Jason Ferreira, "All Power to the People: A Comparative History of Third World Radicalism in San Francisco, 1968–1977" (PhD diss., University of California, Berkeley, 2003). Still others describe her feminism, including Susan Britt Keale, "Issues of Female Mobility in Yolanda López's Artist as the Virgin of Guadalupe" (master's thesis, California State University, Chico, 2000), and Dyan Ellen Mazurana, "Uprising of Las Mujeres: A Feminist and Semiotic Analysis of Mexicana and Chicana Art" (PhD diss., Clark University, Worcester, MA, 1999). But rarely is her shifting oppositional consciousness addressed within the scope of a single work, a deficiency López noted in interviews by the author, March 22 and 23, 2007.

11. Chela Sandoval, *Methodology of the Oppressed* (Minneapolis: University of Minnesota Press, 2000), 71.

12. Ferreira, "All Power to the People"; C. Cordova, "Heart of the Mission"; and Tomás Francisco Sandoval, "Mission Stories, Latino Lives: The Making of San Francisco's Latino Identity, 1945–1970" (PhD diss., University of California, Berkeley, 2002).

13. Kusmiss, "Yolanda M. López," 120.

14. This section benefits from the largely original archival and oral history research of Ferreira in "All Power to the People," C. Cordova in "Heart of the Mission," and T. F. Sandoval in "Mission Stories, Latino Lives."

15. López, interview by author.

16. Rubén Cordova indicates that she was also aware of the movement to free Caryl Chessman, on death row for robbery, kidnapping, and rape. Chessman was convicted of dragging a woman a short distance from her car before raping her. His case led to the repeal of the Little Lindbergh Law, a California interpretation of the Lindbergh Law that made any crime involving kidnapping with bodily harm a capital offense. López, interview by R. Cordova, August 11, 2004.

17. William Barlow and Peter Shapiro, *An End to Silence: The San Francisco State College Student Movement in the '60s* (New York: Pegasus, 1971); C. Cordova, "Heart of the Mission," 196.

18. C. Cordova, "Heart of the Mission," 8.

19. Barlow and Shapiro, *End to Silence*, 238.

20. Ibid., 263–64; Ferreira, "All Power to the People," 140.

21. Lowe, *Immigrant Acts*, 40.

22. C. Cordova, "Heart of the Mission," 17.

23. López, interview by R. Cordova, December 14, 2001.

24. Ibid.

25. López, interview by author.

26. Quoted in C. Cordova, "Heart of the Mission," 15.

27. López, interview by author.

28. Quoted in Ferreira, "All Power to the People," 133.

29. Quoted in ibid., 134. Emphasis added.

30. Quoted in ibid., 239. See also C. Cordova, "Heart of the Mission," 16–17.

31. Quoted in Ferreira, "All Power to the People," 134. Emphasis added.

32. Ibid.

33. Quoted in C. Cordova, "Heart of the Mission," 208.

34. Ferreira, "All Power to the People," 265.

35. Ibid., 266.

36. Ibid., 267.

37. T. F. Sandoval, "Mission Stories, Latino Lives," 212.

38. Ferreira, "All Power to the People," 295.

39. Ibid., 337. Ferreira is astute in his observation that the Los Siete Committee made significant contributions to the community, especially by providing a morning meal to impoverished school-age children through the breakfast program. The state eventually started its own school breakfast program when educators realized that hungry children cannot concentrate on learning.

40. Marjorie Heins, *Strictly Ghetto Property: The Story of Los Siete de la Raza* (Berkeley, CA: Ramparts Press, 1972), 159–69, 191–201.

41. Heins, *Strictly Ghetto Property*, 163.

42. Carol Wells, "La Lucha Sigue: From East Los Angeles to the Middle East," in Noriega, *Just Another Poster?* 193.

43. López, interview by author. See also Ferreira, "All Power to the People," 301.

44. Erika Doss, "'Revolutionary Art Is a Tool for Liberation': Emory Douglas and Protest Aesthetics at the *Black Panther*," in *Liberation, Imagination, and the Black Panther Party: A New Look at the Panthers and Their Legacy*, ed. Kathleen Cleaver and George Katsiaficas (New York:
Routledge, 2001), 183. See also Sam Durant, ed., *Black Panther: The Revolutionary Art of Emory Douglas* (New York: Rizzoli, 2007).

45. See Colette Gaiter, "What Revolution Looks Like: The Work of Black Panther Artist Emory Douglas," in Durant, *Black Panther*, 109; and Greg Jung Morozumi, "Emory Douglas and the Third World Cultural Revolution," in Durant, *Black Panther*, 135.

46. Quoted in Doss, "Revolutionary Art," 175. While Emory Douglas voiced this artistic purpose among African Americans, it was Malaquías Montoya and Leslie Salkowitz Montoya, in "Critical Perspective," who brought it to public discussion among Chicanos.

47. Gaiter, "What Revolution Looks Like," 96.

48. Doss, "Revolutionary Art," 180.

49. Gaiter, "What Revolution Looks Like," 106.

50. Allan Sekula, "Dismantling Modernism, Reinventing Documentary (Notes on the Politics of Representation)," in *Photography against the Grain: Essays and Photo Works, 1973–1983* (Halifax, Nova Scotia: Press of the Nova Scotia College of Art and Design, 1984), 54.

51. Alexander Alberro, "Reconsidering Conceptual Art, 1966–1977," in *Conceptual Art: A Critical Anthology*, ed. Alexander Alberro and Blake Stimson (Cambridge, MA: MIT Press, 2000), xvii.

52. Ibid., xxii.

53. Sekula, "Dismantling Modernism," 56.

54. Lucy Lippard, "Escape Attempts," in *Reconsidering the Object of Art: 1965–1975*, ed. Ann Goldstein and Anne Rorimer (Los Angeles: Museum of Contemporary Art; Cambridge, MA: MIT Press, 1995), 17, 23. The second quote is from Alberro, "Reconsidering Conceptual Art," xxvi.

55. Lippard, "Escape Attempts," 17, 31.

56. López, interview by author.

57. Doss, "Revolutionary Art," 178; López, interview by author.

58. López, interview by author.

59. Ibid.

60. Quoted in Ferreira, "All Power to the People," 372–74.

61. Ibid., 375.

62. Villa, *Barrio-Logos*, 172.

63. Lucy Lippard, *Get the Message? A Decade of Art for Social Change* (New York: E. P. Dutton, 1984).

64. George Lipsitz, "Not Just Another Social

Movement: Poster Art and the *Movimiento Chicano*," in Noriega, *Just Another Poster?* 73.

65. Conceptual artists who mixed art and politics include the Art Worker Coalition and the Guerrilla Art Action Group in New York City.

66. Lipsitz, "Not Just Another Social Movement," 77.

67. Ibid. Throughout the movie, Tom Donovan (John Wayne) refers to Ransom Stoddard (James Stewart), the new man in town, as "Pilgrim." Although it was the first time Wayne uttered that moniker, it became his signature expression.

68. For an analysis of purported Mexican illegality, see Nicholas P. De Genova, "Migrant 'Illegality' and Deportability in Everyday Life," *Annual Review of Anthropology* 31 (2002): 419–48.

69. Hidalgo de la Riva, "Chicana Spectators and Mediamakers," 72. The voter-approved proposition was later deemed unconstitutional by the courts.

70. Goldman and Ybarra-Frausto, introduction to *Arte Chicano*, 51.

71. López, personal communication to author, June 17, 2007.

72. López, interview by author.

FINDING A LANGUAGE

1. López, interview by author.

2. Hopkins, *After Modern Art*, 181.

3. Martha Rosler, "Statement," in Alberro and Stimson, *Conceptual Art*, 487. López vividly recalls watching Rosler's *Semiotics of the Kitchen*, which she thought was "just astoundingly—just hilarious, where you fall down on your knees and just die laughing." López, interview by author.

4. Like López, René Yáñez was from San Diego, although at the time of her MFA exhibition he was living in the San Francisco Bay Area and co-directing Galería de la Raza in the Mission District. Their relationship started as a friendship and then evolved through several stages as they first agreed to parent a child together, then lived together as partners, and finally entered into a professional association. López, interview by author.

5. Karen Mary Davalos, *Exhibiting Mestizaje: Mexican (American) Museums in the Diaspora* (Albuquerque: University of New Mexico Press, 2001).

6. López, interview by author.

7. Lippard, *Get the Message?* 3.

8. Sekula, "Dismantling Modernism," 53.

9. Ibid., 56.

10. López, interview by author.

11. Sekula, "Dismantling Modernism," 53.

12. Forrester, *3 Stories*. See also López, interview by author.

13. Villa, *Barrio-Logos*, 174.

14. Laura E. Pérez, "Writing on the Social Body: Dresses and Body Ornamentation in Contemporary Chicana Art," in *Decolonial Voices: Chicana and Chicano Cultural Studies in the 21st Century*, ed. Arturo J. Aldama and Naomi H. Quiñonez (Bloomington: Indiana University Press, 2002), 30–63.

15. The inability of West Coast women artists, such as Judy Chicago and Miriam Schapiro, to conceptualize class and racial inequality probably kept López from joining the collaborative and collective artist groups that women were forming in the 1970s, although she did find inspiration from peers such as Susan R. Mogul, who attended events organized by the Women's Building in Los Angeles. Mogul often recounted these events to López. López, interview by author.

16. Maria Ochoa, *Creative Collectives: Chicana Painters Working in Community* (Albuquerque: University of New Mexico Press, 2003), 17.

17. Shifra M. Goldman, *Chicana Voices and Visions* (Venice, CA: Social and Public Arts Resource Center, 1983), 5.

18. Gaspar de Alba, *Chicano Art Inside/Outside the Master's House*, 125.

19. Rolando Castellón, introduction to *Mano a Mano: Abstraction/Figuration* (Santa Cruz, CA: Art Museum of Santa Cruz, 1988), 9.

20. López, interview by author.

21. Daniela Salvioni, introduction to Fuller and Salvioni, *Art/Women/California*, 5. See also Forrester, *3 Stories*.

22. Guisela Latorre, "Latina Feminism and Visual Discourse: Yreina Cervántez's *La Ofrenda*," in "Latina/o Discourses in Academe," special issue, *Discourse: Journal for Theoretical Studies in Media and Culture* 21, no. 3 (Fall 1999): 107.

23. López in MFA exhibition brochure.

24. Ibid.

25. Laura Mulvey, "Visual Pleasure and Narrative Cinema," in *Visual and Other Pleasures* (London: Macmillan, 1989), 14–26. Originally published in *Screen* 16, no. 3 (Autumn 1975): 6–18.

26. Guisela Latorre, "Gender, Muralism and the Politics of Identity: Chicana Muralism and Indigenist Aesthetics," in *Disciplines on the Line: Feminist Research on Spanish, Latin American, and U.S. Latina Women*, ed. Anne J. Cruz, Rosilie Hernández-Pecoraro, and Joyce Tolliver (Newark, DE: Juan de la Cuesta Hispanic Monographs, 1999), 323.

27. Annette Stott, "Transformative Triptychs," *Art Journal* 57, no. 1 (Spring 1995): 56–57.

28. An image of the mural can be found in Griswold del Castillo, McKenna, and Yarbro-Bejarano, *Chicano Art*.

29. Yolanda López, "The Virgin of Guadalupe on the Road to Aztlán" (presentation at Loyola Marymount University, Los Angeles, March 22, 2007).

30. Judith Huacuja Pearson, "Chicana Critical Pedagogies: Chicana Art as Critique and Intervention" (presentation at national conference, "The Interpretation and Representation of Latino Cultures: Research and Museums," Smithsonian Institution, Washington, DC, November 20–23, 2002, http://latino.si.edu/research-andmuseums/background/introduction.html).

31. López was surprised to see her mother's interpretation of her own posture—the result of *Mother Standing as Artist* is an older woman imitating "a coquettish young female."

32. López, interview by author.

33. López was influenced by Rosler's deadpan humor and delighted by her video *Semiotics in the Kitchen*. The fact that López often showed the same style of humor is often overlooked.

34. The movement of the runner beyond the frame of the drawing is a deconstructionist assertion that somebody created the image. See Sekula, "Dismantling Modernism," 57.

35. Ileana La Bergère, "Our Lady of Tonantzin: Re-Membering Greater México's Icon" (master's thesis, San Francisco State University, May 1994).

36. López, interview by author.

37. Ibid. Although the widely recognized modernist architect was known for his low-cost materials and careful use of space, the Mandeville Center for the Arts did not function for the students. For example, López reports that skylights were placed over the photography lab and that the small loading dock made it difficult to create large works. The unrealistic understanding of a conceptual school of art and of contemporary shifts in the art world was also expressed by Manny Farber, López's faculty adviser, when he declared López an "ethnic artist."

38. Ibid. The unrealistic portrayal of the buildings also emphasizes the inability of the art world, represented by artist and film critic Manny Farber, to account for portraits that do not reproduce images of whiteness or expectations of what Americans should look like.

39. Martha Rosler, *Decoys and Disruptions: Selected Writings, 1975–2001* (Cambridge, MA: MIT Press, 2004), 100.

40. Peter Selz, *The Art of Engagement: Visual Politics in California and Beyond* (Berkeley: University of California Press in association with the San Jose Museum of Art, 2006), 68.

41. Sekula, "Dismantling Modernism," 74.

42. Alexander Alberro, "The Mobile Passage," in *Rights of Passage*, by Martha Rosler with essays by Anthony Vidler and Alexander Alberro (New York: New York Foundation for the Arts, 1997), 39. Alberro notes that the artists of the 1960s, such as Ed Ruscha, Lee Friedlander, and Danny Lyon, also aimed their cameras out car windows, but he points out that Rosler's view departs from and challenges the male photographic gaze.

43. Laura E. Pérez, *Chicana Art: The Politics of Spiritual and Aesthetic Altarities* (Durham, NC: Duke University Press, 2007), 52–57.

44. Ibid., 54.

45. Ibid.

46. Ibid., 52, 54.

47. The quotation is from Sekula, "Dismantling Modernism," 55–56.

GUADALUPE AS FEMINIST PROPOSAL

1. López, "Artist Provocateur," 38.

2. Gloria Anzaldúa, *Borderlands/La Frontera: The New Mestiza* (San Francisco: Aunt Lute, 1987), 30.

3. López, "Artist Provocateur," 38.

4. Yolanda M. López, interview by Susan Keale, December 26, 1999, quoted in Keale, "Issues of Female Mobility," 84.

5. Alicia Arrizon, "Mythical Performativity: Relocating Aztlán in Chicana Feminist Cultural Productions," *Theatre Journal* 52, no. 1 (2000): 23–49; Jeanette Rodriguez, *Our Lady of Guadalupe: Faith and Empowerment among Mexican-American Women* (Austin: University of Texas Press, 1994); Timothy Matovina, "Celestial *Mestiza*, 1940–2003," in *Guadalupe and Her Faithful: Latino Catholics in San Antonio from Colonial Times to the Present* (Baltimore: Johns Hopkins University Press, 2005); Virgilio Elizondo, *The Future Is Mestizo: Life Where Cultures Meet* (Boulder: University Press of Colorado, 2000), *Guadalupe: Mother of the New Creation* (Maryknoll, NY: Orbis, 1997), and *La Morenita: Evangelizer of the Americas* (San Antonio, TX: Mexican American Cultural Center Press, 1980); and Gloria Inés Loya, "Pathways to a *Mestiza* Feminist Theology," in *A Reader in Latina Feminist Theology: Religion and Justice*, ed. María Pilar Aquino, Daisy L. Machado, and Jeanette Rodríguez (Austin: University of Texas Press, 2002), 217–40.

6. This section draws on Angie Chabram-Dernersesian's 1994 discussion of the study for *Eclipse*, and because she thoroughly analyzes the study, it is included in my analysis. See Chabram-Dernersesian, "And, Yes . . . The Earth Did Part: On the Splitting of Chicana/o Subjectivity," in de la Torre and Pesquera, *Building with Our Hands*, 42–45. Chabram-Dernersesian bases her critical investigation on the study published in "Yolanda M. López/San Diego Series Guadalupe," *Maize: Xicano Art and Literature Notebooks* (Centro Cultural de La Raza, San Diego, California) 1, no. 4 (1978): 55–59. The major difference between the two is the images of Saturn, which are missing from the study.

7. Chabram-Dernersesian, "And, Yes . . . The Earth Did Part," 43.

8. The techniques of color Xerox and collage are precursors to the digital images created by Alma López and others.

9. López, interview by R. Cordova, May 24, 2002.

10. López, interview by R. Cordova, August 12, 2004.

11. Chabram-Dernersesian, "And, Yes . . . The Earth Did Part," 43.

12. *Eclipse* and the study use different techniques to convey the shadow. In the study, the image in the background is faint like a shadow and immediately behind a virgin that is graphically darker and outlined in black. In *Eclipse*, color creates the shadowing. The images in the foreground and background are both pink and of the same intensity, but the one in the front has a black-and-white face and hands, indicating a presence that makes the one in the background into a shadow. Both collages depict a drifting from the center by the doubling.

13. López, interview by R. Cordova, May 24, 2002.

14. Chabram-Dernersesian, "And, Yes . . . The Earth Did Part," 43.

15. Ibid., 45.

16. López, interview by R. Cordova, May 24, 2002.

17. According to Holly Barnet-Sánchez, only Our Lady of Guadalupe is free of sexualized desire. All other women are potentially objectified by the male gaze. Barnet-Sánchez, "Where Are the Chicana Printmakers?" in Noriega, *Just Another Poster?* 132.

18. Villaseñor Black, "Sacred Cults, Subversive Icons," 134.

19. Ibid, 134–74.

20. David Carrasco, "A Perspective for a Study of Religious Dimensions in Chicano Experience: *Bless Me, Ultima* as a Religious Text," in *The Chicano Studies Reader: An Anthology of Aztlán, 1970–2000*, ed. Chon A. Noriega, Eric R. Avila, Karen Mary Davalos, Chela Sandoval, and Rafael Perez-Torres (Los Angeles: UCLA Chicano Studies Research Center Press, 2001), 304. Originally published in *Aztlán* 13 (Spring/Fall 1982).

21. Ibid., 309.

22. Villaseñor Black, "Sacred Cults, Subversive Icons," 137.

23. Jaroslav Pelikan, *Mary through the Centuries: Her Place in the History of Culture* (New Haven, CT: Yale University Press, 1996); and Marina Warner, *Alone of All Her Sex: The Myth and the Cult of the Virgin Mary* (New York: Vintage Books, 1983). Warner points out that the shift in the twelfth century "from virgin birth to virginity, from religious sign to moral doctrine . . . transformed a mother goddess like the Virgin Mary into an effective instrument of asceticism and female subjection" (49).

24. Pelikan, *Mary through the Centuries,* 194.

25. "The signs and symbols of the indigenous spiritual and cultural world" indicate that her hands are joined in offering rather than in prayer. Loya, "Pathways," 234.

26. Ena Campbell, "The Virgin of Guadalupe and the Female Self-image," in *Mother Worship*, ed. James J. Peterson (Chapel Hill: University of North Carolina Press, 1982), 5–24; George L. Scheper, "Guadalupe: Image of Submission or Solidarity," *Religion and the Arts* 3, no. 3–4 (1999): 335–84; Jeanette Favrot Peterson, "The Virgin of Guadalupe: Symbol of Conquest or Liberation?" *Art Journal* 51, no. 4 (Winter 1992): 39–47; Rodriguez, *Our Lady of Guadalupe*; Matovina, *Guadalupe and Her Faithful*. Eric R. Wolf is possibly the only scholar to see Guadalupe as an unchanging "single Master symbol," whereas theologians, anthropologists, and art historians explore the changing devotions, roles, and meaning assigned to the Guadalupe icon of the sixteenth century. See Wolf, "The Virgin of Guadalupe: A Mexican National Symbol," *Journal of American Folklore* 71, no. 279 (1958): 34–39.

27. Loya, "Pathways," 234; see also Elizondo, *La Morenita* and *Guadalupe*. The quotation is from Rodriguez, *Our Lady of Guadalupe*, 22.

28. Theologians also note that the angel does not resemble the cherubic forms of Western devotional art. He is distinctly Indian and a young man. His colored and feather wings are suggestive of the God of Water, Tláloc, and the God of Fire, Xiutecutli. The flowers on Guadalupe's gown represent the divine, but the form is similar to the pre-Columbian glyphs for the heart, the source of the human soul among the Nahuatl people.

29. Alvin John Schmidt, *Veiled and Silenced: How Culture Shaped Sexist Theology* (Macon, GA: Mercer University Press, 1989), 95. Quoted in Pelikan, *Mary through the Centuries*, 3.

30. Stott, "Transformative Triptychs," 63 n. 9.

31. Ibid., 55.

32. Hidalgo de la Riva, "Chicana Spectators and Mediamakers," 71.

33. In 1997 Freida High noted that "it is the most popularized composition" of the series. My own investigation of exhibition reviews, catalogs, and ephemera related to exhibitions, 1978–2006, confirms this claim. High, "Chiasmus—Art in Politics/Politics in Art: Chicano/a and African American Image, Text, and Activism of the 1960s and 1970s," in *Voices of Color: Art and Society in the Americas*, ed. Phoebe Farris-Dufrene (Atlantic Highlands, NJ: Humanities Press, 1997), 154.

34. López, interview by author. Various versions of the title have been published. For the MFA exhibition and elsewhere, the self-portrait of the Guadalupe series is titled *Guadalupe: Yolanda M. López*.

35. Ramón García, "Patssi's Eyes," *Aztlán* 22, no. 2 (Fall 1997): 169–80.

36. Stott, in "Transformative Triptychs," states that the artist leaps down, planting a foot firmly on the back of the angel, and runs forward, but according to López this is inaccurate. The young woman is leaping over the angel. López, interview by author.

37. In the exhibition catalog for *Chicano Art: Resistance and Affirmation* this work is titled *Margaret F. Stewart as the Virgin of Guadalupe*.

38. López, artist's statement in *Poetic Paradox* exhibition catalog, 34.

39. López, interview by R. Cordova, April 21, 2002.

40. The snake has multiple meanings, as Yvonne Yarbro-Bejarano points out in "Turning It Around."

41. López, interviews by R. Cordova, April 21, 2002, and May 24, 2002.

42. Similarly, López does not intend the images to represent model Guadalupes or women as Guadalupe. As art historian Erika Doss explains, "Feminist artists challenged traditionally male-dominant historical narratives by substituting, for example, goddess figures." Doss, *Twentieth-Century American Art* (New York: Oxford University Press, 2002), 191. While López is included among this group, along with Carolee Schneeman, Mary Beth Edelson, Rachel Rosenthal, and Nancy Spero, López was not substituting herself, her mother, and her grandmother for Guadalupe; instead she was offering them as sacred figures similar to Guadalupe.

43. López was interested in the power of working-class women rather than in a feminine mystical power (as emphasized in Gadon, *Once and Future Goddess*, and Stott, "Transformative Triptychs").

44. For a discussion of mythologizing the indigenous, see Goldman and Ybarra-Frausto, introduction to *Arte Chicano*.

45. López also produced a mixed-media collage in which the central image is taken from *Nuestra Madre*, and she adds a golden crown and four scenic medallions to visually depict the apparition of Guadalupe in 1531. This motif draws on the colonial art of Guadalupe in which the scenic medallions of the apparition and miracle surround the icon.

46. Latorre, "Gender, Muralism," 323.

47. Anita Brenner, *Idols behind Altars* (New York: Biblo and Tannen, 1967; orig. pub. 1929).

48. Nancy Pineda-Madrid, "Notes Toward a Chicana Feminist Epistemology (and Why It Is Important for Latina Feminist Theologies)," in Aquino, Machado, and Rodríguez, *Reader in Latina Feminist Theology*, 261. See also Loya, "Pathways," 232; and Norma Alarcón, "Chicana Feminism: In the Tracks of 'the' Native Woman," in Trujillo, *Living Chicana Theory*, 371–82.

49. Pineda-Madrid, "Notes," 260.

50. These are not contradictions for U.S. Third World feminists, who reconcile multiple identities and strategies as well as conflicting and ambiguous social positions.

51. See Karen Mary Davalos, "Poetics of Love and Rescue: Chicana Art Collectors," *Latino Studies* 5 (2007): 76–103, for a complete analysis of the ways in which Chicana art collectors function as communal agents to restore, preserve, or protect the cultural heritage of Chicanos and Chicanas. They abandon the image of the narcissistic collector whose acquisitions are his ego and self-identity. They identify the objects that they purchase and their activity of collecting in ways that signal empowerment and identity with and within a larger social group.

52. Anna Nieto Gómez, "La Feminista," in *Chicana Feminist Thought: The Basic Historical Writings*, ed. Alma M. García (New York: Routledge, 1997), 89.

53. This phrase comes from the title of Eden E. Torres, *Chicana without Apology/Chicana sin vergüenza: The New Chicana Cultural Studies* (New York: Routledge, 2003).

54. Yreina Cervántez, interview by author, May 29, 2007.

55. Lara Medina, "*Los Espíritus Siguen Hablando*: Chicana Spiritualities," in Trujillo, *Living Chicana Theory*, 189.

56. Yolanda Broyles Gonzalez, "Chicana/India/Mexicana Indigenous Spiritual Practices in Our Image," in *Chicana Traditions: Continuity and Change*, ed. Norma E. Cantú and Olga Nájera-Ramírez (Urbana: University of Illinois Press, 2002), 117.

COLLECTING AND EXHIBITING MEXICANA

1. López, "Artist Provocateur," 37.

2. Lippard, "Escape Attempts," 23.

3. Although they are sometimes unattributed, the slides of her work for Galería de la Raza are included in the gallery's papers at the California Ethnic and Multicultural Archives, University of California, Santa Barbara.

4. López, "Artist Provocateur," 37.

5. Ricardo Reyes, "The Mexicana Icon: A Study in Stereotypes," in *Cactus Hearts/Barbed Wire Dreams: Media Myths and Mexicans*, exhibition catalog (San Francisco: Galería de la Raza, 1988), 7.

6. This is evident, for instance, in the California Heritage Museum exhibition *Rancho Monterey: Spanish Revival and Mexican Decorative Arts in California*, February 27 to October 28, 2007.

7. Yolanda M. López, artist's statement in *Cactus Hearts/Barbed Wire Dreams*, exhibition catalog, 5.

8. Sekula, "Dismantling Modernism," 70.

9. Ibid.

10. Hidalgo de la Riva, "Chicana Spectators and Mediamakers," 70.

11. Lippard, *Mixed Blessings*, 41.

12. Ibid., 41–42.

13. Early in his production of the documentary *Ethnic Notions*, Marlon Riggs considered documenting how Latinos were also represented in television and mass media, and he approached López for use of her collection. Although nothing materialized from the encounter, it illustrates the reach of her slide show and video, *When You Think of Mexico*, as well as her innovations in the deconstruction of racist imagery. López, interview by author.

14. Elizabeth Martínez, "For Whom the Taco Bell Tolls," *Crossroads*, April 1995, 32.

15. Sekula, "Dismantling Modernism," 53.

16. The language and strategy of "talking back" emerged in the 1970s and 1980s from U.S. Third World feminists who aimed to take control of their representation by "talking back" to white feminists and social scientists. Two examples are bell hooks, *Talking Back: Thinking Feminist, Thinking Black* (Boston: South End Press, 1989); and *This Bridge Called My Back: Writings by Radical Women of Color*, ed. Cherríe Moraga and Gloria Anzaldúa (New York: Kitchen Table/Women of Color Press, 1983).

17. José Esteban Muñoz, *Disidentifications: Queers of Color and the Performance of Politics* (Minneapolis: University of Minnesota Press, 1999), 31.

18. Yolanda M. López, quoted in Lori Tenny, "Masked Media: Yolanda López Fights Racial Stereotypes," *San Francisco State University Prism*, October 1989, 11–13.

19. Muñoz, *Disidentifications*, 31.

20. Huacuja Pearson, "Chicana Critical Pedagogies."

21. Norma Alarcón, "Conjugating Subjects in the Age of Multiculturalism," in *Mapping Multiculturalism*, ed. Avery F. Gordon and Christopher Newfield (Minneapolis: University of Minnesota Press, 1996), 136.

22. López, "Artist Provocateur," 37.

23. López, artist's statement in *Cactus Hearts/Barbed Wire Dreams* exhibition catalog, 5.

24. Ironically, it is her form and style that causes some critics to dismiss the work because they cannot imagine the position of the marginalized, or if they can, their own anxiety about internalized privilege renders them unable to engage the work as art and appreciate what it is able to accomplish. See, for example, Kenneth Baker's review of *La Frontera/The Border: Art about the Mexico/United States Border Experience* in the *San Francisco Chronicle*, November 1, 1994, E1. He states that López's piece, *Things I Never Told My Son about Being a Mexican*, "is more remarkable as scavenger documentary than as art, but by calling it art, she causes us to register each detail as a small wound of insult or sorrow."

25. Kusmiss, "Yolanda M. López," 121.

26. Ollman, "Centro Cultural's 'On the Spot.'"

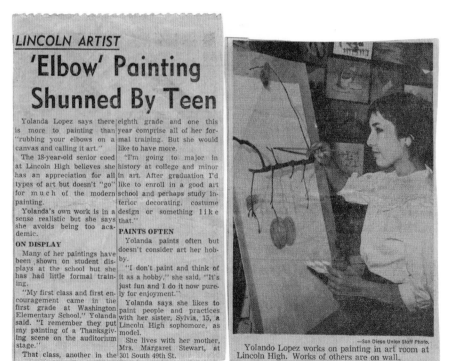

Article about Yolanda M. López
as a high school student, from the
San Diego Union, January 28, 1961.

EXHIBITION HISTORY

EDUCATION

Master of Fine Arts, Visual Arts, University of California, San Diego, 1978

Bachelor of Arts, Painting and Drawing, California State University, San Diego, 1975

San Francisco State University, 1966–69

Associate Arts Degree, Art, College of Marin, CA, 1964

AWARDS

2008 National Lifetime Achievement Award in the Visual Arts, Women's Caucus for Art, Dallas, TX

2004 "Women of Fire," Women of Color Resource Center, Oakland, CA

1998 San Francisco Arts Commission Cultural Equity Grant: Individual Artist Commission

1997 Pollock-Krasner Foundation Grant, New York, NY

1997 Rutgers University Dialogue Grant/The Latina Artist: Response of the Creative Mind to Gender, Class, Race and Identity

1997 KQED Hispanic Heritage Month Honors Local Heroes

1996–98 Eureka Fellowship Grant Award, Fleishhacker Foundation, San Francisco, CA

1996–97 Chicanas in the Arts Award, National Association for Chicano Studies

1990 Guest Artist, III Bienal Internacional de Poesía Visual, Experimental y Alternativa, Núcleo Post Arte/México, César Espinoza, Coordinator, Secretaría de Relaciones Exteriores, Universidad Nacional Autónoma de México, Ciudad de México Sociocultura DF, Lotería Nacional et al., Mexico City

1989 Artist in Residence, Acciones: A Convergence of Latino Artists and Thinkers from the Two Americas, organized by Guillermo Gómez-Peña, Yellow Springs Institute, Chester Springs, PA

1986 Honorable Mention, First Video, San Antonio CineFestival, San Antonio, TX

1985–86 Artist in Residence, California Arts Council

1978 Ford Foundation Dissertation and Thesis Grant

1976–78 Ford Foundation Graduate Fellowship for Mexican Americans, Native Americans and Puerto Ricans

1975–76 San Diego Fellowship, University of California, San Diego

RECENT COMMISSIONS

1997 XXIV Annual Conference: National Association for Chicana and Chicano Studies poster

1995–96 Mujeres Activas en Letras y Cambio Social (MALCS) poster and logo

1990 E. R. Taylor Elementary School, San Francisco, mural

SOLO EXHIBITIONS

2008

Yolanda López: Women's Work Is Never Done/The Promise of the Border, Mission Cultural Center for Latino Arts, San Francisco, CA.

2002

Hybrid Americas: Contacts, Contrast, and Confluences in New World Literatures and Cultures, University of Bielefeld, Germany.

1998

Work about Work: A Woman Working in San Diego 1919–1998, University Arts and Lectures Series, California State University, San Marcos.

Cactus Hearts/Barbed Wire Dreams, Art Department Gallery, City College of San Francisco, CA.

1993

Cactus Hearts/Barbed Wire Dreams, MACLA Center for Latino Arts, San Jose, CA.

1989

Cactus Hearts/Barbed Wire Dreams, Art Gallery, San Francisco State Student Union Association and La Raza Organization, San Francisco, CA.

1988

Cactus Hearts/Barbed Wire Dreams: Media Myths and Mexicans, Galería de la Raza, San Francisco, CA.

1986

Cactus Hearts/Barbed Wire Dreams, Galería Posada, Sacramento, CA.

1979

Recent Paintings: Yolanda M. López, Love Library, San Diego State University, San Diego, CA.

1978

Yolanda M. López Works: 1975–1978, Mandeville Center for the Arts, University of California, San Diego, and Centro Cultural de la Raza, San Diego, CA.

1976

Three Generations: Tres Mujeres, Galería Campesina, La Brocha del Valle, Fresno, CA.

1975

One Woman Show, Chicano Community Center, Chicano Federation, San Diego, CA.

GROUP EXHIBITIONS

2007

Claiming Space: Some American Feminist Originators, American University Museum, Katzen Arts Center at American University, Washington, DC.

In Search of the Miraculous, University Gallery, University of Essex, Wivenhoe Park, Colchester, UK.

2006

Tlazolteotl, Goddess Cleanser of Filth, New College of California, San Francisco.

2005

Weedee Peepo: Icons, Portraits, y Gente, Galería de la Raza, San Francisco, CA.

At Work: The Art of California Labor, Kolligian Library, University of California, Merced.

2002

Three Generations of Chicana Art, Rike Gallery, University of Dayton, OH.

Parallels and Intersections: A Remarkable History of Women Artists in California, San Jose Museum of Art, San Jose, CA. Curator, Diana Fuller.

2001–2

Mexicanidad: Our Past Is Present, Mexican Fine Arts Center Museum, Chicago, IL.

The Road to Aztlán: Art from a Mythic Homeland, Los Angeles County Museum of Art, Los Angeles, CA. Traveled to Austin Museum/Texas Fine Arts Association, Austin; Albuquerque Museum, Albuquerque, NM. Curators, Virginia Fields and Victor Zamudio-Taylor.

Made in California: Art, Image, and Identity, 1900–2000, Los Angeles County Museum of Art, Los Angeles, CA.

2001

Poetic Paradox: Ten Years of Innovation in Latino Art, Movimiento de Arte y Cultura Latino Americana, San Jose, CA.

1998–2001

Just Another Poster? Chicano Graphic Arts in California, Jack S. Blanton Museum of Art, University of Texas at Austin; University Art Museum, University of California, Santa Barbara; Fowler Museum, University of California, Los Angeles; Oakland Museum of California, Oakland, CA; Jersey City Museum, Jersey City, NJ; Crocker Art Museum and La Raza Galería Posada, Sacramento, CA.

The Role of Paper: Affirmation and Identity in Chicano and Boricua Art / El papel del papel: Afirmación e identidad en la obra boricua y chicana, Sala Central del Antiguo Arsenal de la Marina Española, La Puntilla, San Juan, PR, with the Guadalupe Cultural Arts Center, San Antonio, TX. Traveled to Caribbean Cultural Center and Hostos University, New York, NY; Taller Puertorriqueño, Brandywine Workshop, Philadelphia, PA; Mexican Museum and Yerba Buena Center for the Arts, San Francisco, CA; Centro Cultural de la Raza, San Diego, CA; New Mexico Hispanic Cultural Center, Albuquerque, NM. Curators, Pedro Rodriguez and Antonio Martorell.

1998

Give & Take: Artists and Youth in Dialogue, San Francisco Arts Education Project, Mills Building, San Francisco, CA. Curator, Larry Rinder.

Labyrinth: A Day of the Dead, Yerba Buena Center for the Arts, San Francisco, CA, in collaboration with the Youth Ambassadors of Yerba Buena Center. Curator, René Yáñez.

Culture y Cultura: How the U.S.-Mexican War Shaped the West, Autry Museum of Western Heritage, Los Angeles, CA. Curators, Christina Ochoa and Theresa R. Gonzalez.

Unthinkable Tenderness: The Art of Human Rights, Art Department Gallery, San Francisco State University, San Francisco, CA. Principal guest curator, Denise L. Beirnes.

1997

Eureka Fellowship Awards Exhibition, San Jose Museum of Art, San Jose, CA.

Art of the Americas: Identity Crisis, M. H. de Young Memorial Museum, San Francisco, CA. Curator, Timothy Anglin Burgard.

The Community Collects: Latin American and Latino Art from Private Bay Area Collections, Mexican Museum, San Francisco, CA. Curator, Ruben Cordova.

The Madonna: Four Centuries of Divine Imagery, William King Regional Arts Center, Virginia Museum of Fine Arts, Abingdon.

From Within: An Exhibition about Motherhood and the Creative Process, Works Gallery, San Jose, CA.

1996

Sexual Politics: Judy Chicago's Dinner Party in Feminist Art History, Armand Hammer Museum of Art and Cultural Center, Los Angeles, CA. Curator, Amelia Jones.

10 x 10: Ten Women, Ten Prints, Charles Grafly Gallery, Edwin A. Ulrich Museum of Art, Wichita State University, Wichita, KS.

Annual Print Exhibition, Self Help Graphics and Galería Otra Vez, Los Angeles, CA.

Chicano Print Exhibition, California State University, Los Angeles.

The Virgin, Frida and Me: Contemporary Chicana Artists, Saddleback College, Mission Viejo, CA.

GOP: Graficas, Obras, Políticas, Centro Cultural de la Raza, San Diego, CA.

Cancer Support Community Exhibit, Latino Outreach Project, Galería Museo, San Francisco, CA.

Art Objects, Santa Rosa Junior College Art Gallery, Santa Rosa, CA.

1995

10 x 10: Ten Women, Ten Prints, Berkeley Art Center, Berkeley, CA. Curator, Robbin Henderson.

Bogey Down with the Fine Arts Museums, M. H. de Young Memorial Museum, San Francisco, CA.

By Virtue of Age: Lessons from Our Elders, Solano Community College Fine Art Gallery, Fairfield, CA.

No More Scapegoats/A Call for Tolerance and Compassion, Town Center, Corte Madera, CA.

Encuentros, Mission Cultural Center for Latino Arts, San Francisco, CA.

1994

Xicano Ricorso: A Thirty Year Retrospect from Aztlán, Museum of Modern Art, New York. Curator, Armando Rascón.

Los de Abajo: The Undocumented, Orange County Latino Network, the Caged Chameleon, Santa Ana, CA.

Fierce Tongues: Women of Fire, Highways, Santa Monica, CA. Curators, Monica Palacios and Luis Alfaro.

Mirror, Mirror: Gender Roles and the Historical Significance of Beauty, San Jose Institute of Contemporary Art, San Jose, CA. Curator, Terri Cohn.

Three Women Artists: Jean La Marr, Flo Wong and Yolanda M. López, Chico State University Gallery, Chico, CA.

Women's Mentor Show, San Francisco Art Commission Gallery, San Francisco, CA. Curator, Teresa Carnozzi.

1993

La Frontera/The Border: Art about the Mexico/United States Border Experience, Museum of Contemporary Art, San Diego, CA. Traveled to Tacoma Art Museum, Tacoma, WA; Scottsdale Center for the Arts, Scottsdale, AZ; San Jose Museum of Art, San Jose, CA.

Primavera: Faculty Exhibit, Worth/Ryder Gallery, University of California, Berkeley.

From Tradition to Innovation: El Sabor, Galería de la Raza, San Francisco, CA.

From Tradition to Innovation: La Fe, Galería de la Raza, San Francisco, CA. Curator, Amalia Mesa-Bains.

Mira! The Diversity of Latin Expression, Sun Gallery, Hayward, CA.

1992–93

Counter Weight/Alienation, Assimilation, Resistance: Artists Who Investigate the Tension between Group Identification and Self-Representation and Who Counter Socially Constructed Ideas about Race, Gender, Ethnicity, Culture, and Sexuality, Santa Barbara Contemporary Arts Forum, Santa Barbara, CA. Curators, Sondra Hale and Joan Lugo.

1990–93

Chicano Art: Resistance and Affirmation, Wight Art Gallery, University of California, Los Angeles, CA. Traveled to Denver Art Museum, Denver, CO; Albuquerque Museum, Albuquerque, NM; San Francisco Museum of Modern Art, San Francisco, CA; Fresno Art Museum, Fresno, CA; Tucson Museum of Art, Tucson, AZ; National Museum of American Art, Smithsonian Institution, Washington, DC; El Paso Museum of Art, El Paso, TX; Bronx Museum, New York, NY; San Antonio Museum of Art, San Antonio, TX.

Encuentro: Invasion of the Americas and the Making of the Mestizo, Social and Public Art Resource Center, Venice, CA.

1992

TeleMundo: Karen Atkinson, Yolanda López, Iñigo Manglano-Ovalle, Celia Álvarez Muñoz, Jorge Pardo, Danny Tisdale, Terrain Gallery, San Francisco, CA. Curator, Armando Rascón.

Who Discovered Whom? Brook Hall, Islip Art Museum, East Islip, NY.

Journeys: The Bus Shelter Project, Intersection for the Arts, San Francisco, CA. Curator, Ann Chamberlain.

1990

The Decade Show: Frameworks of Identity in the 1980s, New Museum of Contemporary Art, Museum of Contemporary Hispanic Art, Studio Museum in Harlem, New York, NY.

Sacred Forces: Contemporary and Historical Perspectives: *Yolanda López, Ana Mendieta, Mayumi Oda, Nancy Spero*, San Jose State University Art Gallery, San Jose, CA.

San Francisco Bay Artists, San Francisco Arts Commission Gallery and Centro Colombo Americano. Traveled to Medellín, Cartagena, Bogotá, Cali, and Pereira, in Colombia, South America.

1988–89

Mano a Mano: Abstraction/Figuration, 16 Mexican American and Latin American Painters. Traveled to Art Museum of Santa Cruz County, Santa Cruz, CA; Museum of Modern Art, Santa Ana, CA; Oakland Museum, Oakland, CA; Mary Porter Sesnon Art Gallery, University of California, Santa Cruz. Curator, Rolando Castellón.

1988

Shadow Catchers: Máscaras Exhibit, Luna's Café, Sacramento, CA. Curator, Tere Romo.

Chicano Anesthetics/Rasquachismo, MARS Artspace, Phoenix, AZ. A juried invitational exhibition. Juror, Tomás Ybarra-Frausto.

On the Spot: New Works Created at the Centro Cultural de la Raza, Centro Cultural de la Raza, San Diego, CA.

1987

Chicano Expressions: A New View in American Art. Traveled to INTAR, New York, NY; Otis-Parsons, Los Angeles, CA; Mexican Museum, San Francisco, CA. Curator, Inverna Lockpez.

México Arte Norteamérica, Norteamericana Arte Mexicana, Salón de Sorteos, Lotería Nacional, Mexico. Curator, Jorge Burbiesca, Museo Contemporáneo.

Against Fashion: Video & Media Art, Artists' Television Access, San Francisco, CA. Curator, Marshall Weber.

Lo del Corazón: Heartbeat of a Culture, Mexican Museum, San Francisco, CA. Traveled to Charles Allis Art Museum, Milwaukee, WI; Fisher Gallery, University of Southern California, Los Angeles, CA; and San Jose Museum of Art, San Jose, CA.

Imágenes Guadalupanas de Artistas Chicanas. Traveled to Instituto Cultural Mexicano, San Antonio, TX; Museo Nacional de Culturas Populares, Mexico City.

Saludo al Pueblo de Nicaragua, Casa Gallery, San Francisco, CA. Curators, Jos Sances and Robin Henderson.

Chain Reaction 3, San Francisco Arts Commission Gallery, San Francisco, CA.

1986

Content: Contemporary Issues, Euphrates Gallery, Cupertino, CA; Southern Exposure Gallery, San Francisco, CA.

La Misión: Third Annual 94110 Show, Eye Gallery, San Francisco, CA. Curator, María Pinedo.

W x W Women by Women: An Historic Exhibition of Leading Hispana Artists Portraying the Image of Women, Galería de la Raza, San Francisco, CA. Curator, Amalia Mesa-Bains.

Made in Aztlán/Hecho en Aztlán, Centro Cultural de la Raza, San Diego, CA.

Obelisk: Individual Points of Reference, Rara Avis, Sacramento, CA.

1984

Art and Action: A Spring for Change, exhibition to accompany Symposium on Politics and Visual Art, Veterans Memorial Building, Santa Cruz, CA.

Chicana Voices & Visions: A National Exhibit of Women Artists, Social and Public Art Resource Center, Venice, CA. Curator, Shifra M. Goldman.

A Través de la Frontera, Sala de Exposiciones del CEESTEM, Universidad Nacional Autónoma de México, Mexico City.

Exchange of Sources, Expanding Powers, Stanislaus Art Gallery, California State University, Turlock. Curator, Rebecca Ballinger. Traveled to California State University, Hayward; University of Tennessee; Real Art Ways, Hartford, CT.

1983

Stemming the Tide of Militarism: An Artistic Statement, Mission Cultural Center, San Francisco, CA.

1982

In Progress: Artists Creating Work in Open Studio, Galería de la Raza, San Francisco, CA. Curator, René Yáñez.

From Issue to Image: Poster Art for Social Change, Pro Arts, Oakland, CA.

Coast to Coast, New Langton Arts, San Francisco, CA; Fashion Moda, Bronx NY; and Galería de la Raza, San Francisco, CA. Curator, Joe Lewis.

1981

Otra Onda: Fashion Moda and West Coast Artists, Galería de la Raza, San Francisco, CA.

1980
Self Portraits, Galería de la Raza, San Francisco, CA.

1978
Reflexions: The Chicano/Latino Art Experience in California, Centro Cultural de la Raza, San Diego, CA.
A Creative Space for Women, Self Help Graphics and Art, Los Angeles, CA.
La Mujer Chicana/Latina en el Movimiento y el Arte, Centro Cultural de la Raza, San Diego, CA.

1976
Arte Picante: Contemporary Chicano Art, Mandeville Center for the Arts, University of California, San Diego.
Sixth Annual Women's Festival of the Arts, Scripps Cottage, Center for Women's Studies and Services, San Diego State University, San Diego, CA.
Exposition Expression, San Diego Public Library and Institute for Cultural Pluralism, San Diego State University, San Diego, CA.

1975
Sentido Moreno, Mechicano Art Center, Los Angeles, CA. Curator, Leonard Castellano.
An Exhibit of Portraits, Galería de la Raza, San Francisco, CA. Curator, René Yáñez.
Chicanarte, Los Angeles Municipal Art Gallery, Los Angeles, CA.
Cinco Artistas Contemporáneos, Villa Montezuma, San Diego Historical Society, San Diego, CA.
California Chicano Artists, Office of Governor Edmund G. Brown Jr., Capitol Building, Sacramento, CA.
International Women's Week: Woman as Artist, San Diego City College, San Diego, CA.
Fifth Annual Women's Show, Love Library, San Diego State University, and Center for Women's Studies and Services, San Diego State University, San Diego, CA.

1974
Tres Mujeres: Gloria Amalia Flores, Yolanda López, Victoria del Castillo, Galería Poxteca, San Diego, CA, and Mechicano Art Center, Los Angeles, CA. Curator, Pablo de la Rosa.
The Three Mexican Masters and Chicano Artists, Galería Poxteca, San Diego, CA, and Galería de la Raza, San Francisco, CA.
First Annual Barrio Logan Community Art Exhibition, Barrio Logan, Congreso de Artistas Chicanos en Aztlán, San Diego, CA.
Fourth Annual Women's Show, Love Library, San Diego State University, and Center for Women's Studies and Services, San Diego, CA.

1970
First Annual Women's Show, Galería de la Raza, San Francisco, CA. Curators, Graciela Carrillo and René Yáñez.

CURATOR

1996 *Personal Narrative and Social Responsibility*, Nexus Gallery, Berkeley, CA, sponsored by California College of Arts and Crafts.
1994 *Other*, California College of Arts and Crafts Student Gallery, Oakland, CA.
1992 *Boys and Girls: Inside and Out*, Francisco Oller/José Campeche Galleries, Taller Puertorriqueño, Philadelphia, PA. Guest curator and artist.
1989 *Sheltering the Flame: Growing Up in the Mission*, Intersection for the Arts, San Francisco, CA.

BIBLIOGRAPHY

ARTICLES, CHAPTERS, AND BOOKS

Alba, Victoria. "Artists with a Mission." *San Francisco Examiner*, May 20, 1990, Image section, 23.

Alvarez-Smith, Alma. "Lopez, Yolanda." In *Encyclopedia of Latino Popular Culture*, vol. 1, edited by Cordelia Chávez Candelaria. Westport, CT: Greenwood Press, 2004, 491–92.

Arispe, Rudy. "Newer Works and Chicano Classics Grace 'Arte' Exhibit." *Conexion/San Antonio Express-News*, July 29–August 4, 1997, 40.

Arrizon, Alicia. "Mythical Performativity: Relocating Aztlán in Chicana Feminist Cultural Productions." *Theater Journal* 52, no. 1 (2000): 23–49.

"Art and Artists." *Encyclopedia of Multiculturalism*, vol. 1, edited by Susan Auerbach, 186–91. New York: Marshall Cavendish, 1994.

"Art as Antidote." *Caring* (The Caring Institute, Washington, DC), March 1988, 61.

Baker, Kenneth. "La Frontera Crosses the Border of Politics." Review of *La Frontera/The Border: Art about the Mexico/United States Border Experience*, San Jose Museum of Art, San Jose, CA. *San Francisco Chronicle*, November 1, 1994, E1.

Blackmer Reyes, Kathryn. "Yolanda López: 'Activist Artist.'" In National Association for Chicana and Chicano Studies 1997 Annual Conference, 12.

Blanc, Giulio V. "Cactus Hearts/Barbed Wire Dreams." *Galería de la Raza, Studio 24* 1, no. 8 (Summer 1988): 17–18.

———. "When You Think of Mexico: Latin American Women in The Decade Show." *Arts Magazine*, April 1990, 17–18.

———. "Kiosk Posters Turn Market Street into an Art Gallery." *San Francisco Examiner*, August 27, 1992.

Brenson, Michael. "Is 'Quality' an Idea Whose Time Has Gone?" *New York Times*, July 22, 1990, H1.

Brookman, Philip. "El Centro Cultural de la Raza: Fifteen Years." In *Made in Aztlan*, edited by Philip Brookman and Guillermo Gómez-Peña, 12–53. San Diego: Centro Cultural de la Raza, 1986.

Brown, Betty Ann. "A Community's Self-Portrait." Review of *Chicano Art: Resistance and Affirmation, 1965–1985*, Wight Art Gallery, University of California, Los Angeles. *New Art Examiner* 18, no. 4 (December 1990): 20–24.

Brownlee, Tim. "Local Contemporary Art Exhibit Features Works by UTSA Artists." *UTSA Today* (University of Texas, San Antonio), July 20, 2004, http://www.utsa.edu/today/2004/07/20.cfm.

Candelaria, Cordelia. "Letting La Llorona Go, or, Rereading History's Tender Mercies." *Heresies*, no. 27 (1993): 111–15.

Caputi, Jane. "In Search of Earthly Powers." Review of *The Once and Future Goddess: A Symbol for Our Time*, by Elinor W. Gadon. *Women's Review of Books*, May 1990, 14–15.

Castellano, Olivia. "Obelisk: Five Chicana Artists, Five Visions." *On the Wing* (Sacramento), 5, no. 2 (1985).

"CCS Welcomes Visiting Artists." *Crónica* (Department of Chicana and Chicano Studies, Arizona State University), Fall 2001.

Chabram-Dernersesian, Angie. "And, Yes . . . The Earth Did Part: On the Splitting of Chicana/o Subjectivity." In *Building with Our Hands: New Directions in Chicana Studies*, edited by Adela de la Torre and Beatríz M. Pesquera, 35–56. Berkeley: University of California Press, 1994.

Chadwick, Whitney. *Women, Art, and Society*. 3rd ed. New York: Thames and Hudson, 2002.

Chicago, Judy, and Edward Lucie-Smith. *Women and Art: Contested Territory*. New York: Watson-Guptill, 1999.

"Chicana Exhibits 'Tres Mujeres.'" *Sacramento Bee*, June 1976.

"Chicano Art Bared in Display at UCSD." *Triton* (University of California, San Diego), January 8, 1997.

"Chicano Art Panel at Fort Mason." *San Francisco Chronicle*, July 11, 1991, E2.

Cisneros, Sandra. "Guadalupe the Sex Goddess." *MS Magazine*, July–August 1996, 43–46.

Cordova, Cary. "The Heart of the Mission: Latino Art and Identity in San Francisco." PhD diss., University of Texas, Austin, 2005.

Corona, Lupe. "Chicano Art Show/Lecture." *Santa Barbara Independent* 14, no. 686 (January 20, 2000): 29.

Cotter, Holland. "Through Women's Eyes, Finally." *New York Times Magazine*, May 26, 1999, 92.

Curtis, Cathy. "Women's Work." *Los Angeles Times*, April 9, 1996, F1.

Davalos, Karen Mary. *Exhibiting Mestizaje: Mexican (American) Museums in the Diaspora.* Albuquerque: University of New Mexico Press, 2001.

Doss, Erika. *Twentieth-Century American Art.* New York: Oxford University Press, 2002.

Erickson, Mary. "Crossing Borders in Search of Self." *Art Education* 53, no. 2 (March 2000): 46–52.

"Exhibit at UCSD: Chicana Artist to Show Works." *Los Angeles Times,* December 6, 1978, San Diego County edition, section II, 8.

Farris, Phoebe. "López, Yolanda M." In *Women Artists of Color: A Bio-Critical Sourcebook of 20th Century Artists in the Americas,* 167–71. Westport, CT: Greenwood Press, 1999.

Ferreira, Jason Michael. "All Power to the People: A Comparative History of Third World Radicalism in San Francisco, 1968–1977." PhD diss., University of California, Berkeley, 2003.

———. "López, Yolanda." In *The Oxford Encyclopedia of Latinos and Latinas in the United States,* vol. 3, edited by Susana Obler and Deena J. Gonzáles, 13–16. New York: Oxford University Press, 2005.

Fox, Geoffrey. *Hispanic Nation: Culture, Politics, and the Construction of Identity.* New York: Birch Lane Press, 1995.

Freudenheim, Susan. "Diverse Exhibition Puts Viewer 'On the Spot.'" *San Diego Tribune,* March 23, 1988, C2.

Gadon, Elinor W. *The Once and Future Goddess: A Symbol for Our Time.* San Francisco: Harper and Row, 1989.

Gaspar de Alba, Alicia. *Chicano Art Inside/Outside the Master's House: Cultural Politics and the CARA Exhibition.* Austin: University of Texas Press, 1998.

———, ed. *Puro Corazón: A Symposium of Chicana Art.* Pomona, CA: Pomona College, 1995.

Goldman, Shifra M. "Artistas Chicanas Texanas." *Fem* 34 (June–July 1984): 29–31.

———. "Chicano Art of the Southwest in the Eighties." In *Made in Aztlán,* edited by Phillip Brookman and Guillermo Gómez-Peña, 72–82. San Diego: Centro Cultural de la Raza, 1986.

———. "Hecho en Aztlan (Made in Aztlan)." *Artspace* 10, no. 1 (Winter 1985–86): 17.

———. "The Iconography of Chicano Self-Determination: Race, Ethnicity, and Class." *Art Journal* 49, no. 2 (Summer 1990): 167–73.

———. "Madre tierra: Una idea, una exposición, una publicación." *La Comunidad: Suplemento Dominical de La Opinión,* March 13, 1983, 8–9.

———. "Mujeres de California: Latin American Women Artists." In *Yesterday and Tomorrow: California Women Artists,* edited by Sylvia Moore, 202–27. New York: Midmarch Arts Press, 1989.

———. "'Portraying Ourselves': Contemporary Chicana Artists." In *Feminist Art Criticism: An Anthology,* edited by Arlene Raven, Cassandra L. Langer, and Joanna Frueh, 187–205. Ann Arbor, MI: UMI Research Press, 1988.

———. "Trabajadores mexicanas y chicanas en las artes visuales." In *A través de la frontera,* edited by Icla Rodriguez and Salvador Leal, 137–49. Mexico City: Centro de Estudios Económicos y Sociales del Tercer Mundo, A.C., 1983.

Gómez-Peña, Guillermo. *Dangerous Border Crossers.* New York: Routledge, 2000.

———. "The Two Guadalupes." In *Goddess of the Americas, Writings on the Virgin of Guadalupe,* edited by Ana Castillo, 178–83. New York: Riverhead Books, 1996.

Greenstein, M. A. "And You Thought Feminism Was Dead? Judy Chicago's *Dinner Party* in Feminist Art History." *Artweek* 27, no. 7 (July 1996): 17–18.

Gutiérrez, Laura G. "Sexing Guadalupe in Transnational Double Crossings." *El Aviso* 6 (Fall 2006): 8–9.

Hawthorne, Christopher. "Women Times Ten." *Oakland East Bay Express,* March 31, 1995, 21.

Hidalgo de la Riva, Osa, ed. "Chicana Spectators and Mediamakers: Imagining Transcultural Diversity." Special issue, *Spectator: University of Southern California Journal of Film and Television Criticism* 26, no. 1 (Spring 2006): 67–74.

High, Freida. "Chiasmus—Art in Politics/Politics in Art: Chicano/a and African American Image, Text, and Activism of the 1960s and 1970s." In *Voices of Color: Art and Society in the Americas,* edited by Phoebe Farris-Dufrene, 118–66. Atlantic Highlands, NJ: Humanities Press, 1997.

Huacuja, Judith L. "Borderlands Critical Subjectivity in Recent Chicana Art." *Frontiers* 24, no. 2/3 (2003): 104–21.

Huacuja Pearson, Judith. "Chicana Critical Pedagogies: Chicana Art as Critique and Intervention." Presentation at national conference, "The Interpretation and Representation of Latino Cultures: Research and Museums," Smithsonian Institution, Washington DC, November 20–23, 2002, http://latino.si.edu/research-andmuseums/background/introduction.html.

———. "Lopez, Yolanda M." In *St. James Guide to Hispanic Artists: Profiles of Latino and Latin American Artists,* edited by Thomas Riggs, 328–29. Detroit: St. James Press, 2002.

Hume, Bill. "Warring Uses Clash over Symbols." *Albuquerque Journal*, February 17, 2002, E2.

Johnston-Hernández, Beatríz. "Lupita Recast." *San Francisco Examiner Image*, April 10, 1988, 6.

———. "Las Vidas Maravillosas de Yolanda López/The Many Wonderful Lives of Yolanda López." *El Tecolote*, (San Francisco), April 1988, 6.

Jones, Amelia. "Sexual Politics: Feminist Strategies, Feminist Conflicts, Feminist Histories." In *Sexual Politics: Judy Chicago's* Dinner Party *in Feminist Art History*, edited by Amelia Jones, 20–38. Berkeley: University of California Press, 1996.

Joysmith, Claire. "Chicana Writers: Recovering a Female Mexican Legacy." *Voices of México: Mexican Perspectives on Contemporary Issues* 32 (July–September 1995): 39–44.

Kaplan, Cora. Preface to *Feminist Studies* 20, no. 1 (Spring 1994): 3–6.

Keale, Susan Britt. "Issues of Female Mobility in Yolanda López's Artist as the Virgin of Guadalupe." Master's thesis, California State University, Chico, 2000.

Keller, Gary D., ed. "Yolanda M. López." In *Contemporary Chicana and Chicano Art: Artists, Works, Culture, and Education*, vol. 2, 80–85, 90–91. Tempe, AZ: Bilingual Press/Editorial Bilingüe, 2002.

Kelly, Martin. "Portrait of an Artist: Yolanda M. López, San Francisco, CA." *Guadalupe Connection* (Phoenix) 1, no. 4 (Summer 1991): 12–17.

Kendricks, Neil. "'I-5 Resurfacing' at the San Diego Museum of Art." Review of *I-5 Resurfacing: Four Decades of California Contemporary Art*, San Diego Museum of Art, San Diego. *Artweek* 33, no. 5 (June 2002): 18–19.

Knaff, Devorah. "A Collection of Cultures: Shows in San Diego and Claremont Acknowledge the Life and Perils of Multiculturalism." *Riverside (CA) Press-Enterprise*, March 28, 1993, C2.

———. "La Frontera/The Border at San Diego Venues." *Artweek* 24, no. 8 (April 22, 1993): 14.

———. "Life as Art." *Vista*, August 1988, 18, 34.

Kramer, Karl. "La Raza Students Protest Art Rejection." *Golden Gater* (Department of Journalism, San Francisco State University), March 30, 1989, 7.

Kusmiss, Mary. "Yolanda M. López." In *Connecting Conversations: Interviews with 28 Bay Area Women Artists*, edited by Moira Roth, 119–21. Oakland, CA: Eucalyptus Press, 1988.

La Bergère, Ileana. "Our Lady of Tonantzin: Re-Membering Greater México's Icon." Master's thesis, San Francisco State University, May 1994.

LaDuke, Betty. "Trivial Lives: Artists Yolanda López and Patricia Rodríguez." *Trivia: A Journal of Ideas*, no. 8 (Winter 1986): 74–85.

———. *Women Artists: Multi-Cultural Visions*. Trenton, NJ: Red Sea Press, 1992.

———. "Yolanda Lopez: Breaking Chicano Stereotypes." *Feminist Studies* 20, no. 1 (Spring 1994): 117–30.

Latorre, Guisela. "Gender, Muralism and the Politics of Identity: Chicana Muralism and Indigenist Aesthetics." In *Disciplines on the Line: Feminist Research on Spanish, Latin American, and U.S. Latina Women*, edited by Anne J. Cruz, Rosilie Hernández-Pecoraro, and Joyce Tolliver, 321–56. Newark, DE: Juan de la Cuesta Hispanic Monographs, 1999.

———. "Latina Feminism and Visual Discourse: Yreina Cervántez's *La Ofrenda*." In "Latina/o Discourses in Academe," special issue, *Discourse: Journal for Theoretical Studies in Media and Culture* 21, no. 3 (Fall 1999): 95–110.

"Lincoln Artist 'Elbow' Painting Shunned by Teen." *San Diego Union*, January 28, 1961, home edition, A13.

Lippard, Lucy R. *Mixed Blessings: New Art in a Multicultural America*. New York: Pantheon Books, 2000.

"López, Yolanda." In *The Latino Encyclopedia*, vol. 4, edited by Richard Chabrán and Rafael Chabrán, 917. New York: Marshall Cavendish, 1996.

López, Yolanda M. "Artist Provocateur: An Interview with Yolanda López." By Elizabeth Martínez. In *Cinco de Mayo: Homenaje a la Mujer Latina*, edited by Kathleen Baca, 37–38. San Francisco: MECA, 1994. Orig. pub. in *Crossroads* (Oakland, CA), May 1993.

———. "Portrait of My Grandmother." *Connexions*, no. 2 (Fall 1981): 16–17.

———. "Yolanda M. López." In *Contemporary Art and Multicultural Education*, edited by Susan Cahan and Zoya Kocur, 137. New York: New Museum of Contemporary Art, 1996.

———. "Yolanda M. López/San Diego Serie Guadalupe." *Maize: Xicano Art and Literature Notebooks* (Centro Cultural de La Raza, San Diego) 1, no. 4 (Summer 1978): 55–59.

López, Yolanda, and Moira Roth. "My Grandmother." In *Chicanarte* (exhibition catalog), 67. Los Angeles: Los Angeles Municipal Art Gallery, 1975.

———. "Social Protest: Racism and Sexism." In *The Power of Feminist Art, The American Movement of the 1970s, History and Impact*, edited by Norma Broude and Mary D. Garrard, 140–57. New York: Harry N. Abrams, 1994.

Markovitz, Jonathan. "Blurring the Lines: Art on the Border." *Postmodern Culture* 5, no. 1 (1994). http://muse.jhu.edu/journals/postmodern_culture/voo5/5.1r_markovitz.html.

Martínez, Elizabeth. *500 Años del Pueblo Chicano/500 Years of Chicano History in Pictures*. Albuquerque: SouthWest Organizing Project, 1991.

———. "For Whom the Taco Bell Tolls." *Crossroads* (Oakland, CA), April 1995, 32.

———. "Occupied Aztlán." *Crossroads* (Oakland, CA), September 1994, 10–12.

Martinez, Marilyn. "From Icon to Art Fad." *Los Angeles Times*, December 13, 1996, A3.

McDonald, Robert. "Latino Exhibit Uneven but Has Beauty." *Los Angeles Times*, October 19, 1985, D1.

Mesa-Bains, Amalia. "Calafia/Califas: A Brief History of Chicana California." In *Art/Women/California 1950–2000: Parallels and Intersections*, edited by Diana Burgess Fuller and Daniela Salvioni, 123–40. Berkeley: University of California Press in association with San Jose Museum of Art, 2002.

———. "El Mundo Femenino: Chicana Artists of the Movement." In *Chicano Art: Resistance and Affirmation, 1965–1985*, edited by Richard Griswold del Castillo, Teresa McKenna, and Yvonne Yarbro-Bejarano, 137–38. Los Angeles: Wight Art Gallery, University of California, 1991.

Morrison, Keith. "Questioning the Quality Canon: Three New York Museums Join Forces to Refigure the 80s." *New Art Examiner* 18, no. 2 (October 1990): 24–27.

Morse, Kitty. "Big Time Art on Logan Avenue." *San Diego Reader*, June 6–12, 1974, 3.

Muñoz, Daniel L. "Yolanda López Presents Homage to Chicana." *La Prensa San Diego*, December 8, 1978, 3.

Noriega, Chon. "The Aztlán Film Institute's Top 100 List." *Jump Cut*, no. 42 (1998): 67.

———. "The Orphans of Modernism." In *Phantom Sightings: Art After the Chicano Movement* (exhibition catalog), 17–45. Berkeley: University of California Press, 2008.

Ollman, Leah. "Centro Cultural's 'On the Spot' Applies to Both Viewers, Artists." Review of *On the Spot* by Felipe Ehrenberg, Gronk, Yolanda López, and Esther Parada, Centro Cultural de la Raza, San Diego. *Los Angeles Times*, April 8, 1988, San Diego County edition, B6.

Orenstein, Gloria Feman. "Recovering Her Story: Feminist Artists Reclaim the Great Goddess." In *The Power of Feminist Art: The American Movement of the 1970s, History and Impact*, edited by Norma Broude

and Mary D. Garrard, 174–87. New York: Harry N. Abrams, 1994.

Pacheco, Javier B. "Apartheid in the Media Hurts Hispanic Culture." *San Francisco Examiner*, September 7, 1993, A17.

Pagel, David. "'Poster' Flexes Political Muscle." Review of *Just Another Poster? Chicano Graphic Arts in California*, Santa Barbara University Art Museum, Santa Barbara, CA. *Los Angeles Times*, February 9, 2001, F2.

Pearlstone, Zena. "Art and Artists." In *Encyclopedia of Multiculturalism*, vol. 1, edited by Susan Auerback, 186–91. New York: Marshall Cavendish, 1994.

Pearson, Judith Huacuja. "Chicana Critical Pedagogies: Chicana Art as Critique and Intervention." In *Proceedings on The Interpretation and Representation of Latino Cultures, Research, and Museums* (Washington, D.C.: Smithsonian Institution Press, 2003).

Pérez, Laura E. *Chicana Art: The Politics of Spiritual and Aesthetic Altarities*. Durham, NC: Duke University Press, 2007.

———. "Writing on the Social Body: Dresses and Body Ornamentation in Contemporary Chicana Art." In *Decolonial Voices: Chicana and Chicano Cultural Studies in the 21st Century*, edited by Arturo J. Aldama and Naomi H. Quiñonez, 30–63. Bloomington: Indiana University Press, 2002.

Peterson, Jeanette Favrot. "The Virgin of Guadalupe: Symbol of Conquest or Liberation?" *Art Journal* 51, no. 4 (Winter 1992): 39–47.

Ponce, Mary Helen. "Celebrating Guadalupe, Sacred Icon of the People." *Los Angeles Times*, December 12, 1999, B11.

Quirarte, Jacinto. "Sources of Chicano Art: Our Lady of Guadalupe." *Explorations of Ethnic Studies* 15, no. 1 (January 1992): 13–26.

Raven, Arlene, Cassandra L. Langer, and Joanna Frueh, eds. *Feminist Art Criticism: An Anthology*. Ann Arbor, MI: UMI Research Press, University Microfilms, 1988.

Reid, Calvin. "Inside/Out." *Art in America*, January 1991, 57–63.

Reilly, Richard. "Chicano Art Exhibit: By Definition, Diverse." *San Diego Union*, February 1, 1976, E1.

Rodriguez, Roberto, and Patrisia Gonzales. "Women Living and Dying in Anonymity." *San Diego Union-Tribune*, May 24, 1996, B9.

Roth, Moira. "Afterword: Parts of a Puzzle." In *A Bio-Critical Sourcebook of 20th Century Artists in the Americas*, edited by Phoebe Farris, 461–67. Westport, CT: Greenwood Press, 1999.

———. "Traveling Companions/Fractured Worlds." *Art Journal* 58, no. 2 (Summer 1999): 82–93.

Samson, Kevin. "Modern Images Break Tradition." *Santa Cruz Sentinel*, April 14, 1988, D1.

Sandoval, Tomás Francisco Jr. "Mission Stories, Latino Lives: The Making of San Francisco's Latino Identity, 1945–1970." PhD diss., University of California, Berkeley, 2002.

Santiago, Chiori. "Mano a Mano: We Have Come to Excel." *Museum of California Magazine* 12, no. 5 (March/April 1989): 8–13.

Scheper, George L. "Guadalupe: Image of Submission or Solidarity." *Religion and the Arts* 3, no. 3/4 (1999): 335–84.

Scott, Nancy. "Art with a Mission." *San Francisco Examiner*, June 23, 1991, 12.

———. "Drawing the Line at War." *San Francisco Examiner*, January 18, 1991, C1.

Selz, Peter. *The Art of Engagement: Visual Politics in California and Beyond*. Berkeley: University of California Press in association with San Jose Museum of Art, 2006.

Shaw, Rebecca Salome. "Drums and Roses: An Introduction to Feminine Deity Presence in México's Religious History." Thesis, Pacific School of Religion, Berkeley, CA, 1994.

Sichel, Berta. "Chicano Art: Resistance and Affirmation." *Art Nexus: Edición Internacional de Arte en Colombia*, January–March 1994, 120–22.

Smith, Leo. "'Today Art.'" *Los Angeles Times*, April 4, 1991, J14.

Solochek Walters, Sylvia. "Feminists Celebration in Prints." *California Printmaker* 2 (July 1995): front cover, 2–5.

Sperling Cockroft, Eva. "Chicano Identities." Review of *Chicano Art: Resistance and Affirmation, 1965–1985*, Wight Art Gallery, University of California, Los Angeles. *Art in America*, June 1999, 84–91.

Stone, Judy. "How a Barrio Underpass Became 'Chicano Park.'" *San Francisco Chronicle*, May 23, 1989, E2.

Stott, Annette. "Transformative Triptychs in Multicultural America." *Art Journal* 57, no. 1 (Spring 1998): 55–63.

Sullivan, Kathleen. "Classes Aim to Draw Out Hidden Talents of Elderly; Chico Man Is Eldergivers' Artist of the Year." *San Francisco Chronicle*, August 15, 2003, E7.

Taylor, Pamela G. "Inventively Thinking: Teaching and Learning with Computer Hypertext." *Art Education* 55, no. 4 (July 2002): 6–12.

"10 Women, 10 Prints." Review of *10 x 10: Ten Women, Ten Prints*. Berkeley Art Center, Berkeley, CA. *Oakland Post* 31, no. 107 (March 5, 1995): 6B.

Tenny, Lori. "Masked Media: Yolanda López Fights Racial Stereotypes." *San Francisco State University Prism*, October 1989, 11–13.

Thym, Jolene. "Borderline Views." *Oakland Tribune*, October 6, 1994, CUE1.

Tibol, Raquel. "Artistas chicanos de San Francisco en La Lotería Nacional." *Proceso* (Mexico City), no. 569 (September 28, 1987): 52–54.

Torres, Anthony. "Art of the Americas: Identity Crisis." Review of *Art of the Americas: Identity Crisis*, Memorial Museum, San Francisco. *New Art Examiner*, February 25, 1998, 54.

Trujillo, Carla. "La Virgen de Guadalupe and Her Reconstruction in Chicana Lesbian Desire." In *Living Chicana Theory*, edited by Carla Trujillo, 214–31. Berkeley, CA: Third Woman Press, 1998.

Trujillo, Marcella. "The Dilemma of the Modern Chicana Artist and Critic." *Heresies* 2, no. 4 (1979): 5–10.

Turegano, Preston. "Museum Prospers in First Year Downtown." *San Diego Union-Tribune*, January 30, 1994, E1.

Uriegas, Berin. "Arte chicano en Washington." Review of *Chicano Art: Resistance and Affirmation, 1965–1985*, National Art Museum, Washington, DC. *El Diario/La Prensa*, September 1, 1992, 21.

Van Proyen, Mark. "Ethnicity, Culture and Vitality." *Artweek*, April 1, 1989, 1.

Walker, Hollis. "Depiction of the Virgin of Guadalupe Stirs Objections." *Los Angeles Times*, April 4, 2001, F3.

Westcott, Gloria. "Mano a mano: Un encuentro abstracto y figurativo." *El Tiempo Latino*, March 22, 1989.

Whyte, Chris. "Artist Fights Mexican Stereotypes." *Daily Titan* (California State University, Fullerton), October 2, 1998, http://media.www.dailytitan.com/media/storage/paper861/news/1998/10/02/News/Artist.Fights.Mexican.Stereotypes-1536526.shtml.

Windhausen, Rodolfo. "Activa muestra de video chicano." Announcement for *Xicano Ricorso: Una retrospectiva de 30 años desde Aztlán*, Museum of Modern Art, New York. *La Opinión*, March 24, 1994, 3F.

Wright, Lili. "Yolanda Lopez's Art Hits 'Twitch Meter' to Fight Stereotypes." *Salt Lake Tribune*, May 14, 1995, E3.

Yarbro-Bejarano, Yvonne. "Turning It Around: Chicana Art Critic Yvonne Yarbro-Bejarano Discusses the Insider/Outsider Visions of Ester Hernandez and Yolanda López." *Crossroads* (Oakland, CA), May 1993, 15, 17.

"Yolanda López." In *Notable Hispanic American Women*, vol. 2, edited by Joseph M. Palmisano, 182–83. Detroit: Gale, 1998.

"Yolanda M. Lopez Works: 1975–1978." *Carta Abierta: Keeping an Eye on the Chicano Literary World* (Albuquerque), December 1978.

Zamudio-Taylor, Victor. "Chicano Art." In *Latin American Art in the Twentieth Century*, edited by Edward J. Sullivan, 315–29. San Francisco: Chronicle Books, 1996.

EXHIBITION CATALOGS

Artistas México-Americanos de San Francisco, California. Salon de Sortes, Lotería Nacional, Mexico City, 1987.

Cactus Hearts/Barbed Wire Dreams: Media Myths and Mexicans. San Francisco: Galería de la Raza, 1988.

Chicana Voices and Visions. Curated by Shifra Goldman. Venice, CA: Social and Public Arts Resource Center, 1984.

Chicano Art: Resistance and Affirmation, 1965–1985. Edited by Richard Griswold del Castillo, Teresa McKenna, and Yvonne Yarbro-Bejarano. Los Angeles: Wight Art Gallery, University of California, 1991.

The Decade Show: Frameworks of Identity in the 1980s. Curated by Julia P. Herzberg, Laura Trippi, Gary Sangster, and Sharon F. Patton. New York: Museum of Contemporary Hispanic Art, New Museum of Contemporary Art, and Studio Museum in Harlem, 1990.

Encuentro: Invasion of the Americas and the Making of the Mestizo. Venice, CA: Social and Public Art Resource Center, 1991.

Exchange of Sources, Expanding Powers. Hayward: California State University, 1983.

La Frontera/The Border: Art about the Mexico/United States Border Experience. Curated by Patricio Chávez and Madeleine Grynsztejn. Exhibition and catalog coordinated by Kathryn Kanjo. San Diego: Centro Cultural de la Raza and Museum of Contemporary Art San Diego, 1993.

Just Another Poster? Chicano Graphic Arts in California / ¿Sólo un cartel más? Artes gráficas chicanas en California. Edited by Chon Noriega. Santa Barbara: University Art Museum, University of California, 2001.

The Madonna: Four Centuries of Divine Imagery. Curated by Kathryn Charles. Abingdon, VA: William King Regional Arts Center, 1996.

Mano a mano: Abstraction/Figuration. Santa Cruz, CA: Art Museum of Santa Cruz, 1988.

Mixed Messages: Chicano Art in the Border Region. San Diego: Centro Cultural de la Raza, 1993.

Mutual Influences/Influencias mutuas. San Antonio, TX: Guadalupe Cultural Arts Center and Instituto Cultural Mexicano, 1991.

Parallel Expressions in the Graphic Arts of the Chicano and Puerto Rican Movements. Curated by Yasmin Ramírez and Henry C. Estrada. New York: El Museo del Barrio, 2000.

Poetic Paradox: Ten Years of Innovation in Latino Art. San Jose, CA: Movimiento de Arte y Cultura Latino Americana (MACLA), 2001.

The Road to Aztlán: Art from a Mythic Homeland. Edited by Virginia M. Fields and Victor Zamudio-Taylor. Los Angeles: Los Angeles County Museum of Art, 2001.

The Role of Paper: Affirmation and Identity in Chicano and Boricua Art / El papel del papel: Afirmación e identidad en la obra boricua y chicana. San Antonio, TX: Guadalupe Cultural Arts Center, 1998.

10 x 10: Ten Women, Ten Prints. Curated by Robbin Légère Henderson. Berkeley, CA: Berkeley Art Center, 1995.

3 Stories: Flo Wong, Jean LaMarr, Yolanda López. Text by Susan Forrester. Chico, CA: University Art Gallery, California State University, 1994.

Yolanda M. López Works: 1975–1978. La Jolla, CA: Mandeville Center for the Arts, 1978.

VIDEO

W x W, Women by Women: An Evening of Exchange. Videorecording of exhibition at Galería de la Raza/Studio 24, May 29, 1985. VHS. Directed by Elizabeth Sher. San Francisco: IV Studios, 1985.

When You Think of Mexico: Commercial Images of Mexicans. VHS. Directed by Carl Heyward. Oakland, CA: Piñata Publications, 1986.

ARCHIVAL COLLECTIONS

Brookman, Philip. Papers, 1980–95. Archives of American Art, Smithsonian Institution, Washington, DC.

López, Yolanda. "Yolanda López Papers." California Ethnic and Multicultural Archives, Donald D. Davidson Library, University of California, Santa Barbara. Guide at http://cemaweb.library.ucsb.edu/lopez_toc.html.

Sánchez, Ricardo. Papers, 1941–95. Special Collections, Cecil H. Green Library, Stanford University. Finding aid at http://content.cdlib.org/ark:/13030/tf796nb2g4/.

INDEX